ORIENTAL ANTIQUES IN COLOR

Oriental Antiques in Color

Michael Ridley

ARCO Publishing Company, Inc.
New York

Published 1978 by Arco Publishing Company, Inc.
219 Park Avenue South, New York, N.Y. 10003

Printed in Great Britain

Library of Congress Cataloging in Publication Data

Ridley, Michael.
 Oriental antiques in color.

 Includes index
 1. Art, Far Eastern—Catalogs. 2 Art Objects,
Far Eastern—Catalogs. I. Title.
N7336.R5 709'.5 77-26876
ISBN 0-668-04474-8
ISBN 0-668-04485-3 pbk.

Contents

ABRIDGED CHRONOLOGIES

CHINA

Shang Dynasty	c. 1523-1027 B.C.
Chou Dynasty	1027-221 B.C.
Spring and Autumn Period	770-475 B.C.
Warring States Period	481-221 B.C.
Ch'in Dynasty	221-206 B.C.
Han Dynasty	206 B.C.-A.D. 220
Three Kingdoms	A.D. 220-A.D. 280
Six Dynasties Period	A.D. 280-A.D. 589
Northern Wei	A.D. 385-A.D. 535
Northern Ch'i	A.D. 550-A.D. 577
Northern Chou	A.D. 557-A.D. 581
Sui Dynasty	A.D. 589-A.D. 618
T'ang	A.D. 618-A.D. 906
Five Dynasties	A.D. 907-A.D. 959
Sung Dynasty	A.D. 960-A.D. 1280
Yuan Dynasty	A.D. 1280-A.D. 1368
Ming Dynasty	A.D. 1368-A.D. 1643
Ch'ing Dynasty	A.D. 1644-A.D. 1912

JAPAN

Jomon period	1000 B.C.-200 B.C.
Yayoi period	200 B.C.-A.D. 500
Tumulus or Great Tomb period	A.D. 300-A.D. 700
Asuka period	A.D. 552-A.D. 645
Early Nara period	A.D. 645-A.D. 710
Nara period	A.D. 710-A.D. 794
Early Heian period	A.D. 794-A.D. 897
Heian or Fujiwara period	A.D. 897-A.D. 1185
Kamakura period	A.D. 1185-A.D. 1392
Ashikaga or Muromachi period	A.D. 1392-A.D. 1573
Momoyama period	A.D. 1573-A.D. 1615
Tokugawa period	A.D. 1615-A.D. 1868

INDIA

Mauryan period	c. 322 B.C.-c. 183 B.C.
Sunga period	c. 183-c. 71 B.C.
Kushan Emperor Kanishka	A.D. c. 78-101
Gupta period	A.D. c. 320-540
Pallavas (Madras state)	· A.D. 300-888
Harsha	A.D. 606-647
Palas of Bengal	A.D. 760-1142
Cholas (Madras state)	A.D. 850-1267

6

Introduction

Collecting antiques is today an international hobby, with objects of all kinds from many ages and countries being collected by both Eastern and Western collectors. As well as antique and curio shops which are found all over the world, there are international salerooms in London, Paris, Geneva, Amsterdam, Tokyo and New York, to name but a few. For antiques today are not only the hobby of millions but also the big business of a few.

For years European antiques have dominated the scene, but increasingly oriental antiques have come into their own. Now there is world wide interest in them, and many objects which have found their way to Europe and America are being purchased by oriental dealers and returned to their land of origin. Thus, interest spans both East and West, a fact which tends to increase their rarity. Therefore oriental works of art make good investments, as well as aesthetically pleasing furnishings for the modern home.

The field of oriental antiques is extremely large, for it encompasses the arts and crafts of many lands. The great civilisations of China, Japan, India, Tibet and Nepal have between them given the world some of its greatest treasures.

This is a book for those interested in these treasures as art objects and for the collector whose joy lies in trying to acquire them. Within its pages lie testaments to the skill and artistry of hundreds of artists and craftsmen.

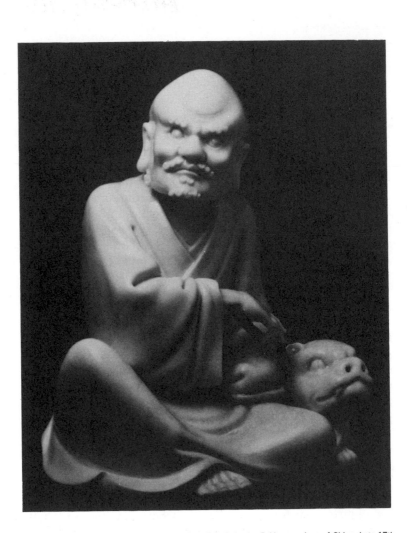

Porcelain Blanc-de-chine figure of a Lohan from Tehuâ, in the Fukien province of China. Late 17th century.

1 *Chinese Pottery and Porcelain*

Chinese porcelain is probably the most collected of all oriental antiques. This may be due to the fact that it is the finest porcelain in the world, which in a way is hardly surprising, as the Chinese invented it.

The Chinese ceramic tradition is unique, for its genealogy extends backwards, unbroken by time for nearly 5,000 years. Even in the Neolithic period, c. 3000 BC, the Chinese can claim to have produced the finest and most advanced pottery in the ancient world.

For the collector, the first pottery that will be of interest to him is that of the T'ang dynasty. Pottery of this period is superb. Its form, modelling, colour and especially its glazes are unsurpassed. It was the 'golden age' of Chinese pottery as well as the beginning of the porcelain tradition.

Synonymous with the term T'ang, are the exquisite pottery figures of horses and other animals, blending together as they do, the art of the sculptor with that of the potter. Virtually unknown until the beginning of the century, they have since become extremely desirable and much sought after. Once on the open market, the figures created a demand that could only be satisfied by illicit digging or faking. It is interesting to note that some very fine fakes were produced which even found their way into museums. They are a constant menace to collectors.

The superb models of horses of the T'ang period are among the masterpieces of Chinese art, and rival Greek sculpture in the mastery of spirit and movement. T'ang pottery sculpture is dynamic, naturalistic and extremely plastic. T'ang artists were masters of ceramics and their skill and artistry is clearly seen in the tomb figures, which seem endowed with a sense of life and movement.

The cosmopolitan atmosphere of T'ang China is reflected in the figures of foreigners from the Near and Middle East and Central Asia. The figures of both Chinese, and foreigners, animals and humans, accurately capture the everyday life of the period, even the high spiritual ideals of contemporary philosophy.

Advances in pottery technology were used to great effect. In fact the ceramic art of T'ang China was far ahead of other countries, not only in the Far East but also in the world as a whole. Delightful glazes of cream, green, brown and yellow were used both on vessels and pottery figures. The glaze was applied thickly to the vessels so that it dripped down the side, leaving the lower part of the cream, almost white body, unglazed. The glazes often merged with each other producing beautiful effects. Unglazed figures were painted with unfired pigments, such as white, red, green and black.

Foreign designs greatly influenced Chinese potters, especially the shapes of Sassanian Persia. The technology of the T'ang potters reached its apex in the 10th century, when they developed pure porcelain. This was achieved by using kaolin, a white clay, and firing at high temperatures. Vessels in this early porcelain have a beautiful creamy white glaze.

Tz'u, the Chinese name for porcelain, encompasses more than does our own word, for the Chinese do not classify porcelain by its colour, but whether it gives a clear musical note when struck. These wares may be opaque, dark and even brown. Pure white translucent ware is only one of the many varieties of ceramics which the Chinese classified under the term tz'u.

Whereas the T'ang dynasty is known for its pottery, the Sung

dynasty is known for its porcelain, which is probably the finest, both in technique and in vision, that the world has ever seen. The creamy wares of the T'ang dynasty, were refined and perfected to become the famous white *ting* ware of the Sung dynasty. Shapes became much more delicate. White glazed ware was, however, only one of the many subtle coloured glazes that were perfected. Superb pastel colours such as pale blue, lavender and green were made. Sung pottery is full of surprises and delights and is almost infinite in its variety, from celadons and crackle-ware such as the so-called *kuan* ware, to the dark brown glazed *chien* ware. Shapes too are delightful, simplicity at its best. Designs were often incised and covered with a thick glaze which accentuated the design as a darker tone.

During the short but important Yuan dynasty, which followed the overthrow of the Sung, celadons continued to be made, but now under the patronage of an alien Mongol dynasty. Some of the kilns in the north, however, had been overrun by Chin nomads, but in the south some Sung ceramic types continued to be made. The pottery was less graceful and heavier than the Sung. Yuan celadons for example are much heavier.

During the period there was extensive trade with the Middle East, bringing about a flow of ideas between the two areas. A direct result of this improved trading relationship was the production of the first blue and white underglazed porcelain in the early 14th century. The blue was achieved from cobalt, at first imported from Persia, but later during the Ming dynasty, obtained from indigenous sources. Cobalt was known in T'ang times and used by Kashan potters in the 13th century to decorate their vessels with overglaze blue. The superior knowledge of ceramics of the Chinese potters, however, enabled them to develop a technique for using the blue underglaze. The decoration of the early pieces was almost black but by the mid 14th century, they had overcome all the technical problems and mastered the technique to produce true blue decoration. Underglaze red was also mastered about this time. The use of copper-red underglaze decoration fell out of fashion after the

11

beginning of the 15th century, maybe because of the difficulty in controlling the design.

During the Ming dynasty, blue and white ware became the main product of the Chinese potters. Production was taken out of the hands of small individual potters and centralised in large factories, some, from the beginning of the 15th century, under Imperial patronage. The largest of these factories was situated at Ching-te-chen in Kiangsi. There are records which show orders of over 100,000 pieces for the Imperial Household.

Ming blue and white is notable for its brilliance of both its decorative colour and white surface. Decorations tended to be floral, though the use of dragons and figures as decorative devices was popular.

It was at about this time that the export trade with Europe began, through Portuguese traders based in Macao. Later the trade was taken over by the Dutch.

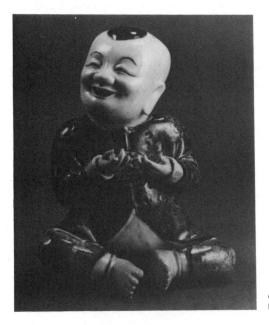

Chinese porcelain figure of a boy. 17th century.

It would be a mistake to assume that all porcelain was decorated in underglaze colours. On the contrary, other forms of decoration continued in use, including the manufacture of monochrome wares which echo back to Sung times, and polychrome enamelled ware. The latter began to be made in the reign of the Emperor Ch'eng-hua. Another ware imitating cloisonné also became fashionable.

The Ming dynasty also saw the birth of the famous and beautiful creamy white blanc-de-chine ware of Fukien, which reached its apex in the Ch'ing dynasty in the 18th century. It was a reflowering of the combined skills of potter and sculptor.

Porcelain during the Ch'ing dynasty reached the peak of technical perfection. After a brief period of decline following the cessation of the Ming dynasty, porcelain factories turned out a constant flow of superb products. Blue and white porcelain was the speciality of the 18th century. It had a depth of colour all its own, unlike anything before or after it.

The 18th century is also famous for its coloured porcelains decorated in the *famille verte* (green), *famille rose* (red), and *famille noir* (black), palletes. In each, the colour mentioned in brackets predominates. Floral designs were the most popular. In addition to these, monochromes were made, which, though more brash than those of the Ming period, have a range of colours which more than compensates for this. Although there were numerous new innovations, potters also looked backwards to the great days of the Sung and Ming periods, copying their masterpieces in acts of reverence.

Chinese porcelain was to the Europeans the wonder of the East, and large quantities left China for Western homes. Porcelain decorated in the European taste, sometimes embellished with coats of arms, was exported by the ship load. Armorial porcelain was also exported to America, Russia and Africa. In the 19th century a colourful ware decorated in overglaze enamels with heavy gilt was made and exported from Canton.

Porcelain was marked with the reign mark of the emperor

from reign of Yung-lo (1403–24). Although a piece of porcelain may bear such a mark it does not necessarily mean that it was made in the reign indicated, for such marks were often placed on porcelain of later dates as a mark of respect for the artistic and technical achievements of an earlier reign. Thus marks alone are no guide to date (see chapter on Marks). Even styles of decoration and shape are but little use in dating porcelain, only experience gained in actually handling genuine pieces from different periods will help. Fakes and copies abound (see chapter on Fakes).

It may be fitting to end this chapter with a cautionary tale. Six well known experts were invited to spend a day together examining a blue and white porcelain bowl with a view to ascertaining its date. After many examinations and much discussion five decided that the bowl was Ming, and one an 18th century copy. It had in fact been made only the previous week!

Pair of porcelain vases from South China. 19th century.

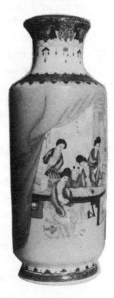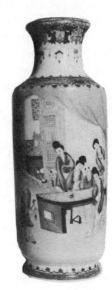

2 *Japanese Pottery and Porcelain*

Mention Japanese pottery or porcelain to many collectors and they will instantly conjure up an image of a jug, cup or tea-pot over decorated with relief decoration of dragons, warriors or geisha girls in vivid colours, smothered with gilt—in short Satsuma-ware. With this image they often dismiss Japanese ceramics as vulgar and insignificant. But this is not the whole story—it is just the rather sad ending to a once glorious art, an art that was appreciated both inside and outside Japan, and one which, like that of Chinese porcelain, influenced the designs of European pottery and porcelain.

The Satsuma ware described above is in many cases not really Satsuma but a cream ware made in Satsuma and decorated in Kyoto, or even made in Kyoto and decorated in Tokyo. However, popular ideas tend to stick and as Satsuma it is commonly known. But the story of Japanese ceramics begins several centuries before this degenerate form of Satsuma ware.

Ceramic art in Japan never developed to the same extent as it did in China. Until the 16th century earthenware was predominant, glazed ware not coming into general use until later during the Tokugawa period (1615–1868).

In dealing with Japanese ceramics we should at the outset distinguish between pottery and porcelain. The Satsuma we are most familiar with is pottery. Both pottery and porcelain were produced in Japan and both were exported. While Satsuma

became the most popular export pottery, the Imari ware of the Arita district became the most popular export porcelain. The two traditions of pottery and porcelain are quite separate in Japan and little attempt was made by one to imitate the other. The natural quality of both materials was utilised to its full extent, therefore, with the introduction of glazes to pottery it remained simply pottery with glaze and not imitation porcelain. It is perhaps the lateness of the introduction of both glazes and porcelain to Japan that may account for this.

Porcelain was not introduced into Japan until the 16th century. The early examples therefore owe much to the porcelain traditions of China and Korea. It was first made in Japan with materials brought from China by Gorodayu go Shonzui. With this material, which included some of the famous Mohammedan blue used by the Chinese for their underglaze ware, he established himself at Arita in Hizen province on the island of Kiushiu. This early porcelain is extremely rare, and is almost invariably made in the Chinese tradition decorated with paintings in the Kano style. True Japanese decorative tradition did not make itself felt on porcelain until the raw materials for making porcelain had been found in Japan.

Ironically these was discovered on Mount Isumi-yama some fifty-five years after Shonzui's death, close to where he had established his first kilns; I say ironically because his porcelain was limited to what he could make before his imported Chinese materials ran out.

The earliest true Japanese porcelain made at Arita was decorated in underglaze blue with some additions of green and red enamels. It was not until 1660 that Japanese porcelain was decorated in a manner that not only appealed to the Japanese but also to Europeans. At about that time a potter named Sakaida Kakiemon developed a style of porcelain decoration in overglaze enamels, in which he painted flowers, birds, trees and other designs from nature, on white porcelains in grass green, blue and orange-red and sometimes with the additions of turquoise green, pale yellow and gold.

16

The decoration is in the best Japanese taste, the painting sparsely applied to the whole porcelain body. At first sight much of Japanese pottery and porcelain and in particular some of the Kakiemon pieces look imbalanced to the Western eye. They do not have a symmetrical design as do European or even Chinese ceramics; however on closer examination, as one gets used to Japanese ideas of taste and aesthetics, one notices a subtle balance between the design and the areas of undecorated porcelain.

In spite of this Japaneseness, these early porcelains attracted the attention of Dutch traders who had established themselves in 1641 in a trading settlement on the island of Deshima, off Nagasaki and they exported large quantities to Europe, where it was well received. Kakiemon wares were freely copied in Europe and had great influence on the development of European porcelain decoration, both on the Continent and in Britain. Copies were made by the Dutch at Delft and by the porcelain factories at Meissen, St. Cloud, Mennecy, Bow, Chelsea, and Worcester.

The other Japanese tradition which greatly influenced European porcelain factories was prompted by the Dutch traders themselves, who, thinking that porcelain with overall decoration and richer colours would find an even better market in Europe, persuaded the potters to develop the designs based on brocade patterns. This Imari pattern proved extremely successful and was exported in great numbers from Imari, the port of Arita, from which it gets its name.

While Kakiemon ware was appreciated both by the Japanese and the Europeans, Imari principally appealed to the European taste, and as such became the major export porcelain. Imari pattern combined underglaze blue painting with overglaze enamels and gilding; sometimes even lacquer was added. The underglaze blue tended to spread a little, but the edges were sharpened by the cleverer application of areas of iron red overglaze enamel. The fuzzy edge of the blue was caused by the Japanese practice of first firing their porcelain to a biscuit ware before glazing, unlike the Chinese who fired and glazed in one

17

operation. The second firing in the Japanese technique created a glaze with a surface finely pock-marked rather like muslin.

The peculiarities of early Japanese firing also influenced the shapes. The characteristic octagonal and hexagonal shapes of Imari bowls and the square sectioned vases evolved in an effort to hide the warping that sometimes occurred during firing. While the shapes did not prevent distortion they did help disguise it when it occurred. Both the designs and the shapes of Imari ware were copied in European factories.

On the whole Imari porcelain is rather heavy and coarse with a greyish tinge. The large masses of underglaze blue are offset by the iron red overglaze and the gilding. These colours are sometimes enhanced by the addition to the palette of yellow, purple, green and a sort of brownish black. The designs are on the whole crowded, irregular and on the face of it confused. The brocade patterns are separated by a symmetrical panel of decoration.

The Imari pattern in Europe came to be known as 'old Imari' and was added to the pattern books of a number of European factories. In England, Worcester made extremely good copies and it is sometimes possible to see a Worcester piece wrongly labelled as Japanese Imari, but it should never be mistaken by the initiated.

The Chinese were quick to notice the popularity of the Imari pattern and hastened to fill their own export orders with their 'Imari ware'. This Chinese Imari is sometimes confused with the Japanese but close inspection will easily distinguish between the two, as there are many differences. First there is the difference between the porcelains themselves; the Chinese is crisp with an oily glaze of a rather greenish tinge, with the biscuit at the foot rim slightly brown, while the Japanese is heavier with a somewhat greyish colour—the glaze has also the muslin-like appearance mentioned before. There is also a difference between the blues—the Chinese is clearer than the Japanese while the latter is also darker. The red of the Chinese tends to be less opaque, more of a coral. Japanese Imari often shows the marks on

the base where it was supported by spurs in the kiln.

During the second half of the 19th century a coarser variety of Imari was exported under the name Nagasaki ware.

Two other products of Japanese ceramic factories which found a ready market in Europe were rather large-sized vases and eggshell porcelain. The massive Japanese vases seem to find their way into most salerooms or antique shops. Sometimes as high as 4 ft (1.2m) and usually with decoration in predominantly iron-red tones or blue and white, these vases were made in the latter part of the 19th century at Seto in Owari and exported in quantity.

The famous 'eggshell' porcelain of Japan was made at a number of factories including Seto, Shiba, Kilawachi, Mino and Yamato. The eggshell ware of Shiba was often richly decorated in the Tokyo enamelling studios.

In addition to the Imari and the Arita porcelains decorated in the Kakiemon style for export, there were the other porcelains which appealed principally to the Japanese taste. Two of these were under the patronage of princes and produced the bulk of their ware primarily for them. The Okawachi factory eight miles from Arita was founded by Nabeshima, Prince of Saga. Later in the 18th century he withdrew his support and the factory was forced to produce ware mainly for popular consumption, whereas earlier this had taken only part of its output.

Mikawachi first started as a pottery factory but switched to porcelain in 1712. It came under the patronage of Matsura, Prince of Hirado in 1751 and from then until 1843 some of the finest Japanese porcelain was produced. The potters especially excelled in figure modelling. Other factories large and small produced porcelain at Kutani, in the province of Kaga in western Hondo (1650–1750), in the Nomi district, and in the Enuma district. Kyoto also produced porcelain of very high quality—in fact there were numerous studios, mostly family affairs that produced fine porcelain in the style of famous factories at various centres in Japan for the Japanese market.

The majority of Japanese pottery, too, is of a kind which

Japanese porcelain figure decorated in vivid green red and yellow overglaze enamels. 19th century.

appeals principally to the Japanese taste. Its intentional irregularity, apparent imbalance and crudeness, were to the Japanese connoisseur or Master of the Tea Ceremony essential points of quality. Thus much of the finest Japanese pottery has remained in Japan, where it is highly valued. However not all pottery falls into this category. Satsuma is quite different; early in its development it showed characteristics which when developed and exaggerated were to find wide appeal in Europe.

It is interesting to note that none of the export wares were appreciated or valued by the Japanese, as it was tailor-made for Western taste and quite alien to their own taste. In fact, what many judge to be Japanese taste—the over decoration, vivid enamels and profuse gilding—is no guide to Japanese aesthetics whatsoever, but merely an indication of what the Japanese thought the European was!

Satsuma on the southern part of the island of Kiushiu, did not produce any pottery of significance until 1596, when the prince of Satsuma Shimazu brought a number of talented potters from Korea to settle there and establish kilns. They settled in two groups, one at Sasshiu and the other at Chosa. Potters from both groups spread into a number of districts.

The Chosa group developed many unusual glazes, but it was the potters of the Sasshiu group who had established a kiln at Nawashiro, who produced a creamy crackled ware which can be described as the prototype of the Satsuma faience. Later, at a factory at Tadeno in Kagoshima, this crackled creamy white ware was first decorated. The designs inspired by brocade patterns (nishiki-e) were applied sparsely at first, in coloured enamels and gold. This was about the year 1796. These early pieces still emphasise the creamy crackled body, the decoration being secondary. With the increasing popularity of Satsuma for export, the decoration became heavier and the gilding more profuse until at the end of the 19th century the whole of the body of the object was smothered with decoration.

It was so successful, in fact, that a number of imitations were made at Kyoto, Ota and other centres, perhaps the best imitation

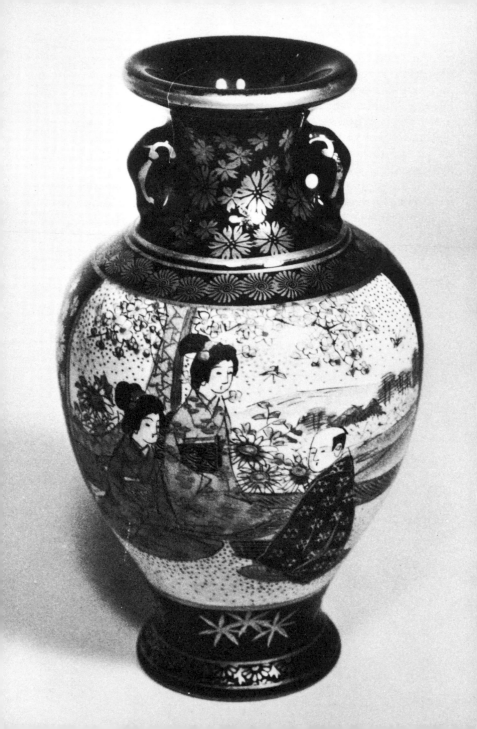

being made at the Meizan factory at Osaka. Many of the pieces so freely labelled as Satsuma by collectors have never been near the princedom, but were probably made in Kyoto and decorated at the enamelling establishments of Tokyo.

Many of the designs on the later examples of Satsuma ware are figurative with themes drawn from some of the heroic tales of old Japan. Scenes from nature were also used and in some pieces the dragon makes his appearance, usually in relief, highly charged with gilt.

However gaudy the worst examples of this type of pottery may seem to some, one is forced to admit that the painting is very detailed and fine, and great skill has gone into the production. The best of these are certainly worth collecting as it is possible that they will be as widely sought after in the future as the earlier pieces of Satsuma are today.

The ceramics of Japan, which have been underrated for far too long, have now taken their rightful place alongside the other great arts of the East. Japan had moments when ceramics of sheer beauty were produced which were admired by art lovers on both sides of the world and which had a profound effect on some of the finer ceramics of Europe.

So next time you see a piece of late overdecorated Satsuma don't think of it as a representative of ceramic art of Japan but rather as a joke—a joke on us, for the Japanese would certainly not have had export Satsuma as a gift!

A very late pseudo 19th century vase, decorated with paintings of geisha girls on two panels. Probably made at Ota.

3 Chinese Lacquer

Lacquer is one of the finest arts of China. Her craftsmen have worked in the medium for well over 3,000 years. The technique of manufacture was similar in both Japan and China, and is fully described in the chapter on Japanese lacquer. There is evidence to suggest that lacquer originated in China during the Chou period (1027–221 BC). The crumbled remains of wooden objects, covered with a trace of substance that may be lacquer, have been discovered in recent excavations. Lacquer in this case was used purely as a preservative agent rather than a decorative aid.

The earliest lacquerware which has survived dates to the 'Warring States' period (481–221 BC). Excavations of tombs at Ch'ang Sha in Hunan province, have produced a number of very fine objects. The tombs of the ancient capital of the state of Ch'u date from the 4th century BC to the 1st century AD. The lacquer which was small in size included cups, plates, brushpots, trays and bowls. The motifs are varied. Older pieces have abstract and geometric designs, while later pieces are decorated with spirals, twirls and stylised dragons which convey a marvellous feeling of movement. Objects decorated with compositions of equestrian processional and figurative scenes were fashionable during the period.

The fantastic designs of the Han period (206 BC–AD 220) which were usually painted in red on lacquer of a soft brown colour, reflect the sophistication of the everyday life of the upper

24

classes. In contrast to the smaller pieces, a few specimens if lacquered wood sculpture were found. These differ greatly from the traditional style of the north. Examples of these sculptures can be seen in collections both in the United States and Europe. Other examples of early lacquerware have been discovered in Korea at Lo-lang in 1931–32 by Japanese archaeologists. Apart from all the excavated evidence and inscriptions there are a number of documentary references which mention the antiquity of lacquerware in China. The Han chronicles record the Emperor Wu Ti's interest in lacquer. They also record that the manufacture of lacquer objects was put under the direct patronage of the emperor. There must have been a number of Imperial workshops but only three are recorded in the chronicles, Szechuan, Hunan and Kiangsu.

Carved circular red lacquer box with a figure of Pu-tai, Ming dynasty.

Lacquer was made in Korea at Lo-lang by Chinese craftsmen, but at the end of the Han dynasty when China lost control of Lo-lang, a large number of artisans left for Japan where they were warmly welcomed.

The lacquer of the T'ang period is extremely scarce. Most of it was made for personal use and has perished with age. Little or no lacquer was placed in tombs as ceramics had become more fashionable as tomb furniture.

Sung and Yuan lacquer is mainly represented by large Buddhist images, mostly of Kuan Yin. These figures usually made of wood covered with gesso and lacquer are really magnificent works of sculpture and out of the field of domestic lacquerware. Smaller articles were made and incised lacquer was widely used for the first time, though it had probably been invented much earlier.

A Chinese text published in 1591, entitled *The Eight Discourses on the Art of Living* describes a number of methods of using lacquer that were current during the Sung dynasty (AD 960–1280). Incised lacquer some on bases of precious metal was made for the palace. Another method using red lacquer together with other colours produced a multi-coloured cameo effect.

Ts'ao Chao in a text written in 1387 contradicts this, asserting that red lacquer was applied to precious metals and left plain. This would be more in keeping with the simplicity of Sung ceramic styles. Like the lacquerware of the earlier period, Sung lacquer is extremely rare. To date no specimens with precious metal forms have been found.

Our knowledge of Yuan (1280–1368) lacquerware mainly comes from Chinese and Japanese documentary sources. Altogether five groups of lacquerware are described. Plain red and black ware; the ch'iang-chin process of engraving and gilding lines; mother-of-pearl inlay; guri lacquer or multi-coloured layers of lacquer deeply carved like cameo, some on yellow base; and finally carved lacquer. The latter was highly prized in Japan.

By the beginning of the 15th century carved lacquer was being

produced on a large scale. Between the years 1403 and 1407 more than one hundred pieces of lacquer were sent to Japan as Imperial gifts.

Lacquer of the Ming period (1368–1643) is more plentiful, but is still rare. Many articles attributed to this period cannot be authenticated conclusively. However, we know more about the lacquer of the Ming period than we did a few years ago, and there are pieces which we can reliably accept as genuine. All attributions are usually made by more careful comparisons with dated pieces.

Chinese lacquer of the Ming dynasty is nearly always red in colour and carved. Generally speaking most Ming pieces are cleanly carved with deep incisions. Floral motifs are the most common though figure compositions are also known. The seals of the Emperors Yung Lo and Hsuan Te have been found on some lacquer, but it is possible they may not be contemporary and were added later. Ming lacquer is usually a deep vermilion but as lacquer however is apt to fade when exposed to the light of centuries, especially strong sunlight it is thus highly probable that there were differences in the brilliance and tone of the lacquer of different periods, but it needs an expert eye to detect it. As well as studying books the collector must familiarise himself with the fashionable motifs of periods, and acquaint himself with dates of specimens of lacquer in collections and museums for it takes experience to know lacquer. There are many pitfalls for the inexperienced collector. Fakes and copies abound which were made at later periods but endowed with seals and designs of earlier times.

Many copies of earlier works were made during the 18th century and it is often very difficult to distinguish the later pieces from those of earlier times. Ming lacquer is generally of a much higher quality, the designs are simple and although they usually cover the whole surface, the effect is less crowded than those of the Ch'ing dynasty. The plain surface is often covered with numerous minute hair cracks.

One of the finest surviving specimens of Ming lacquer is a

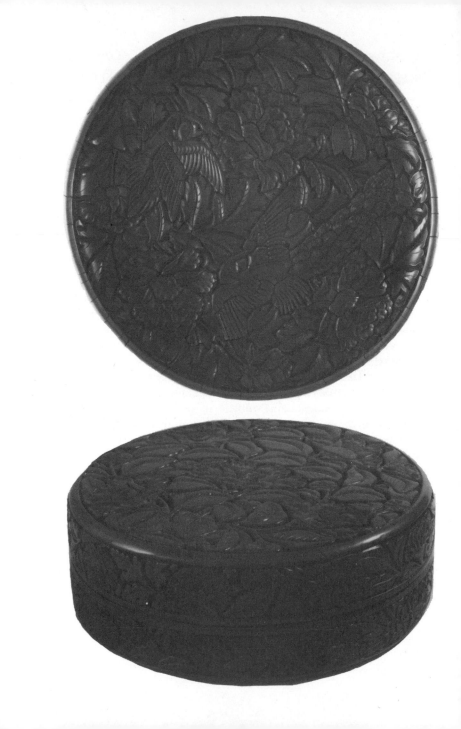

superb table of red carved lacquer in the Low-Beer collection, New York. Made for Imperial use, during the Hsuan Te period (1426–1435), the surface, drawer-fronts, legs etc., are all covered with superb designs. A small cup and stand of red carved lacquer is in the Sir Percival David Collection, London. This fine piece is carved with a design of phoenixes on a background of peony scrolls. It has the date of Yung Lo (1403–1424) but is also inscribed with a poem of 1781.

The above will be largely of academic interest to the collector as it will be most unlikely that he will have the good fortune to obtain pieces of these periods. The majority of the objects that will come his way will be of later Ch'ing dynasty date.

The designs of the Ch'ing dynasty are more detached and fussy, as the artist often included minute details almost to the detriment of the artistic quality of the piece. The boldness of the Ming designs was lost, but was compensated by the delicacy and quality of the work. The colour of the lacquer is more brilliant than the Ming. Objects of all kinds were made, from the tiniest ornament to large pieces of furniture.

Little is known about lacquerwork of the early days of the Ch'ing dynasty and it is difficult to distinguish the work of the reign of K'ang Hsi (1662–1722) from that of the Yung Cheng period (1723–1735).

The Emperor Ch'ien Lung (1737–1795) was very fond of lacquer and ordered objects of all kinds to be made. His throne, a superb piece of lacquerwork, is now in the Victoria and Albert Museum, London. This piece shows to perfection the artistic ideals and fashion current during this period, while keeping some of the Ming boldness of design. The more conservative taste of Ch'ien Lung is shown by the small cups of plain cinnabar lacquer in the form of chrysanthemum blossoms, which were made for

him. Especially towards the end of this period a number of works of inferior quality were exported to the West. Many specimens of Imperial lacquer of the period found their way to Europe after the sack of the Summer Palace during the Boxer Rebellion.

Coromandel lacquer first made its appearance during the Ch'ing dynasty. Although named after a town in India, it has, to the best of our knowledge, no real connection with India. Furniture of various kinds was made in this style but screens were the most common and large numbers were exported to Europe.

The method of manufacture differed from traditional lacquer techniques. The base was made of cloth sandwiched between thin layers of pinewood. Finely powdered slate was mixed with vegetable glue and applied to the surface of the cloth-covered wood. After drying the surface would be levelled and smoothed with ash, until a high sheen had been obtained. The surface was then lacquered until the required thickness was reached, usually about an eighth of an inch. The design was later cut into the lacquer, care being taken not to cut too deeply, lest the wood be revealed. Finally the design was coloured with tempera. Panels of this nature were fixed into lacquered wooden frames to form furniture or screens. The screens were decorated on only one side by this method; a simple painted design usually covered the other. The oldest specimens of this work date to the K'ang Hsi period. Later works have pieces of mother-of-pearl, jade and other hard stones, carved and applied to the lacquer surface. Lacquer as an art form continued in China until the mid 19th century; thereafter lacquer became mass produced and lost its artistic appeal.

Although difficult to collect and store it is well worth the effort, for compared to Chinese ceramics it is underpriced, and can be expected to rise in value.

4 *Japanese Lacquer*

Was lacquer invented in China or Japan? Originally it was thought to be a Japanese invention, indeed the Japanese themselves claimed the accolade. It is now clear, however, that lacquer like many other crafts and techniques is a product of the Chinese mind. However, Europe of the 18th century thought of it as Japanese and thus coined the name of Japanning to describe it. Both Chinese and Japanese lacquer found its way to Europe from the 17th century by way of Portuguese and Dutch traders.

Japanese chronicles record that the first master of lacquer was a certain Mitsumi-no-Sukune, a member of the court of the Emperor Kaon-Tenno, at the end of the 4th century BC. This may however be pure mythology. Although the Chinese can claim to have originated the process, the Japanese can justly claim to have developed the art to perfection. It became one of a number of the outlets for the genius of the Japanese artisan, a role which in China was played by porcelain. Lacquer is in fact to Japan what porcelain is to China.

It is not certain whether the tree *Rhus vernicefer* from which the raw material is obtained grew naturally in Japan or whether it was introduced. What is known is that in early times lacquer was in short supply, a situation hinted at in the record of the Emperor Mommu Tenno (7th century AD) in which he orders estate owners with extensive lands to allocate a portion of the land for the planting of lac trees.

Lac is collected from the trunk of the tree. When about 8–10 years old, a horizontal cut is made in the trunk of the tree and a cup affixed underneath the incision to catch the sap. After collection the sap is purified and stored in special vessels, protected from the light ready for use. As fresh sap from the tree it is white but turns thick and black when exposed to the air. It is purified by boiling, skimming and straining. Dry lac in the form of cakes was sometimes made. These had to be crushed and strained before they could be used.

The technique of lacquer was both complicated and lengthy. It could not be used on its own except for dry lacquer castings. It had to be applied on to a ground of soft wood (for large objects) and hemp cloth or similar material (for small objects). The methods used in making large and small items differed.

Small objects such as cups and plates were made by sticking hemp cloth on to a form or mould of clay. After a priming of lacquer it stiffened, then the clay would be removed. The cloth form would then be reinforced and built up by numerous layers of lacquer until the desired effect was achieved. As many as 200–300 coats could be applied to one article. Only a thin coat of lacquer was applied at a time and after drying was rubbed down with charcoal. Lacquer was in most cases very thin. The process was extremely tricky and care had to be taken to ensure that the lacquer dried slowly and did not flake off. If it dried quickly it became extremely brittle. In order to accomplish this slow drying the Japanese made their lacquerware beside rivers while the Chinese invented an ingenous vapour bath to aid them. After the correct thickness had been obtained, horn ash was used to make the surface smooth.

Objects with flat or slightly curved surfaces were made by stretching hemp cloth over the mould or wooden form and priming it with lacquer until stiff. The ground when removed would be stiffened with numerous layers. Occasionally the cloth was not removed from the wooden original but became a base for the object. Wood was also used as a base for plates. Large objects such as sculpture or furniture had therefore different

sections of wood joined with pegs and then covered with cloth and gesso. Lacquer was added and finished in the same way as all smaller objects.

Sculptures of more modest proportions were occasionally made with a core of mud, ashes and fibre with the lacquer being applied directly to the core. Another technique was dry lacquering. This method did not utilise a core or ground but was produced by taking a cast from a mould made from the original model. The lacquer was pressed into a mould and allowed to dry and harden. It was then removed from the mould and finished in the same way as other lacquer products. For complicated figures and objects separate metals would be used for different parts; the various components then being stuck together with liquid lacquer, the joints would later be disguised, then the entire figure would be coated with layers of lacquer. These are just a few of the many processes that were carried out.

In Japan the oldest specimens of lacquer are not of Japanese but Chinese workmanship. The oldest Japanese specimen is the 'Little Temple of Tamamushi'. Dating to the 7th century AD this superb object is probably the work of Korean artists. It stands six feet in height and is decorated with iridescent wing cases of beetles on a black surface which is painted with Buddhist figures in red, yellow and green. The oldest purely Japanese piece of lacquer is a sheath made for the Emperor Shomu's dress sword, dating to the middle of the 8th century AD. Some of the finest and oldest specimens come from the vast temple warehouses of Shoso-in.

Documentary sources relating to lacquer in Japan are, as already stated, mythological in origin. The story goes that lacquer was invented by accident by a certain Yamato-daki of the court of the Emperor Keiko (AD 72–130). He was said to have noticed sap oosing from the trunk of a tree after a branch had been snapped off. How he adapted this to produce lacquer is not clear but he is said to have conceived the idea of using it for the decoration of objects. A servant who helped him in this respect was later conferred with the title of Court Lacquerer.

The first truly historical documents relating to lacquer belong to the Imperial archives of the Emperor Kotoku Tenno (645–754 AD). These records give details of taxes which he imposed on lacquer production. Another document of the 10th century, also in the Imperial archives, is a book describing the method of decorating lacquer with mother-of-pearl.

Lacquer of the Nara period (645–794 AD) is preserved mainly in the Shoso-in. It is clear from these that a variety of different pieces were used, for there are boxes made from cloth, bamboo, leather, and wooden bases. Musical instruments of this and later periods were also decorated with lacquer. Designs were executed in gold, silver, mother-of-pearl and colour, with subjects drawn from the world of nature and mythology.

The Heian period (897–1185 AD), also known as the Fujiwara period, was a great period for lacquer. It became very popular and began to replace pottery in its various uses. A large variety of objects of this period have survived, which give us an idea of the numerous applications to which lacquer was put. Objects large and small were made, boxes, bottles, furniture and saddles. Gold and silver dust and mother-of-pearl was used to great effect for the decoration. The technique of applying flakes of mother-of-pearl was called raden, while the use of gold and silver dust sprinkled over the surface of the object after the design had been drawn was called maki-e or sprinkled picture. Another method was to cover the gold and silver dust with a thin coat of lacquer and then polish until the metal showed through, this was called togidashi-maki-e. Even interiors were decorated with lacquer and some of the temple decorations of the Heian period still survive. The Byodo-in near Kyoto has a wall decorated with the raden mother-of-pearl technique, dating to the Heian period. Another technique popular during the period was that of hira-maki-e, which was essentially the application of gold lacquer to a uniform flat background.

The lacquer of the Kamakura period (1185–1392 AD) was less sophisticated, though similar to that of the Heian period. Further techniques were introduced including taka-maki-e and Kama-

kura-bori. Taka-maki-e made use of a relief design using multiple layers of lacquer, while Kamakura-bori was almost the opposite, where the design was incised into the object before lacquering. Taka-maki-e was also popular during the succeeding Ashikaga period (1392–1573 AD), when greater relief was obtained by adding ochre to the lacquer.

The Ashikaga period, which is also called the Muromachi period produced lacquer wear of great variety, designs and techniques. Birds, flowers, landcapes and figures were popular and the technique of red carved lacquer, which had reached Japan from China, became fashionable. The Japanese adopted the Chinese idea but added to it by carving through alternate layers of red and black, which had the effect of outlining the design in black.

During the Ashikaga period lacquer continued to be used for numerous purposes, including the manufacture of boxes, cake plates etc. Although the designs were highly stylised they were always in keeping with the object they decorated. Occasionally reproductions of famous paintings were transferred to lacquer. The No theatre added a similar inspiration to lacquer artists as the Kabuki theatre did to the artists of the Ukiyo-e print. A number of fine masks were produced, some of which were signed by famous artists.

A new technique, involving the application of relief designs in gold on to a golden background to which mother-of-pearl was occasionally added, was introduced during the Momoyama period (1573–1615AD). Unlike the designs of the Ashikaga period, which were descriptive in nature, designs tended to be purely decorative with a preference for free painting in yellow, red and green on backgrounds of brilliant red. Maki-e was also popular.

The Japanese artist excelled in a number of mediums. A genius of the Momoyama and the succeeding Tokugawa period was Koetsu. He was skilled in both painting in the Tosa style and potting raku vessels. His lacquer work is unique for he introduced a number of new techniques of his own. For instance,

he pioneered the technique of applying cut-out shapes of lead on to backgrounds of white or black, which produces an extremely beautiful three dimensional effect. The soft lead was finished with an attractive coating of lacquer of the togidashi technique.

The golden age of Japanese lacquer can truly be said to be the Tokugawa period. During this time, also known as the Edo period, the Japanese artist produced some of the finest works of lacquer art, that have never been surpassed. Great artists competed to produce fine works of art, with the accent on variety and elegance. One such artist was Ogata Korin who worked during the 18th century. As was the fashion, he was expert in painting and calligraphy as well as lacquer work and was a follower of the great Koetsu who we have already mentioned. Much of his work was inspired by Koetsu, but has the additional distinction of the artistic inovations current during the Tokugawa period. However, Korin's work contrasts with much of the art of the Tokugawa period in that his designs are noticeable for their simplicity.

Like Koetsu he introduced a number of ideas and unusual effects. He produced a great sense of depth by blending greys of different depths, such as lead and tin, on a background with gold. Lacquer by Korin is very rare but is obtainable. His pupil, Ritsuo (1663–1747 AD), followed his master in that he too worked in another medium, although his choice was ceramics. He conceived the idea of combining fragments of ceramics as overlays on lacquer. This technique is known as hiaku-ko-kan or 'incrustation with a hundred precious things'.

The basic technique of working lacquer varied during the Tokugawa period. Sometimes burnt coal and charcoal were mixed with the lacquer before being applied to the prepared ground. Although the number of coats could be as many as thirty or as few as five, the total thickness of the lacquer usually did not exceed one millimetre. This was joined by a process of laborious rubbing after each coat. The first coats in decorative lacquerware were of black lacquer, while the colour decoration was applied to the upper layers. Before each layer was applied

the previous layer was polished. When finished a final layer of thin transparent lacquer would be applied which was then polished. Lacquer is extremely resistant and hardwearing. It is both resistant to heat, acids and alcohol. Lacquer, however, should not be brittle. Because of its many qualities it was favoured for making bottles, kettles and saki cups.

Tokugawa lacquerware was the natural progression of innovations made during the Momoyama period. There are a

Lacquer cake box on stand, decorated with gold, mother-of-pearl and silver. 19th century.

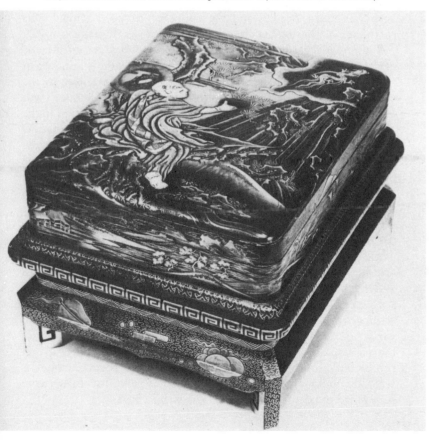

wide variety of unusual and decorative works which the collector will be able to obtain. Japanese lacquer of the Tokugawa period has a superb elegance which reflected the Japanese artist's vision of his world. The Japanese artist had an urge to experiment at the risk of failure. This allowed his creative genius extreme license, unlike the Chinese artist who was essentially conservative. Bearing this in mind it is not surprising that he did not always succeed and there are a number of dismal failures which testify to this. Quite a few pieces of lacquer of the Tokugawa period are signed. Some of the better known artists of the 19th century are Izuka Toyo, Koma Koryo and Nishimura Zopiko and the collector may occasionally be fortunate in finding specimens by them.

Due to increasing foreign influence, lacquerwork of the end of the 19th century had become decadent and by the beginning of the 20th century had almost disappeared as an art, due to the introduction of mass production techniques. Lacquer was exported in large quantities to a market with no objection to the cheap and rather loudly decorated pieces. Lacquer for foreigners and not the Japanese was made, for as Japan Westernised the local market diminished. The Japanese had changed their mode of dress and thus the demand for inro and tabako-bon, part of the Japanese sash ensemble, were no longer in demand. In fact with increasing Westernisation the necessity for lacquer increasingly diminished. Lacquer has not totally disappeared. It is still made today, but mainly for tourists for as an art it is no more.

Collecting lacquer is a delight, but as with most other oriental antiques it is wrought with pitfalls. Experience is all important and if prudent the collector should acquaint himself with as many specimens as possible before he starts acquiring. Copies of early works were made, even with inscriptions attributing them to earlier periods. Take time and assess pieces with common-sense, look for quality, whether it has been repaired or touched up and remember all along what you have seen and read. Lacquer is without doubt a good investment but has to be carefully cared for. It is bound to become rare over the years.

5 *Indian Bronzes*

Probably the greatest achievement of the Indian artist was his skill in making figures of his gods in bronze. He created the most fantastic of shapes in a realistic and life-like way and yet at the same time adhered to a rigid religious code that laid down his every move.

The Indian 'bronze' is, in fact, a misnomer, for the figures are rarely made from bronze but from brass or copper, 'bronzes' however, are the collective name for the figures as a whole. The most common form of Indian bronze consisted of an alloy of copper and tin in the ratio ten to one, although the use of pure copper for the production of religious figures was very common from the earliest times.

Metal was used for casting statuettes in India from pre-history, the earliest known figure being a small bronze statuette of a dancing girl found in the Indus city of Mohenjodaro, now in Pakistan. The method the craftsmen used to produce this figure is the same as was used later during the Medieval period and which is still used to this day, the *cire perdue* or lost wax method.

Indeed, as one studies Indian art one is constantly struck by the conservatism of the people. Nothing is changed, new ideas are assimilated, but the old ones are not discarded, they exist and blend with the new. This often brings violent contradictions but somehow the two manage to survive happily side by side.

Apart from the little bronze figure of the dancing girl from

Mohenjodaro, no other bronze figure of merit has been found which dates before the Christian era.

It was not until the Gupta period that bronze casting came into its own. The metal sculpture of the period was the result of changes in the style of the earlier Indo-Greek Gandhara phase and the classical tradition of stone sculpture. It formed a standard which widely influenced later artists.

In Eastern India the art of bronze sculpture bloomed under the great Pala rulers of Bengal. During this period the arts flourished, liberal patronage being given by the Pala rulers, who raised temples and commissioned great sculptures and paintings. This happy state of affairs was broken by war. For by the 11th century invading Islamic armies had broken the organisation of the Hindu states, and by the 12th century the Islamic chiefs had obtained a foothold in India, which they were to retain for over seven centuries.

The Islamic advances had a disastrous effect on the bronze art of Northern and Eastern India. Most of the existing statues were destroyed by the army, who were sworn to wipe out idolatry, and all further bronze art was stifled. The only outlet available to the artist was in making small figures of animals and people, as toys or ornaments. And so the chain of the great Eastern Indian bronze tradition was broken irrevocably.

Some bronze figures of the Pala period survive but they are mostly small pieces, the larger ones having been destroyed. In Nepal and Tibet, however, the traditions of the Gupta and Pala artists continued, although altered by the codes of Lamaistic Buddhism. We therefore have to look to these countries for bronzes in the early traditions.

During the 16th and 17th centuries a more lenient attitude was adopted towards the Hindus by the Mughal rulers, and metal statuary again began to be made, but the grandeur of the earlier tradition had been lost.

In the South the earliest examples of bronze statuary belong to the Chola period. The bronzes show a high technical and artistic skill, suggesting a continuous development of the bronze art of

South Indian bronze figure of Siva Nataraja (Siva as 'Lord of the Dance'). Chola period, 10th century AD.

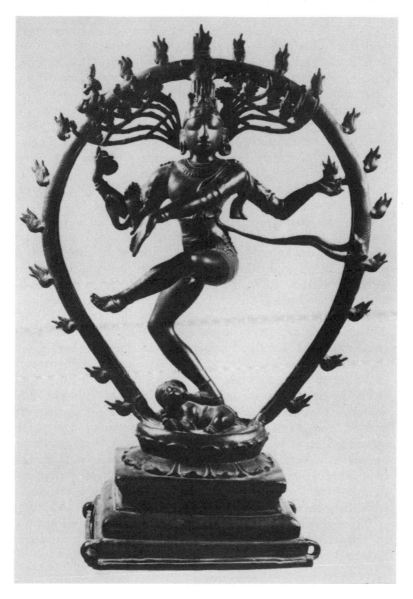

the earlier periods.

Like many warlike peoples the Cholas were patrons of the arts. They built large temples and palaces and commissioned numerous sculptures in metal and stone. During the reign of Kulotunga Chola in the 11th century, many fine bronze sculptures were cast. A number of these masterpieces are known today and provide us with some of the finest examples of Indian metal sculpture. Bronzes from this period are in great demand.

Although bronze casting continued in the far South, unbroken by the Moslem intrusion, it gradually degenerated. The figures of the 19th century are mere echoes of a once majestic art. There are, however, exceptions and within the framework of each century and period one can find bronzes worth collecting, masterpieces of their period.

After the Islamic invasion, when so many of India's bronze masterpieces were destroyed, it was impossible for the bronze worker to work on images in safety. He therefore directed his attention to the production of utilitarian objects until such time, generations later, when the age-old craft could be continued. Unfortunately by that time the deft touch of the old masters had vanished. Their descendants did not know the little tricks and skills that their ancestors had employed. Many started with little or no experience of figure modelling, save for work on toys, etc., while others chose to ignore the freer atmosphere and continued to make toys and other objects.

The bronzes of South India during the 17th, 18th and 19th centuries became stiff and formalised and, to a certain extent, stylised. They lost much of their original plasticity. The metal art of the Deccan was similarly affected, though here many toy-like and folk features slipped into the art. Rajasthan and Central India were no exception. Bihar, Orissa and Bengal were more fluid in style, though often the figures were thickly modelled, with sharp features, the details being engraved after casting.

Although, on the face of it, these figures seem poor substitutes for the earlier pieces, many original and interesting icons were produced which are well worth collecting. They retain some of

the earlier qualities while expressing them in an original way. The surface of many of these bronzes is unfinished and very rough, due to the fact that they were often painted, especially those from Bengal.

Probably most important to collectors is to know what the bronze is, what date it is and where it comes from. There are numerous deities in India, all religions, except Islam, producing bronze images.

Reference to a glossary on iconography and to identification charts of poses and mudras will help with the identification of a figure—though be warned: there are many unusual images, often from villages, that do not fit into the codes of the classical schools. These are usually village gods and unless one is extremely lucky they are likely to remain unidentified.

Large numbers of figures were made of the popular gods in all parts of India. In South India, the god Vishnu the preserver was very popular, and there are numerous images modelled in three parts: the figure, the square base, and aureole, these being slotted together to form a composite piece. Vishnu was usually shown in a stiff, stylised attitude, with four arms, holding the wheel, the conch, the mace, and the lotus with a snake canopy above his head. A popular group sculpture was Somaskanda, which showed the heavenly couple Uma and Siva, with their son Skanda. Various representations of the god Siva, the destroyer, some as Nataraja—Lord of the Dance and some with his consort Parvati were also made. Figures of Parvati alone, were popular.

Various Saivite saints and local heroes were also constantly represented and in the Deccan; Jain figures of Mahavira were popular. Dipa Lakshmis, female figures holding lamps were made in South India, the Deccan (some in Central India) and Eastern India, especially Bengal. Figures of Krishna, with the milkmaid Radha, were very popular in Bengal, Orissa and Bihar in Eastern India while figures of Ganesha the elephant headed god, were produced over most of India. Durga was a popular deity in the east. A common figure shows her slaying a demon.

In Eastern India, Krishna (Venugopala) was portrayed playing the flute to Radha, and as a baby, on all fours, playing with a pat

of butter. In South India a common representation of Krishna showed him as a dancing boy. Images of Krishna portray him in various moods, reflecting his upbringing among the cowherds. The story goes that he was a mischievous child and was always playing jokes on the milkmaids. Large numbers of bronzes depict these episodes. The representations of Krishna in Eastern India, showing him crawling, with a pat of butter, and in South India, dancing with a pat of butter, portray an episode in his life as a child, when he stole a ball of butter from the milk churn when his step-mother was not looking, and danced for joy.

Dating Indian bronzes can be difficult. In the beginning the collector will not find it easy. There are so many different factors that must be taken into consideration. It is essential not only to have a good knowledge of the main schools of Indian art but to be familiar with the differences of the various periods and places. The figure must be examined very carefully, taking note of the subject, the quality of the modelling, the casting, the finishing of the surface and the general condition of the bronze, both on the surface and on the base. Note should also be taken of the costumes prevalent in India at the different places and periods as some deities and poses were more popular in some regions than others. Identification of the subject will help considerably, as images of some gods may have been made only in certain periods.

There are several ways in which the collector can familiarise himself with the different schools and learn to identify the bronzes. Visits to museums and personal handling are all important. There are many specialised books on the subject but, beware, books alone are not sufficient. Without seeing and handling specimens one can often reach the wrong conclusion. Visits must be made to as many museums as possible which have good collections of oriental art. Try, whenever possible, to handle bronzes. This not only gives one a closer look but also alerts the other senses. Soon the collector will find that he is able to tell things which are impossible to describe in a book. If he handles sufficient bronzes his mind sub-consciously makes notes

of such things as weight, feel of the contours, etc. These are all very important when assessing an unfamiliar piece.

Good opportunities to handle bronzes and to buy occur at the

Image of a Jina. Bronze. From Western India; 9th-10th century.

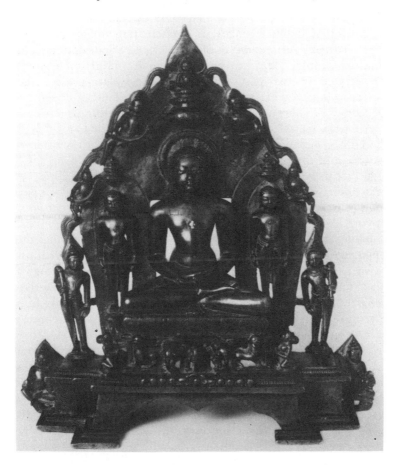

principal sale rooms, where specialist sales are held. Here, one is also aided by a catalogue and one can play a guessing game, personally assess the piece, and then check with the catalogue. He should not be surprised, however, if he is wrong, for there is much to learn. Even some attributions included in such catalogues can be wrong and another important factor is that two experts can give different attributions to the same piece. Finally, remember that most museums containing oriental collections will be pleased to help with attributions.

Collecting Indian bronzes, is a fascinating hobby, because there are many fine examples of bronzes, of periods dating from the 10th century, that can be collected. An unfortunate myth perpetrated in the past was that bronzes dating after the medieval period were not worth collecting. This, of course, is not the case. There are good and bad examples from all periods.

Although they fetch anything from £10 to £250 and upwards in the London and New York auctions; they are by no means out of the reach of the small collector. Many beautiful, and even rare, figures can be had from local auctions and antique shops at reasonable prices. But the collector should beware, and not pay high prices for any bronze until he has some idea of what he is buying. A little time spent in looking at collections in museums, handling figures in antique shops and generally taking the opportunity to see and handle as many as possible will prove most rewarding and will enable him to guard against paying too high a price for a piece. Although interest is growing in this attractive subject there are few people who know much about it. It is therefore advisable to be ones own judge and valuer and not to rely upon others, unless he or she is an expert.

One of the commonest pitfalls in collecting bronzes is that one can often be misled by the seemingly ancient appearance of the image. This should not be taken as a criterion of age, for a bronze of the 14th century AD may be in mint condition, while one of the 19th century may look as if it had been made hundreds of years ago. This is because some figures were made for personal use and were constantly handled and smeared with vermilion in worship,

thus wearing down the features, while others were installed in altars and temples, thereby preserving them. Those still in situ are as mint as the day they were made. Bronzes were sometimes lost or abandoned and may have been buried in the ground. These, when excavated usually have beautiful patinas of blue or green. Forgeries are, unfortunately, most common and one must always be on the look-out for them. The bazaars and antique shops of India are full of them and many a tourist in India succumbs to these attractive but worthless pieces, often going to great lengths to 'smuggle' them out of India, only to find on his return that they are fakes. Many of these figures can be found in antique shops all over the world and there is still a danger of the unsuspecting collector making the same mistake.

These images often have an extremely old appearance due to the fact that the surface of the bronze has been treated by immersion in salt water and other chemicals or even, by burial in a river bed. Occasionally acids are added to corners and protruding parts of the image to give it a worn appearance, while green paint mixed with sand and earth is sometimes used to simulate the appearance of centuries of burial in the soil. Most of these practices, however, can be detected by close examination.

If the beginner takes precautions in examining a potential purchase, and handles as many genuine bronzes as possible, he will, in time, be able to distinguish between the genuine and the fake. Copies of bronzes of early schools tend to be very stiff, and often the forger may slip up by introducing features only found on sculptures of a later date. Thus, it pays to be thoroughly familiar with the different styles and costumes of the various periods. Recent bronzes tend to be rather sharp, and the edges rough, often with file marks showing on the surface. Older bronzes have usually mellowed with age, have smooth edges and are pleasant to handle.

There is one rule which the collector should always remember—never clean a bronze. Dust with a soft cloth but do not use any metal polishes as they will remove its natural patina decreasing its value.

6 Sacred Art of Nepal and Tibet

The Tibetans are related to the Mongolians and like them many are nomads. The people of neighbouring Bhutan, Sikkim and Ladakh are also of Mongolian stock, as were the early settlers of Nepal. Bound by common religious beliefs, it is useful to consider the art of all these lands, although geographically separated from India by mountains.

The Indian classical schools of Gupta and Pala periods had a very strong influence on Nepalese sculpture of the 7th and 8th centuries AD. The figures show practically no trace of Mongolian features in the modelling, but instead look pure Indian in character. This Indian influence had a profound effect on the art of China and Japan. It travelled northwards from the great Gupta artistic centres of Mathura and Sarnath to Nepal and Tibet and then to China, and across the sea to Japan. The Gupta idea had a great influence on the development of Chinese art of the T'ang period and Japanese art of the Nara period.

During the Gupta period sculpture was imported from India into Nepal and then to Tibet. Nepalese art was unaffected by the Islamic invasions, which had such a disastrous effect on the art of India, and shows an almost unbroken continuity from the earliest times, thus enabling us to see a clear reflection of Indian art of the golden age. Early Nepalese bronzes show a strong affinity to those of Eastern India, especially Bengal. They are almost entirely Indian in character, full-bodied, round face and

nose, full lips. The general appearance is of soft curves contrasting with the later bronzes which are sharp by comparison; the face narrower, lips thinner and with the nose equiline in shape. These features are especially noticeable in bronzes from the 15th century onwards. Bronzes of the later periods i.e. after the 15th century tend to show an increase in decoration, often with the use of semi-precious stones. Figures were modelled with bangles, anklets and necklaces and wore head-dresses or elaborate form. Ornaments were elaborated with chasted designs. The hands were modelled long and slender. After the 10th century, Indian features disappeared, with Mongolian features gradually becoming more and more pronounced. This is especially noticeable in the shape of the eyes which were accentuated until they were shown as mere slits.

The iconography of the Nepalese pieces can be both Buddhist and Hindu, for both religions existed side by side, thus it can be difficult to separate iconographic elements in Nepalese art. In Tibet iconography is nearly always Buddhist although it too may echo the proximity of Hindu India. The early Tibetan images, like those of Nepal, were strongly influenced by early Indian originals and even today retain a great deal of the early Indian style. Other influences, however, were more complex. The style was also affected by the Buddhist art of China, which itself was, as we have seen, influenced by that of Gupta India. An earlier Greco—Indian school of art (of Gandhara of Afghanistan and Central Asia) also made its presence felt. Indian influence then was felt both direct and indirect, coloured by Chinese thought. There are records to show that Indian and Nepalese artists worked in China. There is a Chinese record which records the name of Ar-ni-ko, a Nepalese artist who worked at the Court of the Chinese Emperor Kublai Khan in the 13th century. He also built shrines in Tibet.

Nepalese and Tibetan iconography is extremely complicated. The number of icons is infinite. To really appreciate Tibetan and Nepalese art it is necessary to make a study of Tibetan, Buddhist and Hindu iconography. This can be done with the aid of

one or two specialist books.

The technique used in making Tibetan and Nepalese bronzes differs little from the Indian. There is however one major difference and that is the technique of repousse work developed along side the traditional technique of bronze casting by the *cire perdue* method. Figures made under the repoussé technique were formed from beaten sheet metal hammered into shape from the reverse side. This method was especially popular for the production of large figures; the various anatomical parts being made in separate sections and then joined together. It was almost a union of the artist's and bronze caster's techniques with those of the copper and goldsmith. The technique was also employed in the manufacture of reliquaries, god boxes and other religious objects. Bronze figures and images were often gilded and coloured. In some cases the whole image would be decorated and in others only the face. The features were often outlined in paint and the hair coloured blue, a sign of holiness. Some of the large temple images were actually clothed in silks and brocades.

Tibetan and Nepalese bronzes were normally cast hollow. Offerings and prayers were sealed under the image by a copper plate which covered the bottom. This seal usually bears the sign of crossed vajras (ritual thunderbolts) and sometimes an inscription. Bronzes with these seals intact are usually of greater interest than those which have had their seal removed. The collector should never remove such a seal without obtaining advice from a museum, as vital information in the form of dates of dedication etc. can be lost as well as damage to the bronze by

Crossed vajra seal on the base of a Tibetan image.

unsuccessful treatment. The seals can be removed, but they should be replaced afterwards so as not to deface the image. Bronzes were usually consecrated by prayers etc. in temples and the sealing of the image done in the presence of monks and lamas.

Buddhism was not introduced into Tibet until the 7th Century AD. Before this the Tibetans were followers of Bonpo or Pon, a religion which combined sorcery and sexual mysticism and practised human and animal sacrifices. Although largely replaced by Buddhism it survived in pockets until the Chinese invasion in 1952. The story of the introduction of Buddhism into Tibet is legendary. The story goes that it was brought there through the efforts of the Chinese and Nepalese wives of the Tibetan King Srong-san-gan-po. Both Queens were devout Buddhists and brought with them not only their sacred images but also sculptures. They are also credited with introducing the alphabet in Tibet adapting the Indian prototype from the scriptures. To hasten the conversion of the population, Indian Buddhist teachers were invited to Tibet, but the old religion had a great hold over the people and conversion was slow before the 8th century.

This was changed by Padmasambhava, a famous teacher of tantric Buddhism from the Nalanda Monastery in Bihar, India. He was sent for by the Tibetan King Ti-song-de-tsen in 747 AD. He added elements of tantric Buddhism to the indigenous religion of Pon to form what we know today as Lamaism. The word *lama* itself comes from the Tibetan *Bla-ma* (meaning Superior One) it is applied to religious teachers and to the heads of monasteries. The Tibetan name for Padmasambhava is Guru-rin-pocche. Tantric Buddhism, which is based on the worship of the Sakti or female energy of the god, (in conjunction with the male force), was a great success in Tibet and quickly replaced the old religion.

In art, sakti's of the Bodhisattvas are usually depicted as images of Taras. Tantric images can usually be identified by the fact that they have multiple heads or arms and sometimes both. They are shown pacific or angry and can stand alone or be

depicted in union with their male counterpart (Yab-yum).

There were several sects of Lamaism in Tibet. The Nying-ma-pa or red cap sect founded by Padmasamabhava and therefore tantric biased; The Ka-dam-pa sect, founded in 1040 by A-tisa a Hindu priest from the Vajrayana Monastery of Vikramasila in Bihar, and the Ge-lug-Pa, the yellow cap sect, and the most popular, which was born from reforms of the Ka-dam-pa sect by the teacher Tsong-ka-pa. Another sect also formed in the 11th Century, was the Kar-gyu-pa founded by Mar-pa a disciple of A-tisa. From this it would be obvious that there was a wide spread of doctrines of Buddhism, as well as both the monks of the white Pon and the Black Pon sects. Tibet then was a land of religion and her art is mainly religious. Over a third of the population prior to the Chinese invasion were monks.

The Ge-lug-pa or yellow sect had over three hundred divinities of which there are numerous variations. There are for example over one hundred and eight forms of the Bodhisattva Avolokitesvara. It will be clear from this that identification of Tibetan icons can be extremely difficult unless they are of the more common variety.

Bronze images together with the thangka paintings and other paraphernalia were dominant in a religion in which ritual and magic played an important part. There was no room for errors or variations in iconographic form, therefore rigid canons evolved, which determined the features and proportions of every bronze image and painted icon. It may be imagined that these restrictions made the art become stereotyped and unimaginative, but this was not in fact the case, for within the rigid canons the artists found room for individual creative freedom. A freedom which often produced great masterpieces. Many of the artisans were members of the priesthood who utilised their handicraft as a means of religious worship, thus, many works of art are the product of individual genius, the result of inspiration through meditation. Art in Tibet was purely religious and a large proportion was created for the instruction of religious teachings. The thangka paintings are probably the best example of this.

Each temple had numerous images both large and small and apart from the main and subsidiary altars there were special rooms for storing icons. Private houses too had their own household shrine, and even travelling nomads, traders and monks kept images in small portable shrines, while the population at large carried miniature icons in the form of god boxes.

In Nepal, Buddhism had been introduced at a much earlier date than Tibet. Legend has it that the Buddha himself was born in the Nepal terrai, in the Lumbini grove. The oldest Buddhist monuments, however, date from the mission of the Emperor Asoka. There are no examples of bronze art of the earlier periods. In fact bronzes before the 10th century are extremely rare. Most of the bronzes that come the way of the collector will be much later in date, possibly of no greater age than the 16th century.

Identification of an image starts with noting of the details; the ornaments, clothes, mudras and asanas (the hand and body positions) the vahanas (the god's vehicle) and attributes. Reference to the glossaries and charts on the standard work of these subjects *The Iconography of Tibetan Lamaism* by Antoinette Gordon would greatly help in this respect.

Generally, Tibetan icons can be divided into six groups: those dressed in Bodhisattva (princely) ornaments, Dharmapala (also princely) ornaments, monastic costume, miscellaneous garments; nude figures animal and non-human manifestations.

Mild manifestations wear Bodhisattva ornaments and costumes, whereas angry or fierce manifestations are depicted wearing Dharmapala costumes. Both mild and fierce manifestations can be tantric or non-tantric and be in Yab-yum (sexual union). Figures wearing Dharmapala ornaments usually have human-type faces with angry expressions or fierce manifestations with monstrous features usually with fangs. Some deities are made with either Bodhisattva or Dharmapala ornaments and some with both. Yab-yum figures are always tantric.

Bodhisattva ornaments comprise of earings, necklaces,

armlets, bracelets, wristlets and anklets; a shawl which covers the lower limbs; a five leaf crown; garlands to the thighs and navel and a scarf, a girdle and a sash.

Dharmapala ornaments consist of crowns made of five skulls, garland and belts also of skulls and sometimes an apron of human bones. The purpose is to terrify. Necklaces, anklets and wristlets are sometimes shown as snakes. A *urna* or third eye is shown in the centre of the forehead. Dharmapala manifestations usually have their hair arranged in a flame aureole and wear elephant or tiger skins on some part of the body.

Icons robed in monastic ornaments wear peaked caps with long lappets and do not wear ornaments. A shawl is sometimes draped over the shoulder. Images were also made dressed in Tibetan costume with broad rimmed hats; Indian costume with turbans; and warriors costume carrying weapons.

Although the collector will find in the beginning that he is acquiring the more common forms of deities, he may be able gradually to acquire some of the numerous variations. The most common icons depict Buddha, the Bodhisattvas, the Taras, and historical personages such as Padmasambhava, Srong-san-gan-po. Common deities are often represented in uncommon variations, both in the Bodhisattva and Dharmapala ornaments and are shown in both their tantric and non-trantric forms.

Many bronze figures of the Buddha do not in fact represent the earthly Buddha Gautama or Sakyamuni (a Manusi Buddha) but in fact represent Adi Buddhas or Dhyani Buddhas. The Adi Buddha or Dhyani Buddha is the primordial Buddha, the creator of the Universe. There are several manifestations each one worshipped by the Ge-lug-pa (yellow cap sect), as Vajrassattva by the Ka-dam-pa (red cap sect) and as Samantabhadra by the Nying-ma-pa (unreformed red cap sect) Manifestations wear Bodhisattva ornaments with their hair arranged in a high chignon surmounted by Cintamani (or flaming pearl) they have long lobed ears and third eye and an *usnisa* (top knot). They can usually shown nude without ornaments.

Dhyani Buddhas are the spiritual sons of the Adi Buddha and

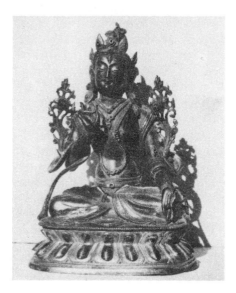

A very fine gilt bronze figure of
Avalokitesvara, originally
jewelled. Tibet.

are sometimes known as the Five Celestial Jinas. They too have
long lobed ears and third eye and an *usnisa* (top knot). They can
sometimes be in Yab yum and when thus shown wear
Bodhisattva ornaments.

Manusi Buddhas are the mortal Buddhas. Sakyamuni was the
4th while the future Maitreya is supposed to appear during the
5th world cycle (the present world cycle is the 4th) Manusi Buddhas
are normally portrayed wearing monastic costume without
ornaments. They are bare headed with the urna, usnisa and long
lobed ears.

There are many forms of Sakyamuni. He can be shown both
standing and seated in various poses, while the Parinirvana
portrays his death, his final release from rebirth. In addition to
the Buddhas mentioned often there are other icons known as
medicine Buddhas.

Another group of icons are the Dhyani Bodhisattvas. Of these
there are two groups, one of five and the other of eight. These
include Manjusri, Vajrapani, Avalokitesvara and Maitreya. The

Dalai Lama is believed to be the living incarnation of Avalokitesvara, God of Mercy. Dhyani Bodhisattvas are normally shown wearing Bodhisattva ornaments with their hair arranged in a high chignon and they have the *urna* or third eye.

Apart from the common icons mentioned above there are many other manifestations depicting femine Bodhisattvas, Taras, Saktis and the Dharmapala (Defenders of the Law of Buddhism) etc., etc.

The creation of beautiful things in Tibet became a form of devotion. It is therefore not easy to judge Tibetan art from the Western point of view. The techniques were part of the devotion and cannot be judged apart. To enter the temple was both an aesthetic, as well as a spiritual experience. The use of beauty, the richness of colour and precious metals were used to glorify the faith. Because art and religion were so closely connected the importance placed on quality was extremely high. Nothing but the best would do for the god, for religion not only controlled the artist's personal life but his future incarnation to, therefore to avoid being reborn as an inferior being and to retain the quality of his present incarnation he could not risk the production of an indifferent work. Thus Tibetan art cannot simply be grouped together as mass produced 'religious art', each and every piece was injected with a degree of personal spirituality, thus it does not mean that all works were masterpieces, on the contrary, only a few talented artists were able to produce artistic works of the highest order within the confines of the canonical laws. Tibetan art is individualistic. It is as individual as the skill of its maker, for no matter how good the intention, the quality of the bronze or work of art was only as good as the skill of its maker.

Collecting the sacred art of Tibet is extremely interesting for there is an infinite variety of objects and icons to please the eye. As investments they are extremely good, for the Chinese invasion of Tibet has wiped out the old order and further examples of fine Tibetan art of the past are unlikely to come out of the country. Much has left Tibet before the invasion and after with the refugees, but that flow has now ceased.

7 *Chinese Bronzes*

The art of bronze casting began early in China. Hundreds of superb vessels, dating to the Shang (1523–1027 BC) and Chou (1027–221 BC) dynasties, have been recovered from excavations of tombs and burials in the area of the great Shang and Chou cities over the last 50 years.

These magnificent bronzes are highly treasured, and although it is unlikely that the collector will be able to acquire specimens (the prices are extremely high), it is well worth including a description of them and their history for two reasons. Firstly, because it gives a good background to the bronze art of the later periods and secondly, because there is always a chance, however slender, that the collector will be able to acquire a genuine piece at a price that will not ruin his pocket.

When we talk about *ancient* Chinese bronzes, we mean ritual bronze vessels, not figures. The art of casting images and figures in China is essentially a later development. For our purpose we will divide the bronze art of China into two: the ritual vessels and secular bronzes of the Shang, Chou and Han periods, and the later bronzes of the T'ang dynasty onwards, inspired by Buddhism, consisting mainly of images and religious works.

During the Shang dynasty, as in later China, ancestor worship was prevalent, and many bronze vessels were cast to commemorate certain rituals and sacrifices. Others were made as funerary furniture, buried with royalty, nobility and men of

substance. Rituals during this period required offerings of food and drink, while sacrifices, both human and animal, were made especially at funeral rites.

While these vessels are superbly made their appearance is often enhanced by wonderful blue and green patinas, the result of being buried for centuries in the earth. The surface of the vessels are mostly decorated in relief with highly stylised designs of dragons, animals, masks and geometric motifs.

The quality workmanship is such that it appears that they were cast by the *cire perdue* or 'lost wax' process (described in the chapter on Indian Bronzes). It is possible, however, that several methods were used, the main being direct casting from pottery moulds. In this process the moulds were first made by working the shape and design in negative onto clay sections.

Whether or not the design was impressed into the clay or simply worked directly, we do not know. However, the multiple sections of the mould were made in clay with key grooves so that they would fit together after they had been fired. The sections were then assembled, an inner core suspended from the top and the molten bronze poured in. When cool, the sections of the mould could be dismantled to extract the bronze vessel.

Scholars are not agreed on this, although we have fragments of moulds, some of which actually have minute fragments of bronze attached. It has been suggested that the pottery moulds were used to make wax originals for casting by the *cire perdue* process. This would certainly be possible and it could well be that both methods were used. Thus we have a possibility that all three methods decribed above were employed.

Archaic ritual bronzes can be divided roughly into containers for cooked food; for preparing sacrificial food; for holding wine; for warming black millet wine; for wine-drinking and water vessels.

Various styles of decoration were used to embellish the vessels, realistic, stylised and geometric, and within these styles or forms there were variations, popular during different periods. The most popular stylised motifs were the *t'ao-t'ieh* masks and *kuei*

or dragon motifs.

There are many versions of the *t'ao-t'ieh* mask. Basically it is a stylised geometric mask produced by the merging of two animals in profile, face to face, the two joining to form a mask. It appears as if the animal has been split down the middle and opened up, flat. The various parts such as the legs, tails, snout, jaws, fang or beak and eyes then form a highly stylised face. In a later form the mask is further broken up and the elements scattered over the surface of the bronze merging with the spiral background.

The so-called dragon motifs the *kuei* are like the unsplit side section of the *t'ao-t'ieh*. Although some are obvious portrayals of recognisable animals, others are too highly stylised to be identified, and probably never were intended to be any simple animal but a composite creature endowed with the power of all. Like the *t'ao-t'ieh* the animal is composed of parts such as the eye, jaw, crest, horn, tail, quill and leg.

During the Han dynasty (206 BC–AD 220) some types of ritual bronzes continued to be made, but by now the force of the earlier decorative motifs had been lost to the 'nomadic' artistic influences, which exerted themselves during the period. Secular bronzes of various kinds were also made, including mirrors, belt-hooks, harness-fittings and bells. With the artistic influence of the Steppes came a tendency for increased naturalism. Although sometimes accentuated and embellished with stylised motifs, the animal or human figures when portrayed are instantly identifiable.

Most of the bronzes that have been buried and recovered from excavations are enhanced by beautiful patinas of green and blue, which are greatly valued by collectors and add to the value of the bronzes. However, Chinese connoisseurs had different tastes, and many bronzes that have been in Chinese collections have been covered with oil and brushed in an effort to produce a black shiny surface.

At the beginning of the 3rd century AD the emphasis on the bronze art of China entirely changed. The break-up of the Han dynasty brought with it unsettled times, with chaos and poverty.

People clung eagerly to the new religion, Buddhism, by which they hoped to regain peace and stability. During the Six Dynasties (AD 280–589) it became the popular religion, offering a totally new outlet for the bronze-caster. Buddhist images were commissioned both for personal worship and for installing in temples.

Early Buddhist bronzes were strongly influenced by the iconographic styles of the Gandhara region of North-west India and of Central Asia. Buddhist iconographic canons were adopted in China and all images that were made had to conform to the specifications laid down for their particular type.

To standardise representation of abstract forms, specifications were laid down for the proportions of the figure, each relative to the others. In this way an artist who had never seen an image of the Buddha should, by using the specifications laid down, produce an acceptable representation. The first anthropo-morphic representations of the Buddha were made by the Indian Gandhara artists.

With all these specifications it might be thought that Buddhist images are the same throughout the Buddhist world, but this is not so. The Buddhist bronzes of China, although strongly influenced by Indian and Central Asian images in the early days, soon established a style of their own, geographically and within the stylistic tendencies of each period. It is these differences that date and place later bronzes.

A problem that will face the collector is one of identifying the subject. Early Buddhist bronzes were mainly of the historical Buddha, Sakyamuni, in either a standing or sitting position. Later however, when the religion developed, other images of Mahayana Buddhism (the Great Vehicle) were introduced, such as Bodhisattvas, the past and future Buddhas and so on. Later still Tantric Buddhism was introduced, and this necessitated the production of images of the numerous deities popular within the sect. Later too, Lamaism was introduced into certain areas of China from Tibet. Lamaistic images are closely related to other Tantric images but have been somewhat modified in Tibet (see

chapter on the Sacred Art of Tibet).

Images, large and small were produced, with some notable exceptions, however, only the smaller bronzes have survived. The largest image that survives today is the massive figure of Kuan Yin at Lung Hsing Temple at Cheng Ting. Made in the 10th century, it is approximately 46 feet high (14 metres).

To cast figures as large as this requires great technical ability. Accounts exist which describe some of the difficulties involved. Although life-size and even larger, figures weighing many tons could be cast at a time. Some of the larger figures were cast in sections.

The majority of bronze figures were formed by the *cire perdue* method. The smaller bronzes were cast solid, while the larger figures were cast hollow. Another method employed was *repoussé*, the construction of images in beaten sheet metal, hammered into shape from the reverse side.

As we have seen, early Chinese Buddhist images are stylistically related to Gandharan and Central Asian prototypes. When seated they are usually in the lotus position, with hands in the *dhyana mudra* (position of meditation—hands lie in lap, palms upwards). The figures are clothed in monk's robes, which cling in U-shaped folds in the Gandharan style. The hair is arranged in waves, and they have an *usnisa* (top-knot), and an *urna* (third eye) on the forehead. Figures are seated on a lion throne and sometimes have a halo of flame aureole attached.

It is an interesting thought that in an indirect way the artistic traditions of Greece and Rome influenced the early Buddhist bronzes of China. The Gandharan style itself was the result of Hellenistic influence, which after many years reached Gandhara by way of Iran, reinforced by Roman influence from the eastern centres of the Roman Empire. In this way the art is more Romano-Buddhist.

The Chinese however soon modified the Indian and Central Asian styles, to produce a style of their own. The round smooth features of the Gandhara images give way to the sharper, more angular lines typical of the indigenous Chinese style.

In the early part of the 6th century, during the Northern Wei Dynasty (AD 385–535), the body and head of the figure became thinner and more elongated. The 'table' and lotus base is popular and flame aureoles are sometimes included behind the figure. Hair-styles vary and may be either with tight curls or with no curls or waves at all. There seems to have been an emphasis on robes which became even more stylised, flowing outwards in layers like a Christmas tree. Jewellery also figures predominantly.

A complete change is seen at the end of the Wei dynasty, when, as a result of renewed influence from India, the style becomes more linear and plastic. During the Sui dynasty (AD 587–618) the figures are more symmetrical and the face rounder. Images of the Buddha usually have a coiffure of tight curls.

Figures of the T'ang dynasty (AD 618–906) have a distinctive style, dissimilar to those of earlier periods. Although the style is influenced by Indian iconographic ideals, bronzes of the period have the typical Chinese look at the T'ang style, reminiscent of the pottery tomb figures.

During this period a large number of images of the Buddha, Bodhisattvas and other deities were made. The figures are somewhat formal with roundish faces, thick lips, slit curved almond-shaped eyes, sometimes with heavy lids, and bow-shaped brows, sometimes shaped with the line of the nose. The hair of Buddha images is usually in tight curls, and the *usnisa* is large, although some T'ang figures have hair without curls or waves.

The diaphanous flowing robes have Indian overtones, and the edges and ends often touch each other, forming an openwork effect. Aureoles too, when present, are often openwork, as are the basis. The overall effect of the images is one of spiritual serenity. The figures are modelled in various positions, both standing and seated.

Bronzes of the Sung dynasty (AD 960–1280) are much rarer, probably as a result of the fact that far greater attention was paid to sculpture in wood than to bronze-casting. The anatomy of the

figures of this period is much heavier and more solid than in preceding styles. Like the much larger figures in wood, images are sometimes seated in the *maharaja-lilasana* (position of royal pleasure) with the right hand raised and the left leg either in the position of a Buddha or pendant. One hand hangs over the knee, the other supports the body which is leaning backwards. The figures have squarish faces with a strong but serene expression; some are fully robed and jewelled. Indian influence can still be seen in some of the figures.

The bronze images of the Ming dynasty (AD 1368–1643) are icons in the purest sense of the word. The influences of Tibetan Lamaism and tantric doctrines can be seen clearly in the many-armed and headed figures.

Bronzes of this period tend to be formal, sometimes to the extent of being rigid. The anatomy is full, the robes stiff and sculptural, and sometimes engraved, while the jewellery is arranged symmetrically. The face is squarish, the nose rather wide, the eyes slit, and some figures have a sublime smile.

A number of Lamaist monastries were established in China, and many of the bronzes made for this sect are difficult to distinguish from the Tibetan. Some of the images in fact bear Tibetan inscriptions. Subjects vary, and include many of the deities from the Tibetan Pantheon. Like the Tibetan images, many of the Chinese metal figures were sealed with prayers, grain, precious stones, and sometimes small images in clay or metal (see chapter on The Sacred Art of Tibet).

After the end of the Ming period the art of bronze working declined somewhat. Some of the bronzes of the Ch'ing dynasty (AD 1644–1912) were iconographic and lacked the inspiration of the Ming and earlier periods, but it would be a mistake to dismiss all the bronzes of this period. Within every era exceptional works of art were produced, within the artistic fashions and restrictions of the day.

The images of the 17th and 18th centuries are, for want of a better description, more 'Chinese', the features sharper, the nose more aquiline, the eyes reduced almost to slits. Apart from

Buddhist images, Taoist and other figures were made.

It is extremely difficult to learn how to distinguish bronzes of one period from another simply from written descriptions; even photographs help only a little. The collector will find, however, that the more bronzes he actually sees and handles, the more he will be able to discover from a piece and the easier he will find it to make attributions.

Dogs of Fo. China, 18th century.

Bronzes continued to be made in the 19th century but they are generally of little merit and somewhat degenerate. However, the collector should not be afraid to acquire specimens that please him.

Many of the bronze images were gilded and coloured. Gilding was done in one of two ways—either by the application of gold leaf or, as in the case of most small figures, by mercury gilding. In

the latter, the gold is applied with the aid of mercury and then the figure is heated driving off the mercury to leave only a coating of gold. Some figures were further embellished with painted facial features and hair. Indeed, like Greek sculpture, which was also painted, some of the figures would not be as appealing to us in their original, sometimes garish colours.

When buying bronzes the collector must always bear in mind two things; firstly, there are some very good forgeries, and secondly, there are some good copies and later pieces with stylistic traits of earlier periods.

Finally a word or two about cleaning bronzes—DON'T! Unfortunately many pieces have suffered from being cleaned with household metal polishes which have removed all the surface tone and patina. Figures that have been cleaned have lost a great deal of their value and charm. Bear this in mind when buying; if you are offered a bronze that has been cleaned, it need not necessarily be passed by, especially if it is at a suitable low price or if it is reasonably rare. Chinese post-archaic bronzes are generally underpriced and make excellent investments.

8 *Japanese Metalwork*

In Europe the finest examples of the art of the metalsmith were created in gold and silver and were the specialist trade of the gold or silversmith. In Japan, where one of the world's greatest traditions of metalwork evolved, this was not the case. Neither was the working of particular metals confined to one group of smiths. It was an all encompassing craft used by artist, craftsman, jeweller and armourer alike—each interchangeable with the other.

The Japanese metalworker did not confine himself to any one metal; he worked with equal dexterity in both precious and common materials often using a combination of metals for decorative effect such as gold or copper on iron or vice versa. In fact the greater works of art are not to be found in precious metals but in copper, bronze or iron.

The origins of metalworking in Japan have almost been lost in antiquity. The Japanese first learned to work metals and to develop techniques of metallurgy in the Yoyoi period (200 BC to AD 500) At first copper and bronze were used primarily for tools and weapons but later religious and ritual objects were made, especially in bronze.

Among these early works the dotaku are the most notable works of art. Dotaku or 'bronze bells' are unique to Japan. Their exact use is uncertain but they appear to have originally been used as percussion instruments though later they assumed the roll

of ritual treasures. A number have been excavated. They are extremely rare and valuable. Recently at Christie's in London a dotaku achieved a world record price for a Japanese work of art, fetching over £35,000, although this record has now been superseded by a Japanese Kakiemon porcelain bowl which fetched over £40,000.

Another popular item for metalworkers during the Yoyoi period was the mirror. These were made in the Chinese style and decorated with designs of geometric patterns or with hunting scenes, houses and so on. Many of the later mirrors were decorated with peculiar Japanese designs.

With the introduction of Buddhism in Japan, in the 6th century AD, came a demand for metal images. The first images in Japan were Chinese in manufacture but soon Japanese craftsmen were satisfying local demand and creating their own interpretations of Buddhist artistic formulae, though still coloured somewhat by Chinese ideals. Buddhist bronzes continued to be made in one form or other until the end of the 19th century.

Bronzes of the Nara period (645–794) are characterised by a dynamic approach which imparted a sense of presence to the figures. Figures were made in all sizes some of them gigantic. Workmanship declined during the Muromachi period, (1392–1573), a decline which continued into the Momoyama period (1573–1615). They tend to be iconographic and rather stiff similar in many respects to the Chinese bronzes of the Ming dynasty.

During the Tokugawa period (1615–1868) bronzes are varied. Buddhist bronzes were produced but many of them tend to lack the original inspiration so evident in some of the figures of the earlier periods. Chinese influence can still be seen in some of the images but they are rather hackneyed interpretations of the iconographic style of the Ming period (1368–1643). Mirrors continued to be made, but, unlike the early disc variety, they were endowed with handles and are called ekagami. The designs were more elaborate and of a pictorial nature. Some of the mirrors of this period bear the signature of the metalworker with

the boast 'first under Heaven'.

Figures other than Buddhist were made and included the Seven Gods of Good Fortune, bronzes however were just one of the many facets of the Japanese metalworker.

The artistic skill gained in executing religious works was later employed to great effect in the production of non-sectarian objects. Although the art of bronzeworking developed early in Japanese history, the majority of examples that have survived and which are in collections both public and private throughout the world are late in date, mainly dating from the 18th and 19th centuries.

During the Tokugawa period the demand for ornamental metalwork greatly increased as a result of the greater wealth of the nation. Demand was particularly strong for metalwork for personal and domestic use. A number of techniques were developed to enhance and decorate, including engraving, relief modelling and carving, inlay with metals and even mother-of-pearl. In addition to these the craft of cloisonné was introduced, though in Japan it made its appearance much later than in Korea or China. Thus, it was to a certain degree, influenced by the work of those countries. Early Japanese attempts were poor, the colours were muddy and air bubbles profuse.

Cloisonné is essentially the art of enamelling, coloured glasses being fused into a metal ground but separated from each other by metal ribbons to form a design or picture. The design was first drawn on to the metal base, either a flat or curved surface. Thin ribbons on wires of copper tin alloy were then bent to the lines and attached to the surface either by glueing or soldering. Coloured glass powder was introduced into the cloison or cells thus produced. Next the object was fired until the glass melted and adhered to the metal, and with the ribbons, formed a composite structure. The surface would then be rubbed down and polished until the metal lines appeared and a high sheen obtained.

There is another form, not a true cloisonné, in which the basic object is caused by the different co-efficients of expansion of

68

glass and metal.

The early cloisonné was much prized by the Japanese, although it may look rather inferior to us today, especially when compared with the Chinese. Fine 16th century tsuba or sword-guards were sometimes embellished during the 17th century by the addition of cloisonné discs. Fine works of cloisonné could be and were produced in good taste, but often the inartistic worker would degenerate the technique into vulgarity. In this connection it is interesting to note that this form of decoration was not usually employed on articles used in the Tea Ceremony for which only items of the utmost simplicity and dignity were considered suitable.

The metalworker's art, however, was not excluded from the Tea Ceremony; on the contrary it was much in demand especially for kettles which were cast in bronze and iron. Kettle-making became an art in itself. In the Momoyama period Kyoto became a centre for kettle-making. The names of a number of kettle makers are known, some of whom made kettles especially for certain tea-makers. Kyoto was also a centre for metal-casting in general, many of the kettle-makers also casting temple-bells and lanterns.

Perhaps the Japanese metalworker's greatest achievement was his mastery of iron, both for armour for which the techniques were originally developed, and for decorative and domestic use. The armour's and swordsmith's skill was in fact an extension of the metalworker's craft, but directed to one particular end. Japanese armour is complicated and has almost ritual significance.

The designs of armour changed over the centuries, but remained typically and identifiably Japanese. The Japanese sword is a unique weapon, great care and skill being lavished on its manufacture. A great mystery surrounds it. Swords are divided into two periods—'old swords' *koto* and 'new swords', *shinto*, those made between AD 1530 and 1868.

The Ashikaga period saw the beginning of ornamentation of sword fittings which bloomed during the Tokugawa period.

Swords had detachable guards, tsuba, which were made in different shapes in soft metals and iron. Both armourers and swordsmiths made tsuba and would use materials that they had available in their stores. Some of the greatest Japanese works of art can be found in tsuba. The challenge of fitting a design or pictorial composition into a restricted shape was readily accepted by the Japanese artist. Tsuba became more than just an essential part of sword furniture; they were made in large numbers and exchanged as gifts between friends.

The Japanese artist excelled at producing masterpieces in miniature, fitting his compositions into confined space. Other elements of sword furniture included the tall vertical slips of the handle of the kozuka—a small knife attached to the sheath of the sword; menuki, an ornamental metal piece which was placed on the handle of the sword to conceal the pin which attached the sword to the handle; and kogai, a bodkin like instrument used for holding the hair in place, which became part of the sword fitting.

The netsuke or toggle was also made in metal especially the flat 'hollowed out' variety, the kagamibuta. These together with the ojime, the cord bead usually on the end of an inro or pill or seal box, all part of the oban or sash assembly worn by Japanese men, were the ideal challenge to the Japanese metal artist. In spite of the confined space, he achieved almost the impossible, not only in vision and composition but also in technique of inlaying with gold and silver and other soft metals and of carving and engraving.

A number of metals found favour with the Japanese metalworker, including bronze, copper, iron, silver, pewter and an alloy of copper and gold ahakudo. Gold was rarely used alone; it was scarce, expensive and its use was restricted by law. However it was used to great effect in gilding copper and bronze objects as well as for inlays. Gilding techniques ranged from thin gilding or damascening on hatched iron, to the application of gold in sheet form. A technique of high relief inlay, takazogam, was also done using gold, though often a gold substitute was used. It is often difficult to tell the quality of the metal used as

tests would destroy the often delicate work.

Silver was more common, although the pure ore is rare in Japan, quantities were extracted from silver bearing lead ore. In recent times silver has been extracted from copper ore.

Much of Japanese metalwork is signed, though the presence of a signature is no guarantee that the item in question is by the artist named. Like marks and signatures on so much of oriental art, it is put there not with any intention to deceive, but as a mark of respect or admiration for the artist named (see chapter on marks). Signatures were also sometimes added at later dates as attributions. In the case of the latter, these attributions were often over optimistic. The Japanese themselves describe these spurious signatures as atomei or gimei, meaning added or wrong respectively. Even objects of the highest quality may have these false signatures. However, having said this, we must not assume that all signatures are false—on the contrary, many are quite genuine. By studying genuine signatures much as been learnt about Japanese metalworkers.

One of the greatest Japanese artists who worked in metal was Komai. Illustrated is a superb silver elephant by him now in the Russell-Cotes Museum in Bournemouth. The elephant which is jewelled and inlaid with gold and precious stones, is a magnificent example of Japanese metal art. Komai worked with great dexterity in all metals. In marked contrast to the European smith, the Japanese metalsmith had no guild of goldsmiths or silversmiths to control him; his object was simply to produce a thing of beauty, regardless of the material.

The motifs employed by the metalsmiths were drawn from many spheres, including religion, the theatre and the world of nature. Sometimes the metalsmiths would make humorous but beautiful articulated animals. There were usually of iron and would include such animals as dragons, peacocks, and other birds, crabs and lobsters. Humour was an essential element in art and design. It is a strange fact that the Japanese, outwardly so formal and severe, created an art which was gay and happy. It may be this as much as the excellence of execution that endears

the art to so many collectors.

Japanese metalwork is so diverse that it is rare for one collector to encompass it in its entirety. Some collect tsuba, others bronzes and yet others swords. Thus an art, the skills of which to a great extent were interchangeable depending on the item being made, has, because of its diversity been split. However, to appreciate fully the genius of the Japanese metal artist, we should, hard though it may be, try to see his art as a homogenous whole.

9 *Indian Miniature Paintings*

Indian miniature painting is one of man's greatest art forms. It was born of Indian inspiration and Persian ingenuity. These delightful paintings, the products of numerous schools, artists and periods are extremely pleasing and profitable to collect. Averaging 12″×6″ or 30.5 cm × 15.25 cm they can be framed for decoration or kept in port folios for easy storage.

Indian miniature paintings have been known in Europe since the 16th Century. Rembrandt was familiar with them and made a number of free copies of them. They were collected in the 18th century with notable collections being made by Richard Johnson and Sir Gore Ouseley.

Although painting in India has a very ancient history the art of miniature painting may be said to have begun under the Mughal emperors. The earlier Indian traditions were either of fresco painting or of simple sub-miniature book illustrations on thin horizontal leaves of palm or paper. True miniature paintings are rectangular. These early indigenous traditions, however, played an important part in the development of the Indian miniature tradition.

After the Mughals successful invasion of India in the early 15th century by Barbar, they brought to their court Persian painters expert in the art of miniature painting. These painters drew their helpers from the ranks of the indigenous artists and thus indigenous traditions and Persian miniature traditions were

73

merged to produce a new school of painting, the Mughal school, which ranks amongst the greatest in Asia.

Barbar's grandson Akbar can be said to be the real founder of the Mughal school, for it was under his personal supervision that the court studio became firmly established. These ateliers were staffed by local artists under the direction of the two master painters, Abdas Samaad and Mir Sayyid Ali. These artists had originally come to India with Akbar's father Humayan. Of the indigenous artists we know the names of Basawan, Daswanth and Kesadosa but the names of the other artists, which number well over one hundred, are lost in history.

A great patron of the arts, Akbar commissioned numerous projects some of them extremely large. One of the most famous is the Hamza—Namah. This huge project started in 1567 and completed in 1582 consists of 1,400 paintings on linen. Paintings of the early work show very strong Persian influence but later paintings were modified under the influence of both Hindu and European ideas.

Indian miniatures in technique resemble illustrations in European medieval manuscripts. The average size of 16th century miniatures is about 12"×8" or 30.5 × 20.3 cm.

Subjects of Mughal pictures included scenes from actual life, historical incidents and portraits, but not religion. Akbar also specially commissioned paintings of the great Hindu epics in which he was greatly interested. Mughal painting, unlike Indian art of the earlier periods, was not inspired by religion. The Koranic law was against the representation of the figure, whether human or animal, for it was said that whosoever made a representation of a figure would give it his soul on the Day of Judgment. This principle was originally meant to cover representation of all kinds and was adhered to during earlier times, but it later only applied to public buildings and especially mosques.

The early Indo-Persian style of painting was a kaleidoscope of colour, especially prominent in red, blues, and golds. The colours were obtained from ground minerals such as lapis lazuli, which was used for the blues. Gold leaf was frequently used on

backgrounds and for patterns and accessories of costumes. The style is closely related to the Persian and is fine and delicate.

The true Mughal painting is quite different, it is more realistic and much freer than the earlier works. European influence was shown by the application in some paintings of fine line shading. The backgrounds are more natural as Mughal painters had an unusual sense of perspective and even made somewhat amusing attempts at foreshortening. The artists lavished great care on their work, even down to the personal preparation of their materials, which as in the West, were made to their own personal formulae. Paper was chosen from three kinds; *bhansi* made from bamboo, *tataha* made from jute and *tulat* from cotton, while a fourth variety, *sunni*, made from flax was used occasionally.

Once chosen, the paper was burnished with an agate pebble to give it a uniform enamel-like surface. Single sheets were used for book illustrations, while for independent paintings (i.e. non book illustrations) two pieces were stuck together back to back. The outline was drawn in Indian red, as this was not mixed with binding agents it could easily be removed if any mistakes were made. The outline was then covered with semi-transparent white. The somewhat faint outline was then reinforced with lamp black. Colours were then added, and finally the detail. It is the detail and the superb sense of composition of Indian miniature paintings that makes them so fascinating. Every single hair was painted separately and true appreciation can only be made under a magnifying glass. In order to achieve this detail, brushes had to be extremely fine. They were made with squirrel, monkey or camel hair. The pigments too had to be free flowing and were applied with water mixed with binding agents such as gum, sugar or glue.

As in European schools of painting apprentices worked under the direction of masters, but the work was always signed with the masters name. In India, however, it was a regular practice in court ateliers for more than one artist to be employed on the painting of a picture, although each had a specific job. One

would specialise in the drawing of the outline, another on the main subject and yet another on the background. Mounting was the work of yet another artist, a specialist in his field. The main panel of an Indian miniature is known as *taswir* and the border is the *hashia*. The latter was commonly speckled with gold, a technique common to both Mughal and Hindu schools. Akbar's interest in painting was continued by his son Jehangir (1605–1627). Jehangir's inherited his father's studio and commissioned many works. It was during his reign that Mughal painting really bloomed. He was mad on art and collected both contemporary and early paintings, which he mounted in large albums. These inspired albums were enhanced with elaborate floral borders, specially developed by his court ateliers. During his reign the style of painting became much more naturalistic. The old Persian idea of bird's eye perspective gave way to the popular side view of the Rajput style. Jehangir had a great interest in natural history and commissioned many botanical and zoological studies. These beautiful and delicate paintings are masterpieces of Mughal art. Other subjects which were also popular included romances, historical works, hunting scenes and group and single portraits. Many are works of sheer genius.

Jehangir was also interested in the Europeans and their culture and had many amusing copies of occidental paintings made. European art, in fact, had a very definite influence on the art of the Mughal court as can be seen in the faint line shading of some of the paintings, which gives a quality of depth to an otherwise flat style.

Another instance of European influence in Indian painting can be found in the work of a certain Persian artist, Mohammad Zaman who worked at the court of Jehangir's son, Shah Jehan, in the early 17th century. Zaman studied art in Rome, became a Christian and changed his name to Paolo Zaman. Because of this he was barred entry back into his home land and had to seek shelter at the court of Shah Jehan, where he worked as a painter. Many paintings in European style are thought to be by him.

During the reign of Shah Jehan (1628–1658), a new technique

was introduced called *Siyahi Kalam*. This involved adding just a page of colour to a simple line drawing. It became very fashionable for portraiture. Painting in the Mughal court was extremely popular and both emperors and courtiers had their portraits painted, often with numerous copies being made of the same painting. Royal personages, both Mughal and Rajput (Hindu schools), are normally always shown with a halo of gold around their heads. These portraits, which are drawn with fine and delicate lines are always true to life.

Paintings of figures are normally always shown in profile. The robes are richly painted with all the detail of the brocades and silks enhanced with gold. A sense of transparency was also achieved when diaphanous robes were painted. In this case the limbs were shown. Backgrounds to portraits were usually plain and executed in tinted colours, though dark colours were occasionally used. The effect was achieved by the delicate outline and colouring.

Some Mughal portraits can be a trifle stiff. However, the artist attempted to relieve this stiffness by the natural and soft treatment of the hands, which in the case of men was shown resting on the man's sword-hilt or holding a flower. The latter was not considered unmanly, for the Mughals were extremely fond of nature. Full length portraits were usually shown standing in a grassy patch of flowers or on a terrace. Although there were many copies of important paintings, originals can usually be detected from the later sterotyped copies by the overwhelming quality of the painting.

Kings, courtiers, saints and soldiers all had their portraits painted. Paintings of emperors also could be posthumous and it is not unusual to come across a painting of a group of emperors together.

The flower of the Mughal painting began to wilt during the reign of Shah Jehan but it did not completely die for another 200 years. Under the despotic Emperor Aurangzeb (1658–1708), painting was abandoned as a court pursuit. Hundreds of artists were made redundant and sought employment elsewhere.

Mughal paintings, however, of the period continued to be made, all be it with little encouragement, but this seemingly catastrophic event in fact was a blessing in disguise, at least for Indian art. Forced by the need to find employment elsewhere, artists moved to the courts of the Hindu Rajasthani rajahs and to the maharajas of the Punjab Hill states. Another new environment created dynamic and vigorous new styles of painting, free from the limitations of the Mughal court. Their inspiration came from Hindu sources, mainly the great epics.

The Mughal style, however, did not die, for in the 18th century it entered a new phase. Artists who had left the court found employment within the Mughal empire with princes and nobility and especially the rich merchants, whose growing demands for painting they met.

This change of patronage also meant a change in subjects. At the court in Delhi it was an era of Imperial pleasure and paintings of dancing girls, courtesans, harem scenes and love scenes were most popular. These paintings are beautiful and delicate and have a strong sense of composition and colour, but they are different in style to the works of Jehangir and Akbar.

In the provinces vigourous styles of painting grew up, especially in Murshidabad, Patna and Farrukhabad. These provincial styles differ from the Delhi style, especially in their preference for warm colours. *Raga malas*—visual interpretations of musical scenes, hunting scenes, group and single portraits of rulers and courtesans were extremely popular. The Nawabs of Oudh at Faizabad were great patrons of the arts and encouraged paintings to be produced. These intricate compositions are notable for their brilliant colours. The Lucknow style was similar to that of Delhi but not of the same quality. The technique differed, with a preference for almost purely water colours, while the background was often kept white. The Patna style was cruder than that of Delhi for although the drawing is fine the overall effect is hard.

The local paintings of the Deccan were small even sub-miniature in style. Apart from this they are similar to the Delhi

paintings, but are richer in colour and embellished in gold. Non-Mughal traditions which included both Hindu and European influence, the latter by way of Portuguese Goa strongly influenced the style.

The provincial Mughal paintings continued to be made up until the first quarter of the 19th century. The Company school (named after the East India Company) developed as a branch of the Mughal school. The British, especially in Bengal and Madras, commissioned many paintings of every day life from local artists. These included a wide variety of studies such as their own houses and gardens, native customs, transports, dress, birds and animals and last but not least landscapes.

The new demand was eagerly met by the Indian artists who rapidly adapted themselves to the wishes of their new patrons,

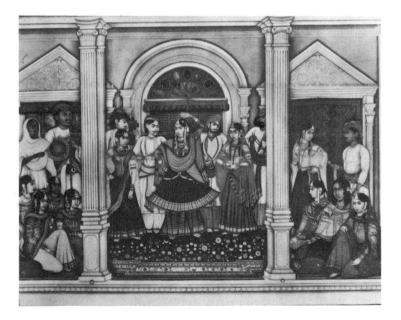

An early 19th century Mughal painting of Nautch dancers performing in a European mansion.

both in technique and in colour. Many paintings of the Company school are reminiscent of British watercolours. They are of great interest as records of contemporary life, though not as good artistically as the provincial Mughal schools. A later variation of the Company school of art can be found in paintings of similar themes on mica.

The paintings of Hindu India run parallel to and are contemporary with the Islamic paintings of Mughal India. However, their styles are quite different. The contrast of colours of 16th and 17th century paintings are brilliant and contrast strongly with Mughal art. However, as Mughal influence in painting increased, some of the Hindu schools, including those of Rajasthan, Colah, Marwar, Kishangarh and Bikaner adopted some of the techniques to their needs which tended to have a rather softening effect.

Much of the Rajasthani and central Indian paintings relied on mythology and religion for their theme. Illustrations from the Puranas, which related the exploits of Indian kings and heroes and paintings of the god Krishna were very popular. In addition portraits, scenes from every day life and *raga malas* were painted. The style is generally not realistic, especially when compared with the Mughal school and to a certain extent is stylised. It represents in part a continuation of the indigenous tradition, modified and influenced by Indo-Persian ideals. The technique of painting, however, is the same only the style and colouring is different.

Paintings often have a superb luminous quality due to the use of silver and gold primings. Gold was used in so far as it represented two lighting effects such as moonlight and firelight, while cleverer techniques also using gold gave luminous effects to shadows. Silver was used for the effect of still water.

Mewar was the centre of one of the most important styles of Rajasthan. The 17th century, which was the hey day of Rajasthan, also saw other styles developed at Bundi, Marwar

Rajasthan painting of the Maharaja of Jaipur, 18th century.

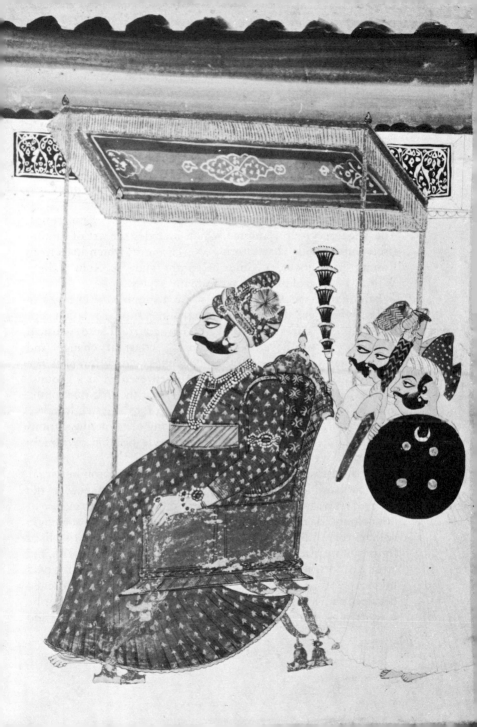

Narsingarh and other centres. Kishanagarh produced a short but brilliant period of painting between 1735–1755. During the 18th century Rajasthani painting became more and more influenced by the Mughal school.

Large numbers of paintings were produced in the courts of the Rajput princes and nobles in the 18th and early 19th centuries. Hundreds of artists were employed in court workshops producing paintings of court scenes, hunting, music parties and portraits. Some exquisite paintings of elephants were produced at Bundi.

The paintings of the Punjab Hill states form two main groups. The western group (Jammu) which includes the art of Jammu itself and Basohli; The eastern group (Kangra) which apart from Kangra itself includes Guler, Chamba and the Kulu Valley. Within these groups there were many styles.

Painting of the Punjab Hills show a number of changes in styles, which are due to the changes in political relationships between the states and the Mughal court. These political influences acted as stimulae causing constant change and developments. In spite of these changes and differences the paintings of the Punjab Hills are still represented as a group.

Raja Kirpal Pal of Basohli (1678–1694) was the first ruler of the hills to form an atelier of his own. Prior to this we have no evidence of any kind of miniature painting or book illustrations being made in the hills. The Basohli style became extremely important, influencing all other states.

The artists who had left Aurangzeb found a patron in Kirpal Pal. The Basohli school was therefore strongly influenced by the Mughal style. It was notable for its strong lines and daring use of hot colours. Backgrounds were invariably large sheets of a single colour, red, orange and green. The exagerated almost stylised figures of men and women are drawn with sloping foreheads and large eyes. Paintings are, however, flat with little attention paid to perspective. The zenith of Basohli painting was reached between the years 1675–1740. Once seen, the style can never be forgotten as it is most distinctive. The treatment of hands and

The Deceitful Heroine. A lady blames the cat for scratches inflicted by her secret lover. Basohli, Punjab Hills; about 1680.

legs of standing figures for instance are similar to that of ancient Egyptian frescoes. There are numerous sub-styles.

By about 1730 the style had become somewhat tame, dampened and naturalised by a new wave of Mughal artists, who had left Delhi after the sacking in 1739 by the Persian Nadir Shah. This subdued version of the Basohli style known as the 'pre-Kangra' spread throughout the hill states and prevailed until 1765. Basohli, however, continued to be an important influence, still felt in Chamba as late as 1770. Nadir Sha can be thanked, for in a way he is indirectly responsible for the style of Guler painting, for artists who fled from Delhi were instrumental in developing the new style. Taking refuge in this state and enjoying a new atmosphere which the Mughal court lacked, they produced splendid paintings of the Hindu epics especially of the Krishna legend. Fine portraits were also painted in this style, especially during the period 1745–1770. This style led to the development of the true Kangra school.

Kangra is a term applied to all paintings in the style, not just those painted at Kangra. It remained a major style from about 1770–1805, although it continued in a somewhat decadent form under the Sikh rulers well into the 19th century. From about 1770–1780 it retained many elements derived from Guler paintings but later became repetitive in execution, sentimental and facile. In spite of this, Kangra paintings are amongst the most sensitive and beautiful paintings of all.

Women are the principal subjects. They can be of two facial types, the Bhagavata type so called because it first appeared in a series of illustrations of the Bhagavata Purana period—is delicate and small, round, with rounded chin, small nose and finely painted hair. The other 'standard' type of face has a mass of black hair, narrow slanting eyes, pointed chin and a straight nose, the line of which continues upwards to the forehead. The painting of women in Kangra was in true romantic spirit. Kangra painting contrasts strongly with that of Basohli in that it is more delicate and fine, but the passionate quality of the Basohli paintings is sacrificed at the expense of this refinement.

In India the lover is often symbolised as a woman; the beloved as a man. This is why many of the scenes depicted in the miniatures show women inflamed by passion, visiting their lovers or waiting in secret meeting places. It is the female quality to love, rather than be loved, which is stressed in the paintings. The *raga malas* were, in a way, musical love poems or garlands of music. The illustrations depicted the various musical modes, *raga* or *ragini* if they were a prince or a lady.

Many paintings of the Hindu schools were executed as a proof of devotion. Just as the saying of the sacred names of Rama or Krishna would help the devotee to ensure his ultimate bliss, so the illustration of the epics of Rama and Krishna was thought to be a devotional act and an offering to the god. It was therefore important for the sponsor to commission the best possible illustrations he could afford, for in his way his gesture would be more effective.

It is interesting to reflect on the cost of these miniature paintings,

both Mughal and Rajput, in comparison with the prices paid today. With the exception of a very short period they have always been highly valued. In 1641 a Spanish priest, Father Sebastian Manrique, who was in Agra at that time, valued the Imperial library, which contained approximately 24,000 volumes at £720,000, an average of about £30 a volume over 300 years ago!

Although it is possible to describe the drawing the colouring, the techniques of painting and the style, there is no substitute for experience, and the collector should view as many Indian miniatures as possible, to acquaint himself with the numerous variations and styles. This is the only really reliable way to appreciate the technique and to be able to distinguish the different schools and periods. Much can be learned from books but, in the end, experience gained from actually seeing paintings is all important.

The art of miniature painting is not yet dead in India. Although no original works are being produced and the tradition in the true sense of the word is dead, a number of copies are being painted, some of them excellent works of craftmanship. The experienced collector will not be deceived by these, but the novice should beware—he may have to pay dearly for his mistakes.

Although far from common, Indian miniatures can occasionally be found in antique shops, while a few specialist dealers, mainly in the larger cities, usually stock a wide selection. The best examples can cost a great deal but there are fine paintings that can still be purchased for a modest outlay. Compared with paintings of other schools of art, both oriental and occidental, they make ideal investments as they are still underpriced.

10 Tibetan and Nepalese Thangkas

The painting of Tibet has for long been one of the neglected arts of the world. It is therefore a strange twist of fate and circumstance that has attracted attention to this now rare art form. Strange, because when examples were readily available nobody seemed to want them, and strange because the interest in the first instance came not from those interested in art but from the evergrowing number of those interested in oriental philosophy and mysticism. The thangka, steeped as it is in symbolism and religious mystery became a magnet for those seeking to understand the secret mysteries of the East. Thangkas, however, were no mystery to the initiated student of Mahayana and Tantric Buddhist iconography, as it had long been a vehicle of study.

Once a fashion has been created, all sorts of people find themselves suddenly liking things that previously they would not have had in their homes—such is human nature. Demand once established has to be satisfied and a steady supply has to be found. When supply falls short prices rise and the inevitable happens, supply enventually dries up—of the real thing, at least. With thangkas the supply was short to start with, owing firstly to their fragile nature and secondly to the fact that they are a sacred art from an inaccessable and closed country, a country whose culture has been irrevocably changed since the Chinese occupation. Demand has to be satisfied, however, which it is, not

with old and genuine works of art but with modern copies masquerading as the real thing. Much of what is on the market today is modern and most have never seen Tibet.

What then are thangkas? The thangka paintings of Tibet and Nepal are religious works meant for teaching rather than for pure decoration, although many that hung in Lamasaries were of great beauty and greatly enhanced the decoration of the building. Thangkas were also hung on the walls of homes and carried in religious processions. The Tibetan word *thangka* is derived from the words *than-yig* meaning 'written record'. The word '*yig*' is replaced with the substansive ending '*ka*'. Written record is a true description of these paintings for they are records of the teachings of Buddhism (and in Nepal sometimes Hinduism) 'written' in symbolic picture language, a language which could easily be understood by a people who were largely illiterate.

The thangka has its origins early in Tibet's history. A large number of Tibetans were nomadic and before the establishment of the great permanent monasteries even they were nomadic and travelled around the countryside. Such a mobile monastery could comprise of hundreds of monks. It was mobile in every respect, everything needed for religious services was carried, everything that was later incorporated into the large and small permanent monasteries was portable. The thangkas evolved as a kind of mobile frescoe, in fact the technique used by thangka artists is almost identical to that used on frescoes, and later the same artists painted both thangkas and murals. When the monasteries moved into permanent buildings the thangkas became an essential part of the furnishings of the shrine. Thangkas were still carried around but by travelling monks and mendicants.

Although the style of painting is ancient and initially derived from classical Indian sources, and the painting may look extremely old, thangkas older than the 17th century are extremely rare. Most are much later, belonging to the late nineteenth and the first half of the twentieth century—these are all true thangkas regardless of their age. In fact age has often

very little to do with quality, good and bad can be found in most periods. The 'new' thangkas date from the 1950's and in particular the last five years—but more about these 'new' thangkas later. Apart from the style of painting there are other reasons for their apparent age. Thangkas belonging to travelling monks tend to 'age' quickly as they were rolled and unrolled many times. Another illusion of age is created by the dark colour, the film caused by the smoke of butter lamps that lit the temples and homes. Thangkas are sometimes so heavily impregnated with this soot that they retain a strong smell. These two elements are often utilised artificially by unscrupulous dealers to give modern paintings an appearance of age.

Closely related in style to the 10th and 11th century Pala paintings of Bengal in India, they were in fact executed in the technique of mural painting on cotton, linen and rarely, silk grounds prepared in the same ways as murals, and painted in tempera. The ancestor of the thangka can probably be seen in the temple banners of Chiu-tzu in Central Asia which date to about the 8th century.

The technique of painting is interesting. The ground was first prepared by stretching the cloth over a wooden frame. A mixture of lime plaster and flour, sometimes with added glue, was then spread over its surface. A mixture of chalk mixed with gum arabic was also used. When dry the surface was burnished with polished stone.

The outline was drawn with charcoal, or sometimes produced on a stencil plate. This was a sheet of paper with the motif perforated with pin-holes through which charcoal dust was sifted. The charcoal outline was then fixed in with Indian ink. Although many thangkas are the work of one man some of the more important masters employed apprentices who helped him. They would add the colours to the painting, which he would indicate in ink notes. Colours, which were simply mixed with hot thin glue, came from a number of sources but mainly from India and China. In old thangkas and modern ones of good quality the blue is made from ground lapis lazuli. The yellow is

sulphur, the green is from tailor's greenstone while the red is vermilion from cinnabar.

The paintings were not varnished and so are liable to be attacked by damp. For this reason, thangkas must not be kept in a damp atmosphere. If damp does attack them, it often causes the paint to flake off. When finished the panel was mounted on silk or brocade banners. The brocades were often extremely beautiful and rich and were usually imported from China. The painting itself was surrounded by a frame of brocade of a different colour to the hanging. This frame was usually of red and blue, but yellow was also acceptable, and in recent years borders of three colours, red, yellow and blue were made. Beneath the painting in the centre was a rectangular panel, usually of elaborate brocade, which is known as 'the door'. The symbolism of the borders represent an edifice in which the world of the painting resides, and the 'door' beneath is the entrance to that world. Not all thangkas have this 'door'.

The subjects of the thangka were by nature religious, illustrating the Buddhas and other deities of the Tibetan Buddhist Pantheon. Tibetanised Hindu gods were also included, such as the elephant headed god Ganesha and Kubera. In Nepal as well as Buddhist subjects, Hindu thangkas were painted, especially of Mahadevi, Kali, Siva and Bairava.

Thangkas can be separated into several types: those depicting manifestations of deities; Mandalas or ritual diagrams; Tshog-shing, depicting assemblies of deities; and Bhavacakramudra, the Wheel of Life.

Mandalas were used by Lamas in special rituals, invoking deities to grant Siddhi—superhuman powers. These charts are divided into sections containing various deities. In order to receive the deity, the thangka is drawn in geometrical sections, with divinities placed at key positions, according to the magical pattern. Instructions for producing the various kinds of Mandalas are included in the twenty-two volumes of the Tantra.

Tshog-shing (or Assembly Tree of the Gods) are paintings of the numerous deities of the Pantheon, assembled together, in

order of rank. The central figure is usually Gautama, Tsong-kha-pa or Padmasambhava. Deities from the whole of the Pantheon are depicted on these pictures, including the Buddhas, Bodhisatvas, Dharmapala deities such as Mahakala and Mahakali (wrathful aspects), Yi-dam- personal deities, feminine deities, witches, arhats, great magicians etc.

The Wheel of Life or Bhavacakramudra is intended to represent the Samsara, the eternal cycle of life and re-birth. The Wheel is divided into sections to illustrate the Conditions of Existence.

Tibetan painting is a subtle blend of Chinese and Indian elements. The technique of depicting flowers and trees, mountains, clouds and rivers, owes its inspiration to Chinese art forms. The painting shows delicate detail, indicating the Tibetan artist's close observation of nature, but only the essential details are included. Chinese influence can also be seen in the treatment of visions or dreams, which the Tibetan artist shows as a transparent mist floating in space.

Indian influence is shown in the treatment of the figure and costumes and in the arrangement of the deities in the compositions. The idea of showing the importance of the central figure by its large size, in comparison with the others, may also have been derived from India.

Contrary to what most people believe, thangkas were generally the work of lay artists and not monks. The tradition was passed down in families from father to son. A small number of thangkas however were painted in Lamaseries, but it was the exception and not the rule.

There are basically three schools of thangka painting. The earliest is the Kadam or classical school, which is simple in the extreme and yet which by the clever use of colour and space has a rich quality. The later classical school, or Menri, was first organised by an artist called Menla Tondrup in the 15th century. This school is essentially a continuation of the Kadam school but shows influence of Persian ideals in its closer attention to detail, which results in a richer canvas than those of the earlier

school. The second main style the New Menri developed in the late 17th century, is essentially baroque in character and extremely colourful. Space has been sacrificed and the entire canvas is painted with a mass of detail. Chinese influence can clearly be seen in the thangkas of the third school, the Karma Gardri. The style, which originated in the 10th century, was elaborated in the 18th century. It contrasts with the others by its use of space and stylised landscapes as well as in the use of pastel colours.

Thangkas in the true tradition are still produced today mainly by Tibetan and Nepalese artists. But thangkas are also a minor industry, an industry mainly directed at tourists but which also indirectly affects the unsuspecting collector.

The Chinese invasion of Tibet forced large numbers of Tibetans to leave the country and live as refugees in India, Nepal and Sikkim, as well as a number of other countries in various parts of the world. They brought with them many treasures as well as their customs and skills, including the art of thangka painting. In Nepal the art of thangka painting never quite died, it only needed an increased demand to set it booming. This boom, however, has largely meant the abandonment of traditional materials and some techniques in exchange for faster and increased production. The degree of sacrifice for production varies and is reflected in the quality of the painting. Not all modern thangkas are of poor quality there are a number of artists still working in the traditional manner and these paintings are well worth collecting. How then should one judge a thangka and determine its age? Observation and common sense are the key. Quality is the all important factor.

If one refers to the description of the process of making thangkas given above, and bear this in mind, judging becomes easier. Modern thangkas are made using modern materials. Thus the natural pigments used on the old paintings have given way to modern chemical substitutes. These are generally harsher in hue and do not have the subtle range of the old paints. These also behave differently. It must be remembered, however, that

artificial pigments have been in use now for a number of decades. The ground on which the thangka has been painted also differs— in many cases an artificial and inferior substitute has been used. This is invariably inflexible and sometimes flakes off the canvas taking the pigment with it. So, we have ground and pigments. Next we have the actual composition itself. In the old and traditional method, the thangka was either drawn free hand or reporduced from a perforated paper stencil. Today some are screen printed, either in outline only or even entirely in colour. This last variety if well done can be extremely convincing and misleading. Some paintings were also done using an outline printed by wood-blocks.

Many thangkas are enhanced by the addition of details and outlines of gold. In old examples this is real gold, in modern examples it is metallic paint. Next we come to the mounts. Thangkas are made to be hung for display and rolled up when not in use. This was achieved, we have seen, by mounting the painting on fabric banners with a rod top and bottom. Fine examples had an additional protective covering of fine yellow silk gossamer, which hung down in front of the painting when it was not being viewed. This was gathered up and draped over the top when the painting was viewed. Two additional strips of brocade hung in front of this covering, an echo back to the days when the thangkas were part of the religious equipment of travelling monasteries. They are known as *lung non* or wind holders, and were originally intended to tie the thangkas to the walls of tents to protect them from the wind. Most modern thangkas are badly mounted and do not have these refinements. They may also not have the border and 'door' mentioned earlier.

Because of their very nature the brocade mountings often required to be replaced, thus it is not possible to judge the age of the painting by the condition of its mount. Sometimes it is possible, however, to detect the tell-tale rows of needle holes on a thangka that has been remounted a number of times. Beware of thangkas that have been mounted onto the brocade by sewing machine! Many poor examples of modern thangkas are mounted

in Indian and Nepalese synthetic fabrics in harsh and brash colours that would never have been used by the traditional thangka maker.

Then we come to the painting itself. Here observation is all important. Observe the way the faces have been drawn, the quality of the outlines of the hands and feet. Compare the quality of the outline and painting of the main subject with the subsidiary subjects and details. A good thangka is good all over with great attention being paid to detail. The criteria should really be is the thangka well painted, and not, is it old. If this is followed then one should not be disappointed. It is art not age that is sought.

Last but not least we come to the observer himself. He should always be dispassionate and detached, only then will a true and accurate appraisal be made. If these rules are not followed, disaster most certainly will.

There are fine thangkas from all periods well worth collecting and these are the ones that should be sought out. They will not only satisfy as works of art but will undoubtedly prove to be excellent investments. For Tibet is dead in everything but name, and we can expect no more of her treasures to leave her borders. Thus, the few treasures that have left this mysterious land will be ever increasingly sought after.

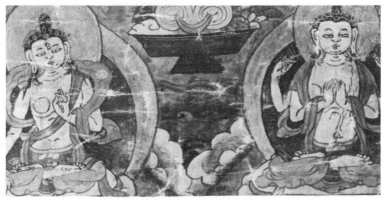

Detail of a Tibetan Thangka painting. 19th century.

11 *Chinese Scroll Paintings*

Chinese painting differs from European painting not only in technique but also in philosophy. In Europe painting was essentially realistic, and conditioned by materials, tended to be heavy. The European artist captured his subject on canvas, building up the painting layer by layer. His intention was to trick the viewer into thinking that the object or persons portrayed were real.

In China things were quite different, painting was light and airy, a fact again reflected in the materials which were ink and watercolour on paper or silk. Unlike his European counterpart the Chinese painter did not paint direct from life. His object was to convey his thoughts as an impresssion of the things he saw. His paintings were pictorial compositions which left out all irrelevant detail from the subject.

Nature was observed and real subjects portrayed, but everything was assimilated in the artist's mind and the painting mentally composed before he put brush to paper. Simplicity was the object, only essentials were included and even shadows were omitted. Thus the artist relied on purity of thought and line. The viewer is invited to travel through a Chinese painting from plane to plane, in what is virtually a theme from a scene.

The air of simplicity in Chinese paintings is quite deceptive as they required great skill and concentration to produce. The picture had to appear alive and not laboured. Additional

difficulties were made by the absorbent nature of the paper or silk which did not allow the artist mistakes or second thoughts. Thus the whole painting had to be clear in the artist's mind, a fact which perhaps explains why Chinese paintings appear so spontaneous and with certain exceptions, unlaboured. Chinese painting is in reality a visual experience of a national philosophy.

To really understand and appreciate Chinese painting we must go back to the days when it was in its infancy. It is essentially a development of calligraphy, for in China writing is done with a brush. Thus the brush is the common denominator, the link. Calligraphy was itself an art in China and was just as important as painting, possibly even more so.

Calligraphic art is often lost on the Western connoisseur, but once the subtleties of Chinese painting are understood, he may with practice be able to appreciate this allied art. Good calligraphy is like good painting. The strokes should be crisp, clean and full of spontaneous energy like the leaves of bamboo.

In the West little was known about Chinese painting until the second half of the 19th century. Even in China, scholarship was left to the traditional literary criticism of art, which, unfortunately, was often more interested in the painter's ideologies than in his work. Well documented and authenticated masterpieces were rare and those that did exist were usually in private collections and inaccessable for study. There was, however, no lack of collectors, who, it seems, were every ready to add their attributions (usually with little foundation) to paintings in their possession. Famous connoisseurs and critics would often add an inscription recording their approval of the painting or their conviction that it was by a particular artist or belonged to a certain period or school. It was also fashionable for collectors to add their own seal to a painting in much the same way as collectors added their mark to old master prints in Europe.

Chinese art dealers, too, were not averse to increasing the value of paintings by adding seals and signatures of popular artists, even to work obviously of later periods and styles. Vermilion seals of critics and former owners, together with their

Painting in the manner of Hsia-lo-shan-jen (Hua Yen) by Sun Yuan-mo. 1827.

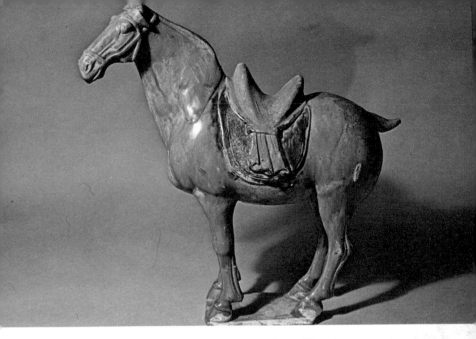

1. *Chinese pottery horse decorated with polychrome glazes. T'ang dynasty.*

2. *Chinese pottery globular urn, decorated with polychrome glazes. T'ang dynasty.*

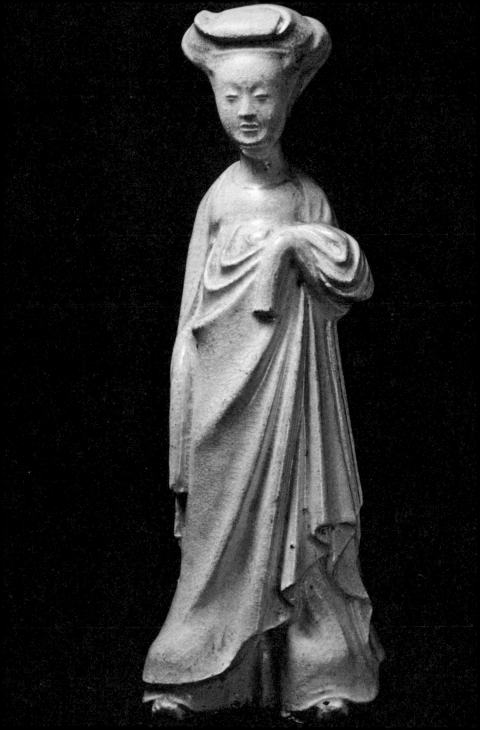

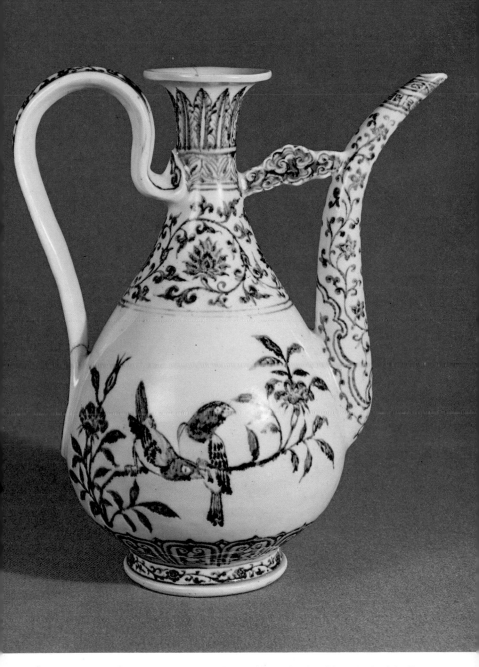

4. *Chinese Ming dynasty porcelain ewer, decorated in underglaze blue. Mark of the Emperor Hsuan Te.*

3. Opposite: *Chinese pottery white glazed figure of a woman. T'ang dynasty.*

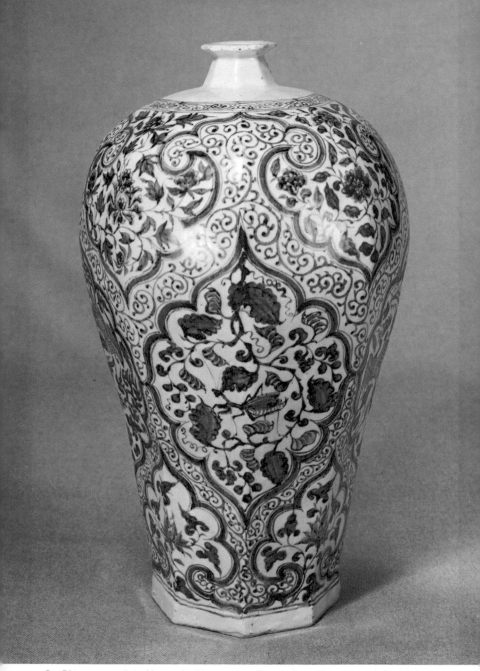

5. *Chinese porcelain blue and white octagonal vase. Second quarter of the 14th century.*

6. Opposite: *Chinese pear-shaped porcelain wine ewer, decorated in underglaze red. Mid 14th century.*

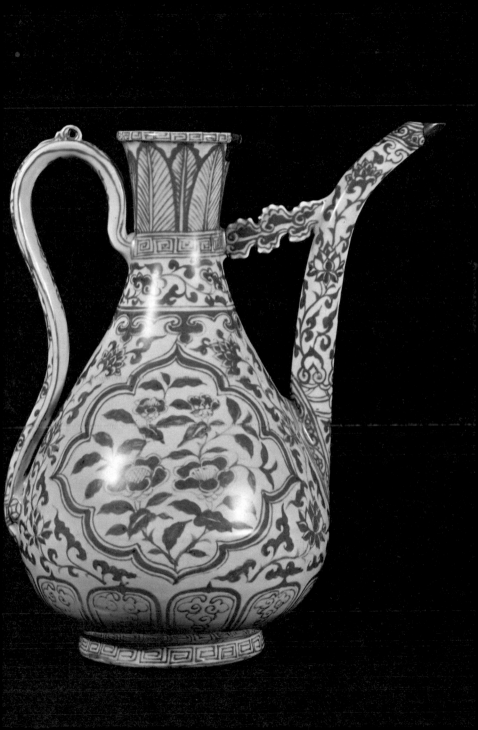

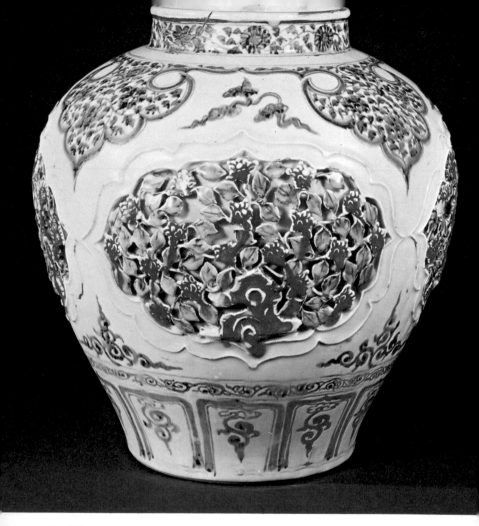

7. *Chinese porcelain wine jar decorated in red and blue. Mid 14th century.*

8. Opposite: *Chinese porcelain export-ware tankard. Ch'ien Lung. 18th century.*

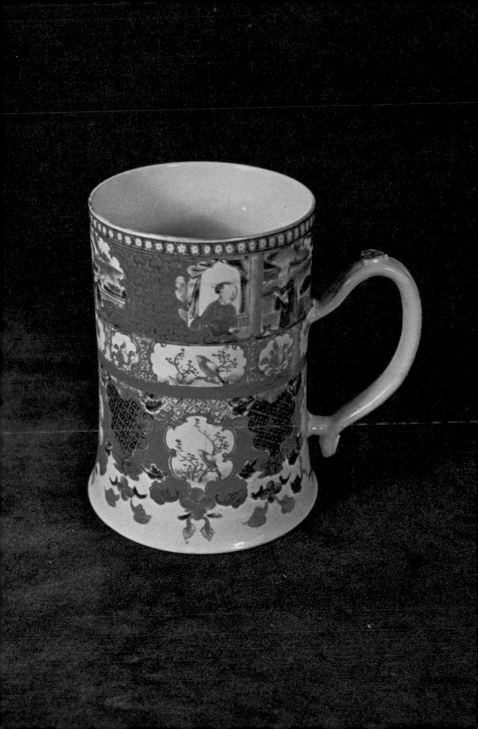

9. *Chinese porcelain*, Famille Rose *plate. Ch'ien Lung. 18th century.*

11. Opposite: *Japanese porcelain pear-shaped vase. 18th century.*

10. *Chinese porcelain plate decorated in multi-coloured glazes. K'ang Hsi. 17th century.*

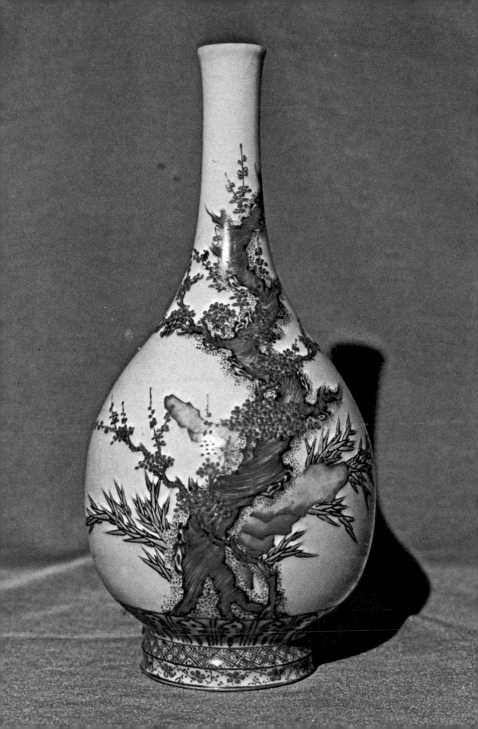

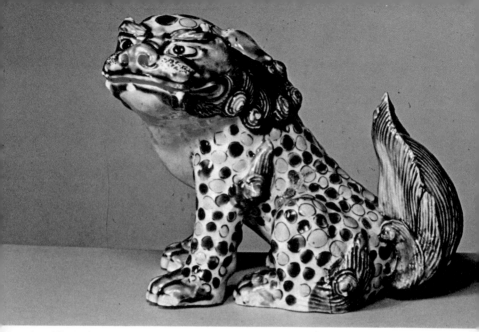

12. *Japanese porcelain figure of a lion, decorated in multi-coloured enamels. 18th century.*

16. Opposite below: *Detail of a Japanese late 19th-century plate.*

13. *Japanese porcelain tea-pot. Kakiemon style. Hizen-Arita. 1660–1680.*

14 *Japanese Kyoto-ware pot, 19th century,* 15 *Japanese pottery figure 19th century*

18. *Chinese lacquered wood figure of Pak-Toi, God of the North. 19th century.*

17. Opposite: *Detail from a Chinese Coromandel lacquer screen. 18th century.*

19. *Extremely fine and unusual early Chinese lacquer box.*

21. Opposite: *Japanese wooden lacquered theatrical mask. 19th century.*

20. *Japanese red and gold lacquer dish. 19th century.*

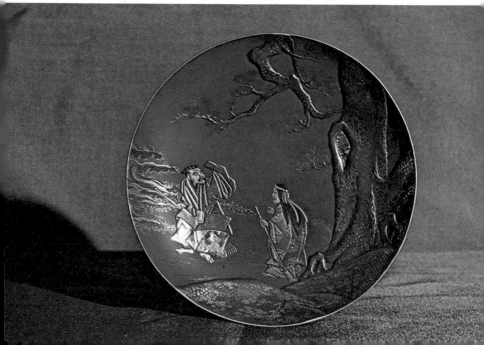

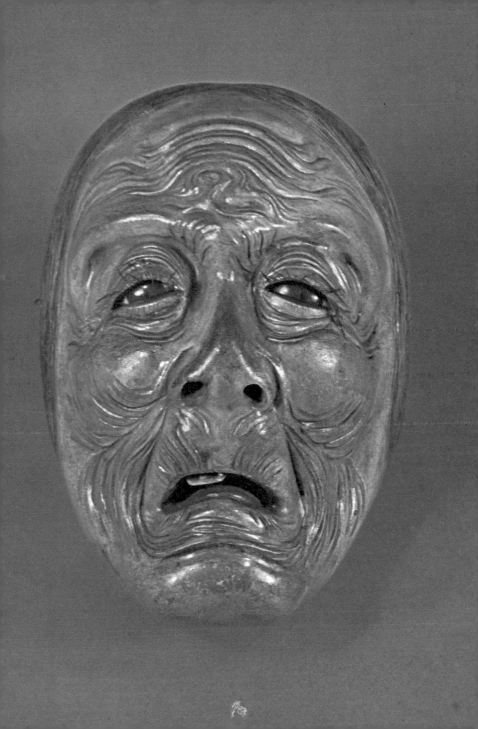

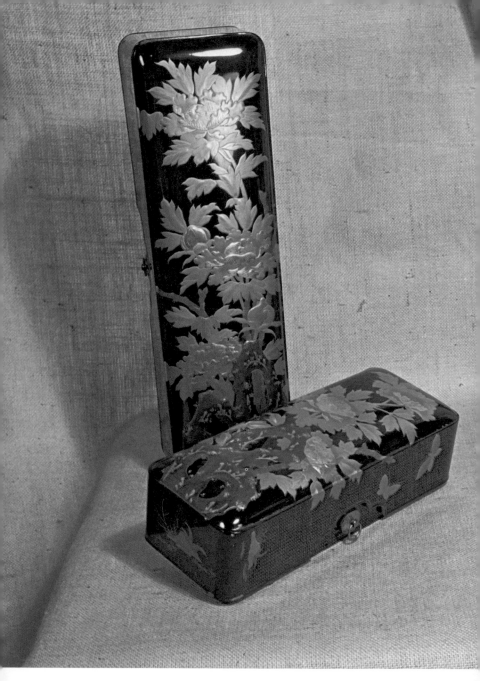

22. *Pair of Japanese lacquer document boxes, decorated in Toka-maki-e.*

23. Opposite: *Japanese gold lacquered wooden figure of Bodhisattva-Kannon. 18th century.*

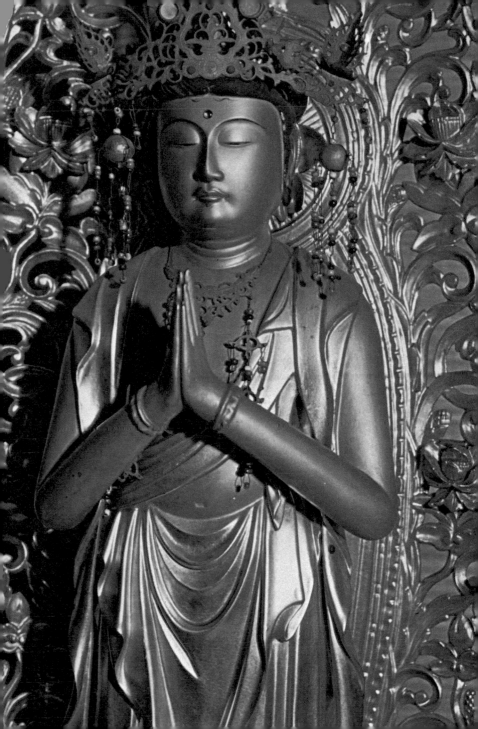

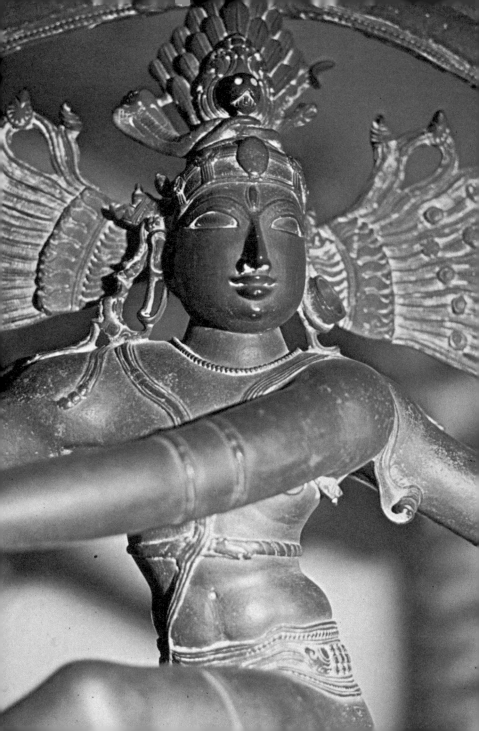

Indian bronze Vishnu. Pala, 10–11th century. 26. *E. Indian bronze Krishna. 17th century.*

24. Opposite: *Detail of Indian bronze Siva-Nataraja. Chola. 12th century.*

Indian Jungli bronze, 18th century. 28. *E. India Bronze Krishna. 18–19th century.*

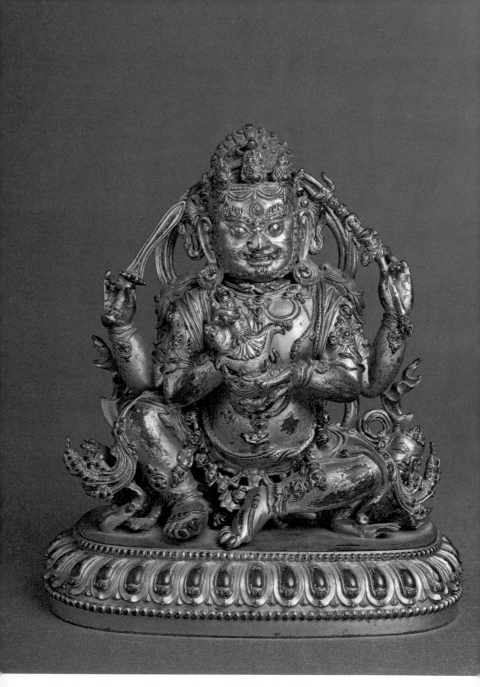

29. *Sino-Tibetan gilt-bronze figure of Mahakala. 15th century.*

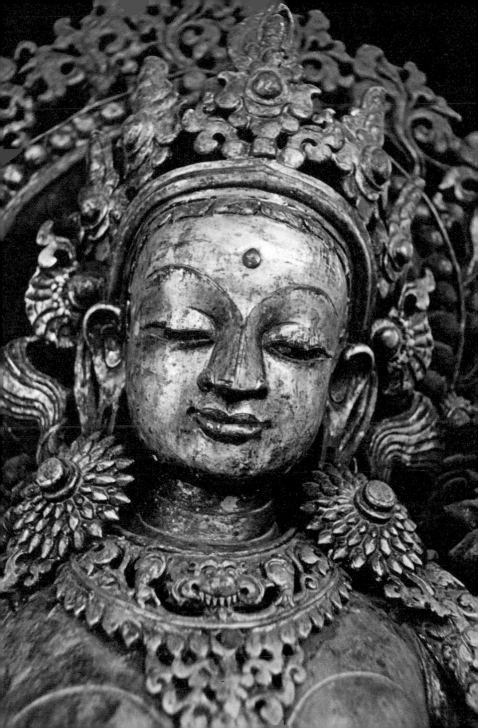

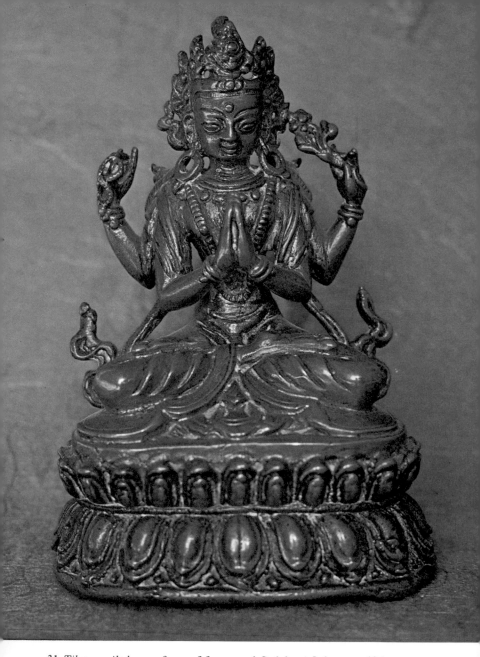

31. *Tibetan, gilt-bronze figure of four-armed Sadaksari-Lokesvara. 18th century.*

30. Previous page: *Detail of a large gilt-bronze figure of Tara. Nepal. 18th century.*

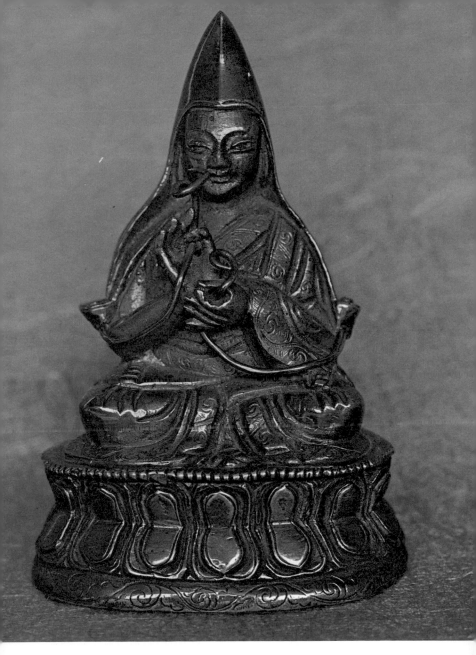

32. *Tibetan gilt-bronze lamaistic figure. 18–19th century.*

33. Overleaf: *Large Nepalese bronze figure of Garuda. 18th century.*

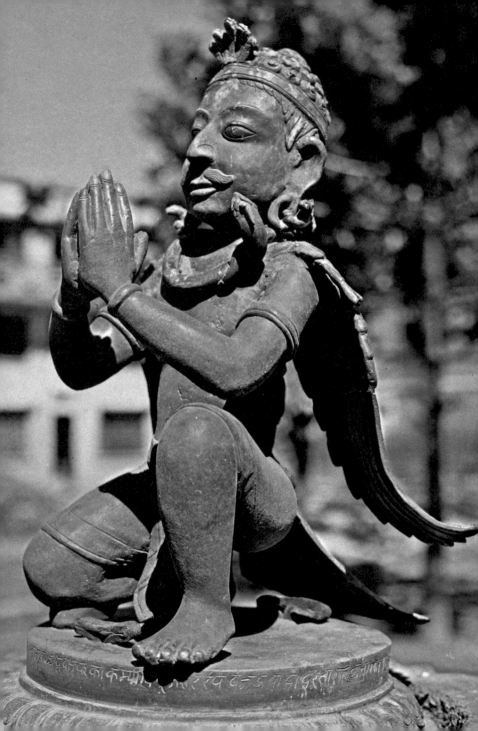

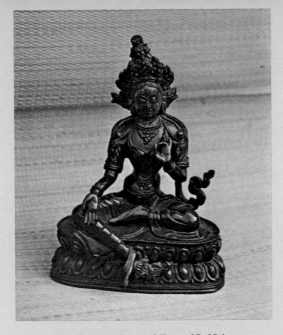

34. *Tibetan bronze figure of Tara. 17–18th century.*

35. *Tibetan copper and silver tea-pot. 19th century.*

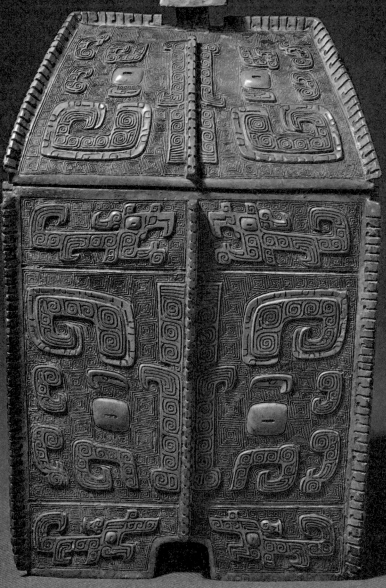

36. Previous page, left: *Chinese archaic bronze. Shang dynasty.*

37. Previous page, right: *Chinese bronze figure, Ming dynasty. 16th century.*

38. Below: *Chinese bronze figure of a mythical beast. 17th century.*

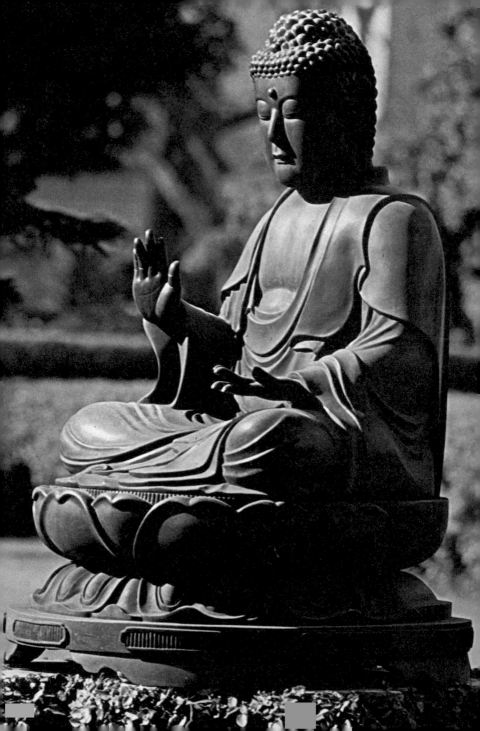

41. *Detail of an ornately decorated iron platter, by Komai. Japan, 19th century.*

42. *Japanese figure of a lion with gold eyes. 19th century.*

43. Right: *Fine Japanese gilt-metal shrine. Early 19th century.*

45. Opposite: *Moghul miniature painting of a youth. India, c. 1610.*

44. Below: *Fabulous silver and gilt elephant, set with semi-precious stones. The work of Komai. 19th century.*

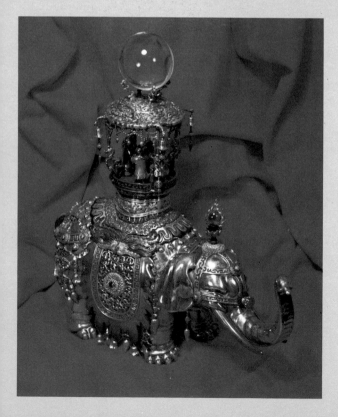

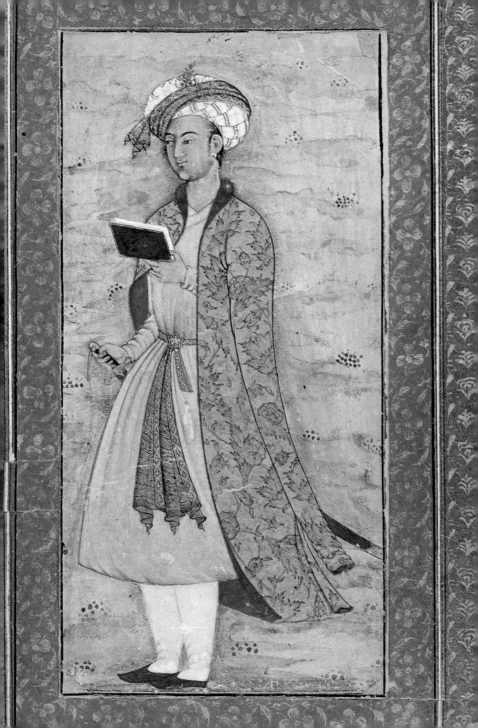

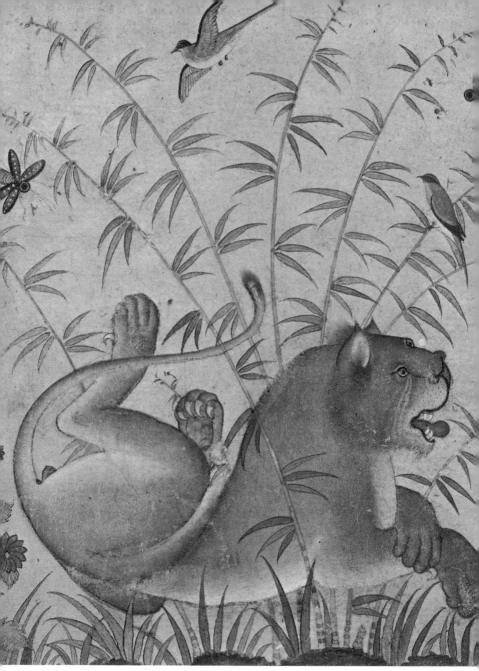

46. Above: *Mughul painting of a lion. India, c. 1620—30.*

47. Right: *Indian miniature painting of a tiger hunt. Mughul, (1580–90)*

48. Overleaf: *Mughul miniature painting of two elephants. Early 17th century.*

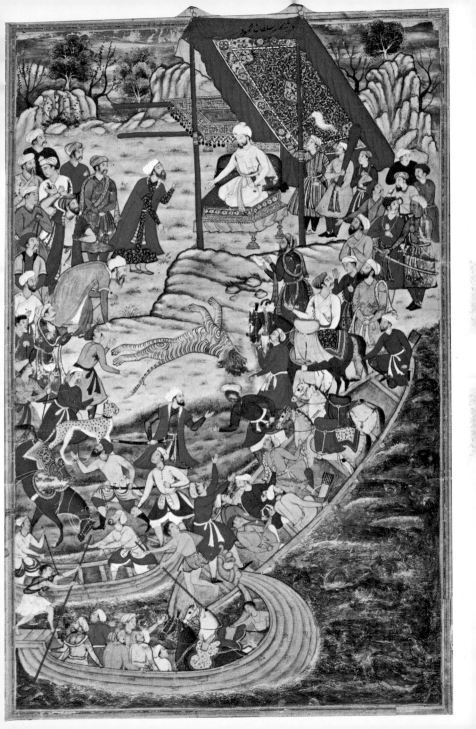

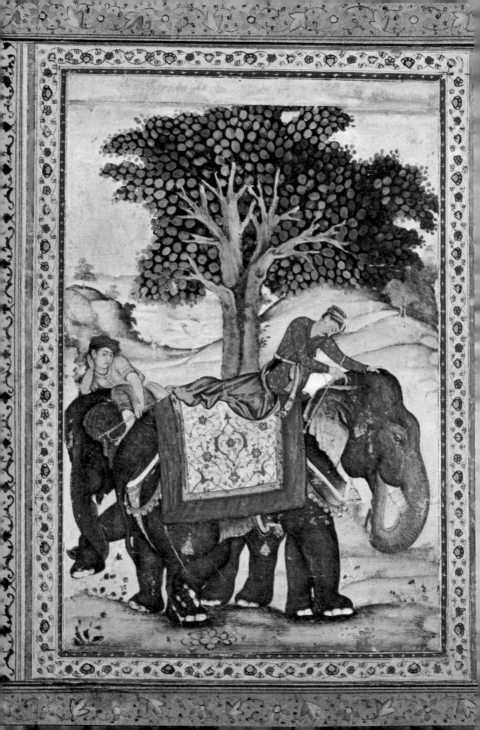

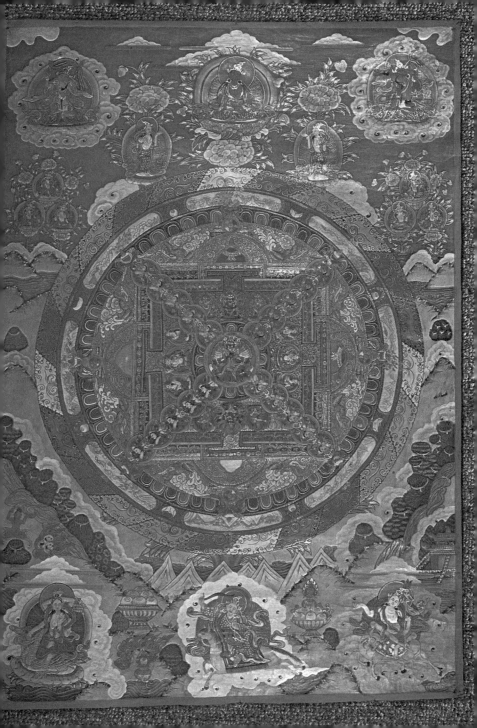

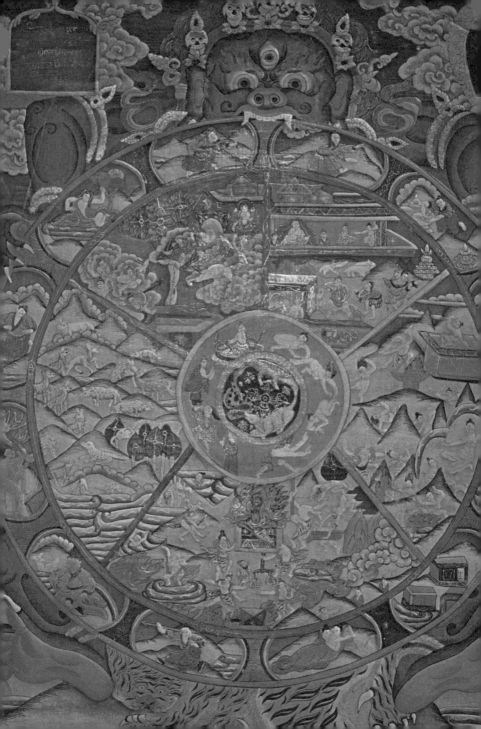

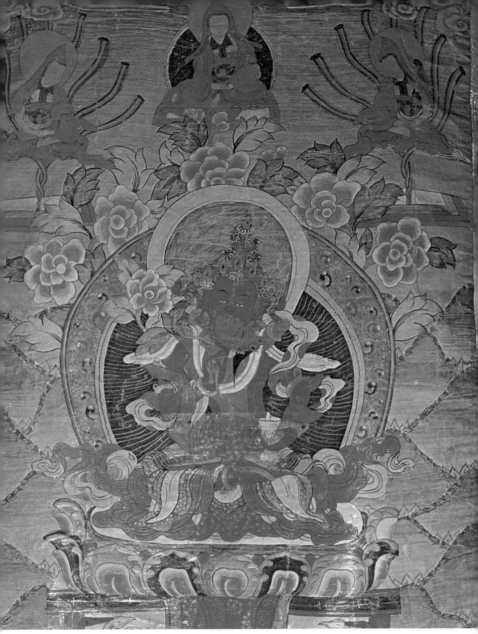

51. Above: *A Tibetan thangka painting showing a deity in Yab-Yum, 19th century.*

49. Previous page, right: *Tibetan Mandala thangka painting. 19th century.*

50. Opposite: *Large Nepalese thangka of the Wheel of Life.*

52. Overleaf, left: *Detail from a Tibetan thangka of the Wheel of Life. 19th century.*

53. Overleaf, right: *Nepalese thangka of Samvara in Yab-Yum. Early 20th century.*

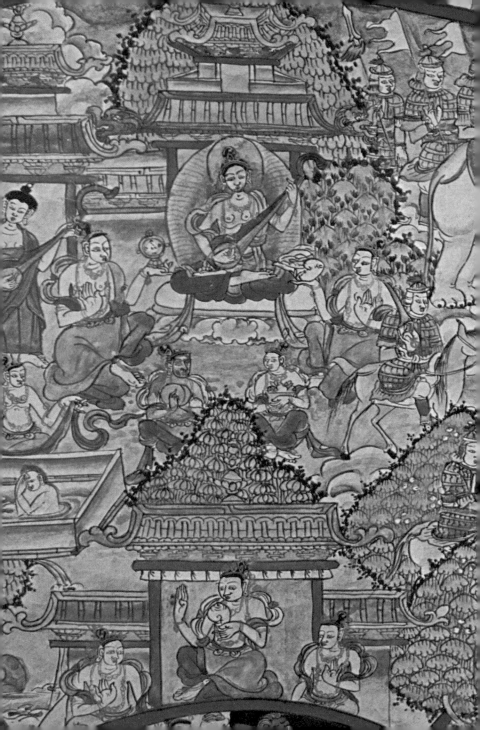

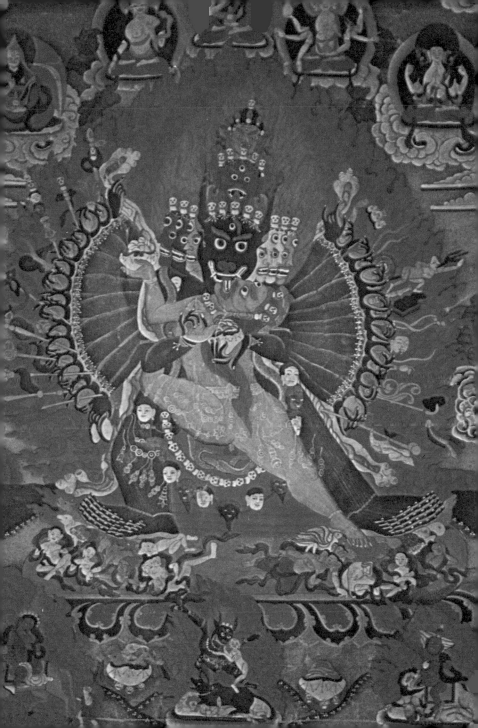

54. *Chinese landscape by Ma Yuan, (1190–1225).*

55. *Chinese painting showing Lohans and a Tantric deity. Ming dynasty.*

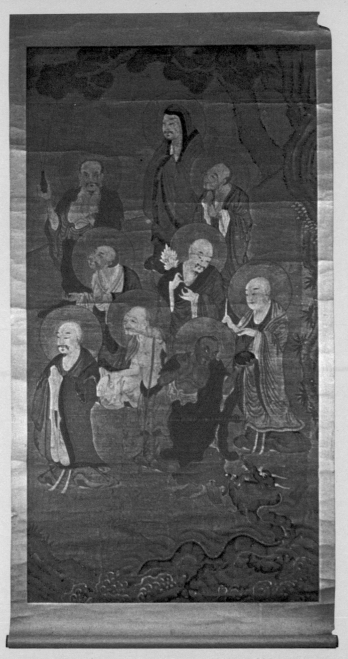

56. *Chinese hanging scroll painting of Lohans, 16th century.*

57. *Chinese hanging scroll painting of seeds beneath a rock, by Chu Ta, (1625–1700).*

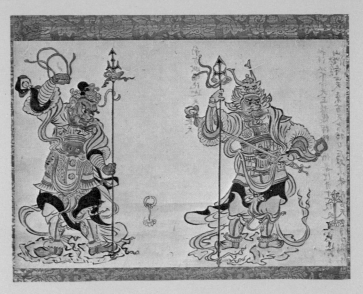

58. *Japanese ink and wash sketch of Ni Tenno, temple guardians. Late Kamakura period.*

59. *Japanese ink and wash painting of a landscape. Momoyama period.*

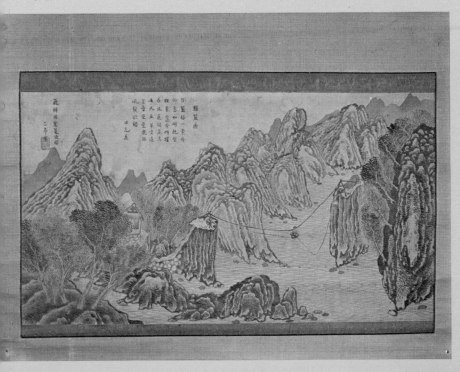

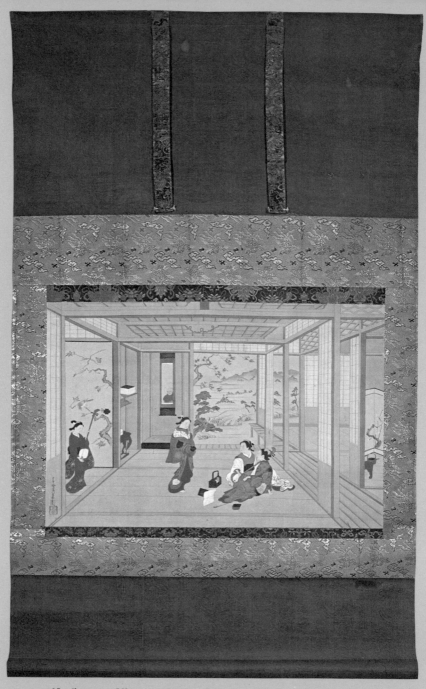

60. *Japanese Ukiyo-e painting of geishas in a room. Tokugawa period.*

61. *Japanese painting of a cat catching a bird. Early 19th century.*

62. *Detail of Japanese screen painting of a street scene in Kyoto. Momoyama period.*

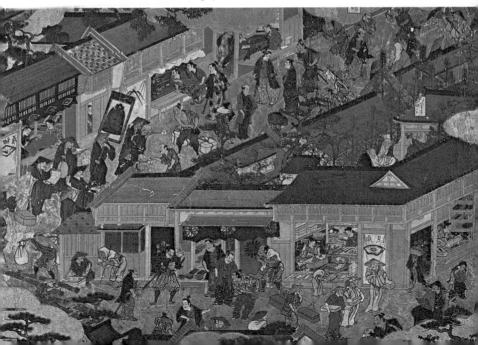

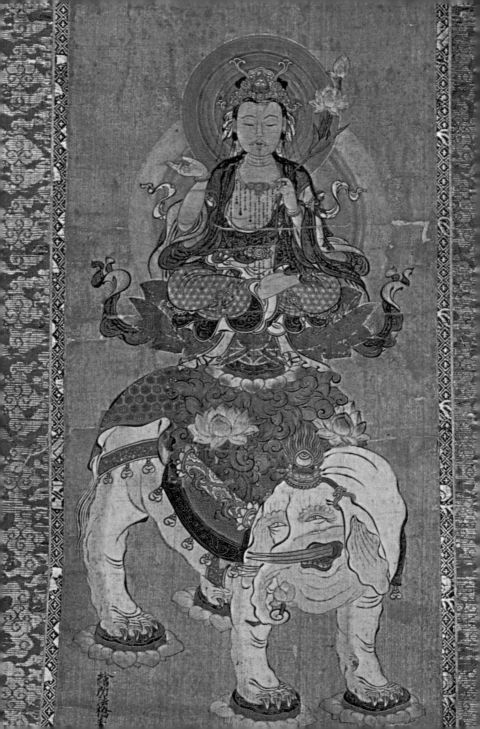

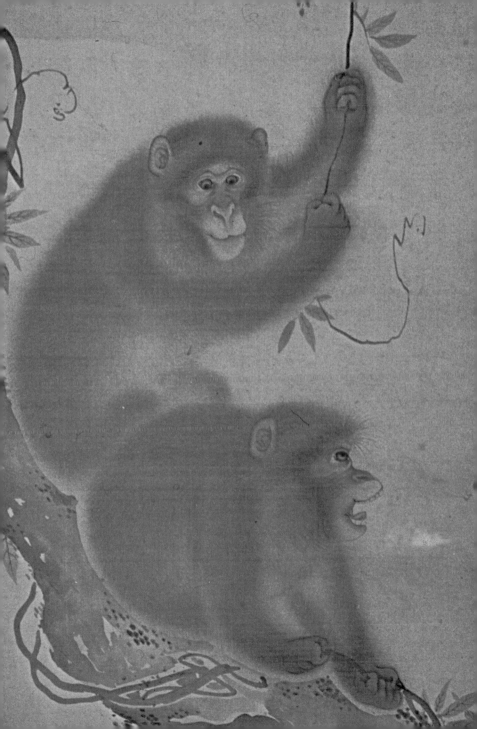

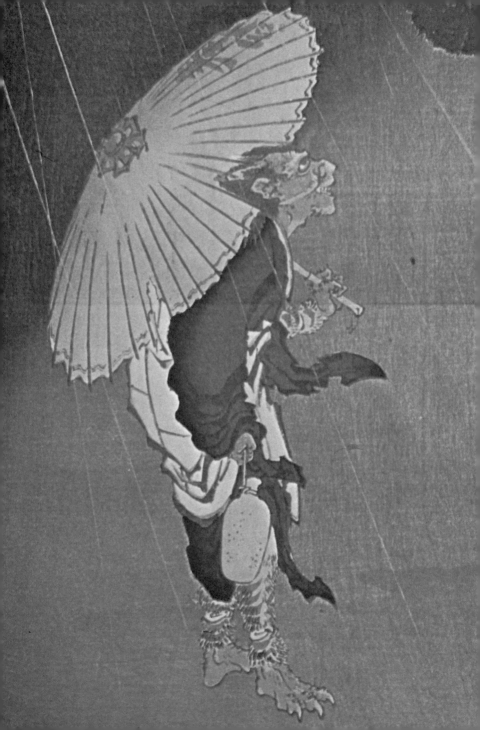

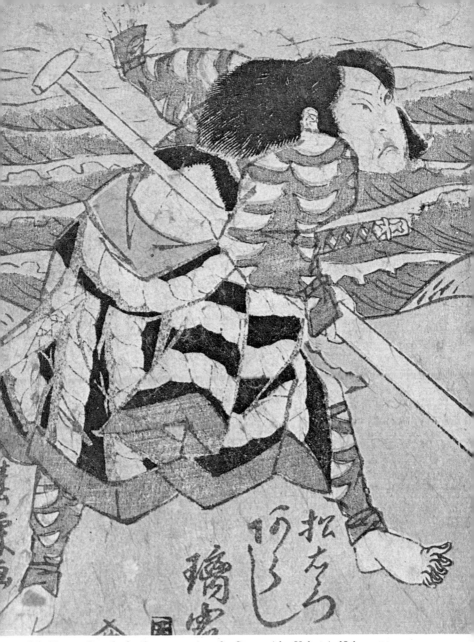

66. Above: *Detail of a Japanese print of a Samurai by Hokusai. 19th century.*

65. Left: *Unusual Japanese book print of a supernatural creature. 19th century.*

64. Previous page, right: *Detail of Japanese Kakemono of monkeys by Sosen. 18th century.*

63. Previous page, left: *A Japanese Buddhist Kakemono painting. Tokugawa period.*

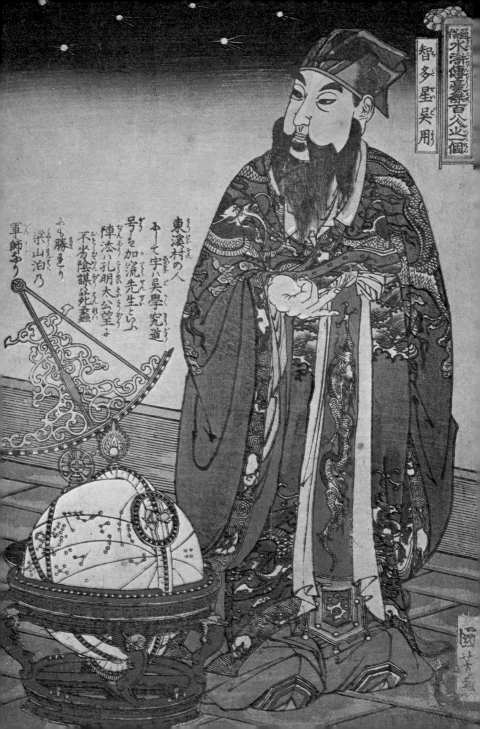

東溪村の人
にして宇ハ呉學究道
號をゝ加流先生とふ
陣添ハ孔明太公望よ
不乏陰謀ゝ死蟲
梁山泊乃
軍師ふり
ふも勝色り

68. *Detail of a Coromandel panel from a Chinese screen. 17th century.*

67. Left: *Japanese print by Kuniyoshi of Nan Huai-Jen (Ferdinand Verbiest), famous map-maker.*

70. *Japanese netsuke of a snake. 19th century.*

69. Left: *Japanese ivory netsuke of a dog.*

71. *Japanese ivory netsuke of a rat. 19th century.*

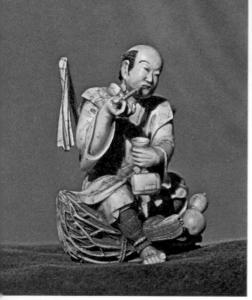

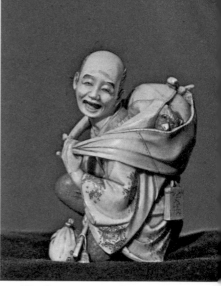

72. *Japanese ivory okimono. 19th century.* 73. *Japanese ivory okimono. 19th century*

75. Opposite: *The famous jade suit of the princess Tou Wan of the Han dynasty.*

74. *Japanese lacquer inros, one with a netsuke.*

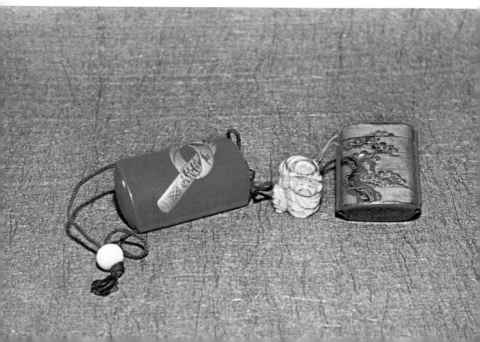

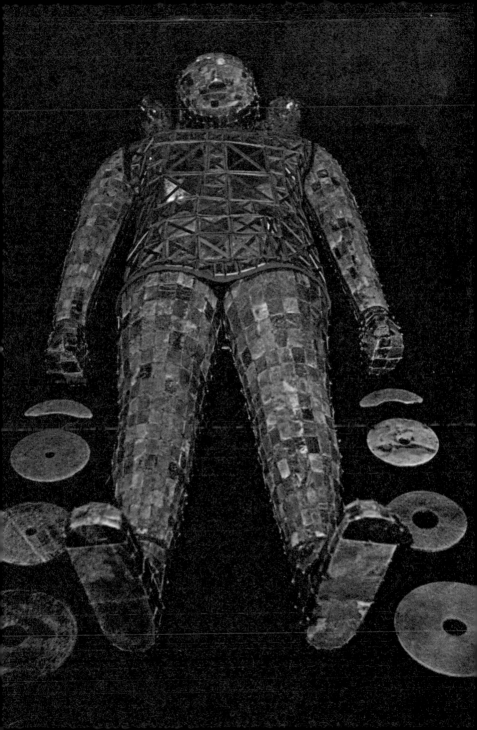

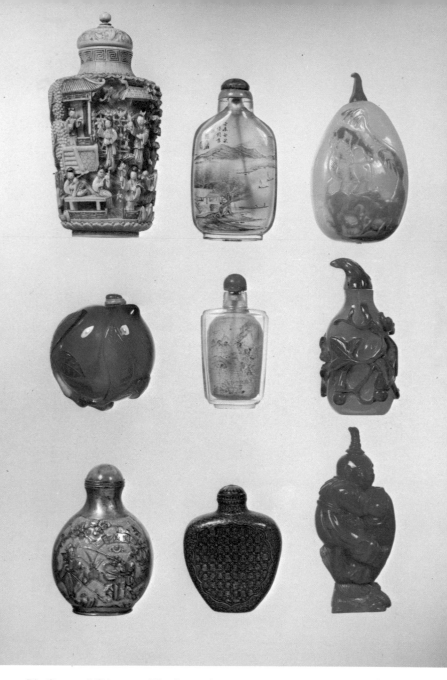

76. *Group of Chinese snuff bottles, made in ivory, glass, agate and cloisonné.*

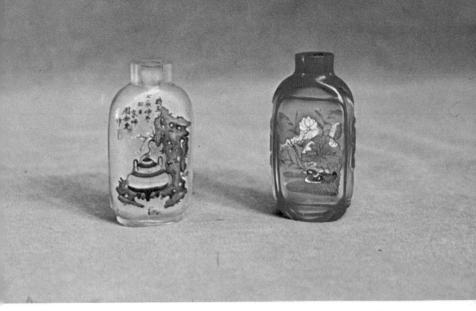

77. *A pair of Chinese glass snuff bottles with internal painted decoration. 19th century.*

78. *Carved glass snuff bottle. 19th century.*

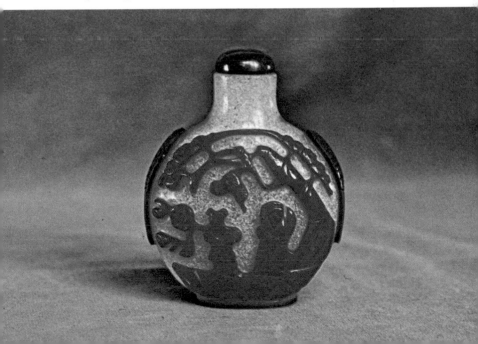

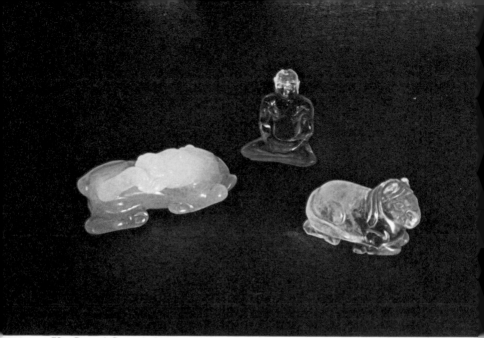

79. *Carved Crystal. Chinese, 19th century.*

81. Opposite: *Chinese soapstone figure of Kuan yin. 19th century.*

80. *Pair of Chinese soapstone figures. 19th century.*

82. *One of a pair of Chinese soapstone figures of the Dogs of Fo. 19th century.*
83. Opposite: *Chinese soapstone figure of Kwan Yu, with Chang Fei behind him holding books. 19th century.*

84. *A fake 'T'ang' horse being made in a factory in Hong Kong.*

85. Left: *Fake figures on the production line in Hong Kong fake factory and* right, (86) *awaiting distribution.*

testimonials are found on most old pictures, however they are of little use as forgeries exist of both paintings and seals. Attributions therefore that can be relied on are very rare indeed. None of the attributions on early paintings can be relied on with any degree of certainty.

Most scroll paintings that come the way of the collector are late in date, dating from the Ming dynasty onwards. The styles however, still reflect influence of the early schools and therefore may appear much earlier than they infact are.

The great tradition of Chinese landscape painting began in the Sung dynasty (AD 960–1280), Sung painting became the model and inspiration for all later landscape artists. Combining elements of both Taoism and Buddhism it provided the perfect medium of expression for neo-Confucianism expressing the natural laws of action and reaction. The importance of man in relation to nature and the relationship and unity between them were especially expressed in paintings of figures set in landscapes of mountains and streams.

Ma Yuan (active 1190–1225) was perhaps the greatest practitioner of this form of art. His lyrical and romantic interpretations of landscapes reflects his supreme mastery and skill of his medium. His paintings became models for later painters. Unfortunately in their effort to follow in his footsteps, they often accentuated the moods, producing paintings of extreme sentimentality, lacking all the elegance and strength of Ma Yuan's ideals.

Landscape painting also became a popular medium for the followers of Ch'an Buddhism, which in Japan was known as Zen. Ch'an had a profound effect on the art of the Sung dynasty. Ch'an teaches that enlightenment could not be obtained by gradual steps but was spontaneous. Thus all religious trappings, including iconographic paintings were brushed aside. This had a tremendous influence on painting for the teaching found its outlet in paintings of explosive simplicity. The essential element in the style was outward simplicity and speed of execution. Subjects chosen from all aspects of nature were painted with

spontaneous ingenuity. Pictures of unusual simplicity were painted, which have an air of spiritual truth showing that truth of enlightenment could be found even in the most humble subject. A more positive approach to nature developed towards the end of the succeeding Yuan period (1280–1368) when romanticism was replaced by a degree of realism.

Paintings of the Ming dynasty (1368–1643) are larger and grander and the colouring richer. The style is perhaps best described as baroque. Paintings of the period can be divided into the Southern and Northern schools. The bulk of surviving pictures belong to the so called Southern school, the painting of the Wen Jen Hua, the Literati, the non-professionals. The Northern school was mainly identified with the work of the professionals.

Painting during the Ming dynasty however was essentially the pursuit of the literati which included both the scholar-administrator class as well as the great landowners. The differnce between the two schools is not one of style but of snobbery. Difference between the styles is arbitrary and it is often difficult to distinguish between them. However it was said that the Southern school carried on the tradition of the early landscapists relying on the use of ink and atmospheric effects while the Northern school relied to a greater extent on colour and detail.

The Che school founded by Tai Chin (active 1446) and the school of Wu founded by Shen Chou (1427–1509) also originated during the Ming dynasty. The work of Tai Chin was greatly influenced by the Sung painter Ma Yuan.

The traditional style influenced by the work of the Sung and Yuan dynasties continued into the early part of the Ch'ing dynasty (1644–1912). The masters confined their work mainly to landscapes. Some paintings of the period lack some of the originality and quality of the earlier works but on the whole they are very skilfully executed. Some artists however, preferred other subjects to landscapes. Yun Shou-p'ing (1633-1690), a professional artist from a poor background, was such a painter.

A painting by Leng Mei of women spinning and weaving silk. 18th century.

His paintings show a superb sense of composition and colour which harmonise to make works of great beauty. His paintings of flowers and plants are detailed without giving the impression of botanical studies. They show a superb rhythmic quality of brushwork.

Other 'individualists', as they are sometimes called, were mostly Buddhist priests who painted in the Ch'an style. Their paintings, notable for their originality and spontaneity seem to explode on the paper. Space assumes an important role with only essentials being recorded.

Chu Ta (1625–1700) was a master of extreme simplicity. Painted with only a few well chosen strokes his paintings pulsate with energy and life. His subjects chosen from the world of animals, fishes and plants reflect his wit and vision. He also painted landscapes but they are generally on a larger scale than his nature subjects.

Tao-chi (1630–1714) was another individualist whose paintings are notable for their sense of vision and simplicity. Unlike Chu Ta he confined himself mainly to landscapes. His paintings however are unusual and his figures, when included in a scene, are always full of life and movement.

Traditional Buddhist subjects were also painted during the Ch'ing dynasty, by exponents such as K'un Ts'an (1625–1700).

Western influence began to be felt during the Ch'ing dynasty and can be seen in the technique and subject matter of some of the paintings. An attractive marriage of the two styles can be seen in the work of Leng Mei, who specialised in paintings of ladies of high station.

In a somewhat different vein are the portraits of ancestors. Though usually considered the work of artisans rather than painters, there are some paintings of considerable merit.

Numerous artists in all periods produced paintings both good and bad. Some as we have seen were traditionalists others were inovators; such was Kao Ch'i-p'ei (died 1734), who dissatisfied with the potential of the brush, became a superb exponent of finger-painting. It is impossible to enumerate all the styles and

name all the major artists, for even if we could, it would be of little help to the collector, as he will find works both by important and less important artists as well as by little known amateurs. He can arm himself with reference books on painters and their seals and signatures, but what he will need most of all is to develop his taste.

Most Chinese paintings will be in the form of hanging scrolls, though occasionally one comes across handscrolls. Framed paintings are generally glazed scrolls or sections of scrolls, for paintings were not meant to be framed.

To develop his knowledge of Chinese painting, the collector should try to see as many paintings in galleries, museums and other collections, as possible. The more he sees the more he will appreciate and understand, and gradually he will be able to distinguish the original idea from the hackneyed copy. As with all fields of painting he must trust in his own taste. He must decide what pleases him. Whether the spontaneous genius of a Ch'an painting or the quiet confidence of a traditional landscape or even a delicate illustration of nature, he will soon find that within his chosen field he will be able to distinguish the minor or major masters from the run of the mill.

Even the experienced collector needs help in such a specialist field, especially with attributions, so he should not be afraid to seek it. Museums with collections of Chinese paintings are always willing to help and give their opinions (but not valuations). Seek out the specialist collection from the general for unless the curator or keeper is a known orientalist he may not be able to help you. Specialists whether fellow collectors, curators or dealers are nearly always willing to help, eager to expand their own knowledge and experience.

Chinese scroll paintings are both beautiful and unusual and those who enter their world will find hours of pleasure awaiting them.

12 *Japanese Kakemono and Makimono*

Painting in Japan was strongly influenced by Chinese art trends though it soon established its own identity, adapting Chinese ideas to its own ends. Other influences, such as Buddhism, with its Indian and Central Asian overtones were transmitted to Japan by way of China. During the Asuka period (AD 552–645), painting was mainly religious and Buddhist in inspiration, but few examples have survived.

Chinese influence during the Nara period (AD 710–794) was very great indeed, and it is often difficult to distinguish between the paintings of the two countries. Little of the painting of the Nara period has survived. Even the fine murals in the Kondo at Horyu-ji were devastated by fire in 1949 and now only the excellent colour photographs taken shortly before the tragedy survive.

It is to the Nara period that we can ascribe the earliest scroll paintings. A number of fragments of e-makimono or handscrolls, illustrating the sutra of the past and present incarnations of Sakyamuni Buddha are preserved in collections in Japan. The fragments illustrate scenes from the life of the Buddha, with text written beneath. The colours are brilliant and the composition simple. The whole effect is one of unpretentious primitive charm. Several other paintings exist which help give us an idea of the art of the period.

The capital was moved from Nara to Heian-kyo, present day

Kyoto, at the beginning of the early Heian period (AD 794–897). The period is sometimes known as Konin (AD 810–823) or Jogan (AD 859–876). A number of new Buddhist sects came into being at this time, which had a profound effect on the art of painting. The simplicity of the early Buddhist art of Nara was superseded by an art strongly influenced by more elaborate iconographies of later forms of Mahayana Buddhism. Tendai was introduced by Dengo Daishi in AD 805 while Shingon was founded by Kobo Daishi in AD 806-7.

Followers of Tendai believed that Nirvana (enlightenment) could be obtained by good living, study of the scriptures and meditation, while Shingon was based on Indian tantric Buddhism with its mystic and esoteric rituals. Its origins can be traced back to the Vajrayana sect 'The Vehicle of the Thunderbolt', a combination of primitive cults and Buddhism, which had established itself in Eastern India in the 8th century AD. The doctrine was introduced into Tibet in the 11th century. Tantric doctrine is based on the worship of the female energy of the god (sakti) in conjunction with the male force. Tantric manifestations generally have multiple heads and arms. The iconography is very complicated

Kobo Daishi returned from China in AD 807 with the 'True Word' and set up his temple in a high forest in Wakayama province. Salvation was made easy for the layman, who only had to recite the public magic formulae, and was not troubled by the more mysterious and esoteric beliefs. The fearsome and awful aspects of Buddhism were emphasised in paintings and sculpture. Part of the ritual was secret and revealed only to initiates.

A popular form of painting used to express the complexities of existence as seen by the Tendai and Shingon faiths was the Mandara (Sanskrit-Mandala), a kind of magic circle diagram illustrating various beliefs of present and future lives. They were used in special rituals invoking deities to grant superhuman powers. Divided into geometrical sections, these charts contain deities placed in key positions, according to a magical pattern. Mandaras are more of interest for their fine execution and

draughtmanship than for their artistic merit. The art of Shingon Buddhism was severely restricted by iconographic canons, but Japanese artists overcame these difficulties far better than those of other countries who embraced tantric beliefs. Paintings other than mandaras were produced which show the true impact of Shingon Buddhism. The typical Japanese feeling of the Heian period has no contemporary Chinese parallels. The typical traits, first seen in the art of the early Heian period had an important effect on the art of later eras.

Although painting must have been the principal artistic outlet of the time, few paintings have survived. Literature tells us that secular painting continued probably in the T'ang style and gives us the names of two masters, Kudara no Kawanari and Kose no Kanaoka, but none of their work exists today.

By the Heian period proper (AD 897–1185), also known as the Fujiwara period, the esoteric forms of Buddhism had lost much of their attraction and the sect of Jodo devoted to the worship of Amida Buddha, Lord of Boundless Light, became popular. This simple form of Buddhism, first introduced in the Nara period made salvation easy by simply reciting the formula 'Namu Amida Butsu' and all would be forgiven, and the road to paradise secure. Jodo had a notable effect on art. Paintings were produced of Amida in various positions, sometimes alone other times attended by Bodhisattvas. A popular composition showed Amida, surrounded by his attendants, descending from heaven to receive his followers. Known as the Amida Raigo, a number of examples of the Heian period as well as the later Kamakura periods survive.

Towards the end of the Fujiwara (Heian) period, paintings were made depicting the Nirvana of Buddha or his emergence from the golden coffin. A form of decoration, kiri-kane, the using of thin lines of gold leaf, was sometimes employed on these works.

Secular paintings were also produced but it is difficult to date these with certainty. During the early Fujiwara period the painting appears to have been essentially Chinese in style (Kara-

e) but the end of the period heralded the introduction of Yamato-e, a distinctive Japanese style which was to flower during the succeeding Kamakura period.

Buddhism changed again during the Kamakura period (1185-1392), with the introduction of the Shingon and Nichiren sects, the change being reflected in the religious painting of the time. Paintings of Amida Buddha, however, continued to be produced. Secular art is by far the most important of the period. For the Yamato-e style blossomed and adapted and developed the Chinese idea of the handscroll into a distinct Japanese art form e-makimono.

Monogatari or story pictures were produced in e-makimono form, measuring on average 12-15 inches wide (30-37 cm) and between 35-40 feet (10.75 m-12.3 m) long. This format gave the artist tremendous freedom, allowing him to use every possible device to impart a sense of drama to the picture. Clever tricks were employed to take the viewer through the scroll from scene to scene; changing perspective, angles and close ups, and sometimes even removing walls and roofs to show action inside buildings. The effect is typically Japanese and although originally developed from a Chinese idea, they can in no way be compared with Chinese painting of the period. Unlike the Chinese artist, who was mainly attracted by the abstract and transcendental, the Japanese painter was concerned with humans and human events, whether humorous or tragic. It is this quality that often makes Japanese art easier for the Westerner to understand.

Early handscrolls had some of the scenes divided by areas of text, but later the text disappeared leaving only a continuous pictorial story. Perhaps the most dramatic scroll of the period is the Heiji-monogotari-emaki, depicting scenes of the Heiji war. Apart from monogotari, other forms of painting were produced during the period, including landscapes and genre scenes. Portraits were painted in a form known as chinso and subjects varied from warriors and priests to children.

Traditional Buddhist paintings continued to be produced and

while ideals of Zen Buddhism influenced some of the paintings it is mainly in the succeeding Ashikaga period, also known as the Muromachi period (1392–1573), that we see its full impact.

Ashikaga painting again becomes influenced by Chinese ideals, this time of the Sung and early Ming periods. Although the old colourful Japanese style fell out of fashion, paintings continued to be executed in the style by the Tosa school, especially scrolls with a narrative.

Zen Buddhism grew in popularity until in the 14th century it became a major stimulus to painting. Artists inspired by the teachings tried to convey the message of Zen through their paintings. Many artists of the period were in fact members of the Zen priesthood and were strongly influenced by Chinese Ch'an painting and techniques. Favourite subjects were hermits, arhats such as Hotei and portraits of Zen priests. Brushwork is extremely simple, the pictures being composed of wash and a few flowing lines.

The Ashikaga Shoguns were greatly attracted to the new styles and made collections of Chinese paintings, many of which served as models for Japanese artists. Landscapes were produced mostly in ink in the Chinese Sung and Yuan tradition, making it sometimes difficult to distinguish between Chinese and Japanese painting in the style. Perhaps the only distinguishing feature is the brushwork, which sometimes tends to be carefully arranged but lacks the originality of some of the Chinese prototypes. The landscapes too, tended to be Japanese idealised impressions of Chinese scenery. An exception to this was the work of Sesshu (1420–1506) who had been to China and had seen the landscape for himself first hand. His paintings were greatly valued in China as well as Japan. However, apart from painting typical Chinese landscapes in his own style, he is noted as the first Japanese artist who recognised the beauty of his own countryside and translated it into painting.

The atmospheric paintings of landscapes again suited the ideals of Zen teachings. One of the first artists to paint in the new style was Mincho (1352–1431). A member of the priesthood, his

works are in the traditional Sung manner, although with overtones of early Ming ideals. Another monk, Josetsu (active 1405–30), painted a masterpiece illustrating Zen doctrines. Many more works can be attributed to Josetsu's pupil, Shuban, who was active during the first half of the 15th century. He was strongly influenced by the 13th century Chinese painters, Hsia Kuei and Ma Yuan. Mist plays an important part in his pictures merging the foreground with the background, suggesting dream-like visions.

His pupil Sesshu (1420–1506) is considered one of the greatest of Japanese artists, certainly the greatest of the period. As mentioned earlier he travelled to China where he studied Chinese painting and observed the scenery first hand. Greatly influenced by what he had seen, he adapted Chinese techniques and evolved his own style, although he painted with a number of techniques.

His work was greatly admired in China and it is said that he was asked to paint a room in the palace at Peking. He was also offered the headship of a Chinese monastery. What may be said to be his greatest work was painted in 1486 at the age of 66. A landscape scroll it measured some 50 feet long (15.4 m) and portrays the countryside in different seasons. This superb work is in the Chinese style and would be hard to tell from a Chinese work were it not for his typical powerful brushwork notable for its thickening and accentuating lines which produced unique effects. In just a few explosive strokes he could create a landscape with misty mountains in the background and hut, trees and water in the foreground.

Detail from the Scroll of Courtiers. Attributed to Goshin. First half of 14th century.

The Japanese style of landscape first introduced by Sesshu was further developed by the artist Sesson (1504–1589). There were a number of imitators of Sesshu's style but the only artist who added something new was Sesson. His lively brush strokes could create a storm on paper.

So-ami (1472–1525) was the last of a family of artists called 'Ami'. His father Gei-ami (1431–1495) and his grandfather No-ami (1397–1471) were all painters in the Chinese tradition.

Towards the end of the Ashikaga period the influence of Zen declined and greater attention was paid to decorative pictures. This decorative aspect is hinted at in the paintings of So-ami, but becomes a major factor in the paintings of Kano Masanabo (1434–1530) and his son Kano Motonobu (1476–1559) founders of the Kano school. The Kano school continued well into the 19th century but had its heyday during the Momoyama and early Tokugawa periods. Yamato-e the traditional native style with its brilliant colours was kept alive by the Tosa school, the greatest exponent of which was Tosa Mitsunobu (1434–1525) who was master of painting at the Imperial court.

The decorative quality of works in the Kano style was to be recognised during the Momoyama period (1573–1615) when they were put to good use. Buddhism had declined and there was a marked increase in secular painting. During this period Japan was dominated by three military men, Oda Nobunaga (1534–1582), Toyotomi Hideyoshi (1536–1598) and Tokugawa Ieyasu (1542–1616), the founder of the Tokugawa Shogunate. Although it may seem strange, all were patrons of the arts and commissioned many works to decorate their castles.

Both of the Tosa and Kano styles were used in paintings, sometimes combined together. Wall paintings and screens in the large public rooms of the castles used bold colours, sometimes with gold backgrounds, while paintings for the private rooms were often in monochrome. The paintings for these castles were often massive. Kano Eitoku (1543–1590) grandson of Motonobu, painted many screens and pictures for Nobunaga as well as Hideyoshi and is said that because of their huge size he had to

paint some of the pictures with a large straw brush.

The climate was ripe for experimentation and invention and it is in this period that we can identify the essential Japanese quality that was to be so important in later years.

Kano Eitoku combined the colour of the Tosa pallette with the tradition of the Kano school to produce masterpieces of Japanese art. Although much of Eitoku's work has not survived, we know he produced works in the traditional ink style used by his grandfather, but they lacked originality. After his death in 1590, the Kano tradition was carried on by his adopted son Kano Sanraku (1559–1635) Although some of his work is more realistic than Eitoku's he also continued Eitoku's more abstract style.

Although the court was dominated by the Kano school other artists were also at work painting a number of styles. One such artist was Hosegawa Tohaku (1539–1610) His work is fascinating because of the skill with which he mixes the Chinese ink style with Japanese decorative ideas.

Japanese art received other influences during the period, this time from the West. The Japanese were fascinated by the Europeans and painted a number of screens depicting the everyday life of the foreigners in their settlements. These Namban Byobu, or screens depicting 'Southern Barbarians', as the Japanese called them are most attractive. Other subjects were also painted by artists of the Kano school but were unsigned as they thought them a lesser art.

Painting like the politics and economics of the country underwent a number of changes during the Tokugawa period (1615–1868) A new and extremely popular style was to be born which reflected the everyday life of the people. Called Ukiyo-e, 'Pictures of the Fleeting World', (see Chapter on Oriental Prints), it became the standard form of expression for another Japanese art form, the woodcut. However during the early days of the period the painting remained more in the Momoyana style.

Afraid of what they had heard about the foreign missionaries in China and the Philippines, the Tokugawa Shogunate banished Christianity and imposed an isolation policy which had a marked

effect on the arts. It lasted until the 19th century. The Togugawa Shoguns patronised the arts, supporting the Kano school a position the school was to hold until the end of the period.

The first painter of note working in the style during the early Tokugawa period was Kano Tanyu (1602–1674), Eitoku's grandson. His younger brother Kano Naonobu (1607–1650) produced works more characteristic of the Sung masters. His free flowing brushwork and superb use of tone produced works of great beauty.

Perhaps one of the greatest artists of the early Tokugawa period was Sotatsu (active 1596–1623) Strongly influenced by the colourful painting of the Tosa school he established a style of his own. The result was superb. All the ingredients were carefully thought out his clever use of space gives a misleading effect of simplicity, while his bright colouring creates an effect similar to that of Yamato-e with the overtones of Momoyama taste. His superb control of the brush was the crowning touch.

His successor was Ogata Korin (1658–1716). The son of a textile merchant he was forced by financial difficulties to become a professional painter. Apart from being familiar with the work of Sotatsu he was well versed in the other styles of the day all of which influenced him profoundly.

In spite of the Tokugawa Shogunate's isolation policy, some foreign influences did penetrate Japan, both Western and Chinese, probably by way of Nagasaki where there was a Dutch settlement as well as a few resident Chinese.

The Chinese Wen Jen style (Japan=Bun-Jin) of literati amateur painting was adopted by such painters as Ike no Taiga (1723–1776) and Yosa Busen (1716–1783). Here again we see a return to the Chinese style. Paintings in the Bun Jin style in Japan show strong elements of Sung and Ming techniques, though the Japanese brush style tends to come through stronger than ever leaving no doubt that the paintings in the style are Japanese.

Western influence can be seen in the work of Maruyama Okyo (1733–1795) whose naturalistic treatment however shows that although he may have been influenced by Western ideals of art,

174

Hanging scroll, depicting a peacock and peahen, by Muruyama Okyo (1733–1795). Colour on silk. Edo Period. 1776. Imperial Collection.

his treatment of his subjects remains essentially Japanese.

The art of genre painting which some Kano artists had practised during the Momoyama period, became a major art form during the Tokugawa period. The merchant class wanted a style of art which pleased them and which they understood. Gradually the style of the Ukiyo-e 'Pictures of the Fleeting World' was born. Elements of both the Kano and Tosa schools, together with inspiration from the established style of genre painting, were cleverly mixed together until finally a new art

form was created. One of the first artists to work in the style was Hishikawa Moronobu (c. 1625–1694).

Although the style was principally used for the production of coloured prints a number of very fine paintings were produced, sometimes by the print artists themselves (see Chapter on Oriental Prints). It is sufficient, however, to mention that paintings were produced in the style as well as the prints though in much smaller numbers.

Japanese painting continued to be a major art form long after painting had declined in China and there are many minor works of merit that were produced in Japan right up until the end of the 19th century.

Some collectors complain that they find it difficult to distinguish between Chinese and Japanese painting. While this may be excusable, in some circumstances if the collector looks for the points described above he should be able to tell the difference with ease. On the whole the Japanese artist was altogether more adventurous than his conservative Chinese colleague who preferred to use his skill and artistry within the limitations or accepted artistic canons, often producing masterpieces which themselves provided the inspiration and stimulation for the Japanese artist. As has been shown, the Japanese painter did not simply copy. He adapted and altered ideas with typical Japanese ingenuity, often adding original ideas of his own. In a general comparison between Japanese and Chinese painting it could be said that the Japanese has more individuality and is enhanced by the artist's superb sense of colour and form. The collector however must decide for himself his preference for a particular school or style.

As with Chinese paintings, there are a number of Japanese paintings in existence with most optimistic attributions. Later works and copies abound, and the collector will do well to seek advice in the beginning. As mentioned earlier, museums are most willing to help. When buying as with other categories of art, if the collector is unsure he should value as if the work was modern, and not over estimate age, rarity or value.

13 *Oriental Prints*

Recently the 500th anniversary of printing was celebrated in Britain. Excitement must have surrounded Caxton's first efforts at his press in 1476. The Chinese, however, would have regarded his efforts as unexciting, for they had been printing books including illustrated books for over 500 years.

At the very time Caxton was labouring over his first printing in Britain, printing in China was about to reach its zenith. Woodblock printing first appeared there in the middle of the T'ang dynasty (AD 618 906). The invention of paper in China in the first century BC no doubt had a great influence on the development of a printing technique, whereas paper did not make its appearance in the West until very much later.

Thus by about the 9th century, China had the technology to mass produce books. Until that time, books as in Europe had been handwritten copies, but with the advent of woodblock printing books ceased to be a luxury and were available to many more people—providing of course they could read.

Buddhism had perhaps its golden age during the T'ang dynasty so it was natural that the first books to be printed were Buddhist scriptures. Buddhist temples set up printing presses, hoping further to popularise the religion among all levels of society. Books were also sponsored by laymen, hoping to attain spiritual merit by their action.

Religious printing of this kind was carried on in this manner in

Tibet until recent times; and is still carried on by Lamaist monasteries in certain centres outside Tibet and in Nepal. Because of the high illiteracy rate, illustrations were included in the hope that the text could be read aloud by a monk scholar, while the lay public viewed the pictures.

Early this century a cache of early printed books and illustrations of this period were discovered by Sir Aurel Stein in Central Asia. These priceless relics of early printing were distributed between the British Museum and the Museum of Central Asian Antiquities, now part of the National Museum in New Delhi, and later a further selection went to the Louvre in Paris. The oldest example of a printed book illustration comes from this cache and is now in the British Museum. Printed in AD 868, it formed part of a scroll book of a Buddhist scripture—The Diamond Sutra. Others from the caves are dated 947 and 983.

Books at this time were in two forms: the horizontal scroll form as mentioned above and the sewn book form similar to modern day books. Illustrations were usually placed at the beginning of scroll books, while in the case of the sewn books they could be inserted in a number of places—at the top of the page, in the middle surrounded by the text, on the left with the text on the right or more popularly occupying pages placed irregularly throughout the book.

After the end of the T'ang dynasty, with its associated upheavals and unsettled times, printing declined and it was not until the Sung dynasty (960–1280) that book-printing again flourished, especially illustrated works. A wide selection of subjects were covered and illustrated; essays, poems, plays, educational instruction and the Confucian classics as well as a host of handicrafts, the sciences and technology.

These early books were first written by hand on thin paper which was then inverted and pasted onto wooden blocks and engraved. The illustrations were done in the same way and were usually the work of the same person. The Wen Jen or literati artists would not soil their hands on this low art and thus the field of book illustration was left mainly to the professional folk artist.

It is for this reason that early book illustrations offer such a refreshing change from the formal art of the period. The book illustrators were not great scholars, but relied on their vivid imagination to illustrate their subjects. This caused many errors both in period costume, objects and even landscapes.

Prints of this period have a simple freedom of line and subject. Attention was focused on the main subject only, minor details and subordinate figures were being neglected. The engraving was of very high standard. Later Chinese scholars described the engraving techniques of this period as 'a good horse running on the plain, a bat flying in the dark'.

There are two main reasons for the rapid growth of book illustrations during the Sung dynasty. One was the increase in popularity of story books and drama, popular mainly with the lower classes and country folk who demanded illustrated works. The other was the increase in the number of publishers who set up in business to try and satisfy this demand.

Book production, and likewise book illustrations, continued in the Sung style throughout the Yuan dynasty (1280–1368) then it flourished once more. The Ming dynasty could perhaps be described as the golden age of Chinese book illustration, especially the reign of the Emperor Wan-li.

The most popular works were again the novel and the play. Illustrative techniques at the beginning of the dynasty were similar to those of the Sung and Yuan periods, but these soon changed. In the early days, the illustration was mainly placed at the top of the page, but later, around 1522 expanded to occupy the entire page.

The style of the early Ming period was somewhat archaic and rigid, with little attention paid to facial expression. This, however, changed and by the reign of Wan-li, Chinese woodblock illustration reached its zenith. The rendering of the human figure had reached a point of such refinement that great delicacy could be conveyed by the engraver. Facial expression became a strong point of emphasis. The whole composition was carefully planned and detail carefully adhered to, even on

179

subordinate figures.

Book illustration became a highly specialised art in the Ming dynasty with many families founding their own distinctive schools of illustrations. Notable among these was the Fei School formed by the Huang family at Nanking. Prints were no longer the work of a single artisan, neither was designing them considered a lowly occupation and a number of painters turned their attention to illustrating books. Two of the greatest illustrated works of this period were *The Story of the West Chamber* and poems by the Warring States poet Ch'u Yun. Both were the work of Chen Hung-shou the painter and calligrapher.

After the close of the Ming dynasty and the introduction of censorship under the Manchu Ch'ing dynasty (1644–1912), Chinese book illustration declined with only occasional masterpieces appearing, such as the illustration for the novel *The Dream of the Red Chamber*. At the end of the Ming dynasty the true genius of the Oriental print passes to Japan where the technique of woodblock printing combined with the newly developed Ukiyo-e style of art to become one of the world's greatest art forms—the Japanese woodblock print.

While the oriental print had its infancy in China it blossomed in Japan. The generic term for the art of the Japanese woodcut is Ukiyo-e which means 'Pictures of the Floating World', a term which implies a view of the world about us, a generic term which is both apt and accurate. The style of Ukiyo-e first developed as a style of painting and it was only later that it became a major form of artistic expression for the print. It was a popular style designed to appeal to the low income urban masses and as such it can be in no way compared with the early artistic masterpieces of the philosophical classical schools. It has no great message and makes no lofty pretences but relies on the pun, analogy and parody to appeal. They are both amusing and visually attractive. They need no great knowledge to understand them, their appeal is quite straightforward.

The technique of printing developed early in Japan. It was similar to that of China where books were printed from

Right: An illustration in the Ch'ing dynasty style to the 'Dream of the Red Chamber', painted by Kai Ki.

Below: Extremely detailed illustration to 'The legend of Chao Si-liang'. Early Ming dynasty.

engraved blocks taken directly from pages of calligraphy. The wood-engraver, used to engraving pages of books, found it an easy matter to use his art in the production of the illustrative print. For Japanese painting is merely an extension of the art of the calligrapher.

The growth and popularity of the Ukiyo-e style was closely linked to the social and political development of the towns, especially to Edo where the style originated. In 1638 the ruling Tokugawa Shogunate imposed a policy of isolation on Japan, an act which resulted in the 18th century in great economic prosperity. The artisans, merchants and tradesmen of the new capital Edo enjoyed this new prosperity, living life to the full. They were a new urban clientele, and it was to satisfy them, to illustrate their books and decorate their homes that the colour print came into being.

The subjects of the colour prints were drawn from the life of the city and reflected the population's appetite for pleasure and the arts. Hence the names 'Pictures of the Floating World'. The new Ukiyo-e style, unlike that of the old art forms of the classical school was directed at the average man. This was reflected both aesthetically and in its price. The Japanese print then must be viewed as an art of mass appeal and must not be compared with the traditional schools even though one can see elements of both Kano and Tosa classical schools embodied in it.

Hishikawa Moronobu was the first to design prints in this style. The son of an embroiderer, he was born in the province of Awa some time between 1625–1640. His early years were spent following his father's trade but he later trained as a painter, studying both the Kano and Tosa styles. He was greatly influenced by Iwasa Matabei, who had founded the style of Ukiyo-e painting, but it was Moronobu's own style of Ukiyo-e which was to influence all later print designers.

He specialised at first in book illustrations later turning his attention to the Ichimai-e single sheet prints. These early prints were in black and white and known as sumi-e or ink pictures. His earliest signed and dated work is to be found in the Buke

Hyakunin Isshu published in 1672.

It was not until the year 1743 that two-colour printing was introduced. This important development was made possible by the introduction of a guide or registration mark, allowing two colours to be printed in register. Until this small but important development all prints were printed in black and white and any colouring was applied by hand.

The invention of colour printing was made quite independently at an earlier date in China. Some of these Chinese prints must certainly have reached Japan some fifty years before colour printing took place there.

Once the Japanese had opened the world of colour they introduced a number of other important innovations which were not adopted in China. Some of these were made by Okumura Masanobu (1686–1764) one of the first artists to design two colour prints. He developed uki-e art, perspective books and urishi-e or lacquered prints. Full colour printing was the invention of the prolific Suzuki Harunobu (d. 1770) he introduced what he called nishikie or brocade prints in 1764.

In the hundred years between the invention of colour printing by Suzuki Horonobu and the death of Utagawa Kunisada in 1864 the Japanese colour print bloomed, wilted and died. Numerous artists produced a multitude of prints of all descriptions, sizes and subjects which were constantly being modified to meet the ever changing fashions and individual needs. Prints were produced as kakemono, scrolls made to hang in the *tokonoma* or quiet corner. Makemono, or prints mounted on a horizontal hand scroll were also occasionally produced. Diptych and triptych prints i.e. prints in sets of two or three were also made for hanging as well as for mounting in books. Hashirakake or 'pillar hanging' prints were popularly used for decorating the wooden pillars in Chinese houses. Some of the finest prints were produced in this format by artists such as Harunobu, Koryusai, Utamaro and Toyohiro.

Some of the most attractive and interesting Japanese prints are classed under the term surimono or 'printed things'. In other words printed ephemera. These were usually small in size and

designed to be used for a variety of purposes such as advertisements, greetings and announcements of various kinds. The artists Hokusai and Shunman were experts in this field.

The subjects of the Ukiyo-e print were numerous, influenced by the individual artist's preference of format and his personal style. Generally the subject reflected the gay life of the citizens of Edo (present day Tokyo), they show their pleasure parties, the Kabuki theatre with its actors, courtesans and the Yoshiwara or brothel quarter with its 'Green Houses' and their inmates. Other subjects were generally inspired from nature although not taken directly, these include landscapes, lake scenes and pictures of flowers and birds.

Perhaps the largest number of prints that have survived are all pictures of courtesans and of the inmates of 'Green Houses'. Many prints and books of these subjects are entitled *'Pleasures of Edo'*. Shunga or erotic prints were also published in large numbers. Many of these still survive although they are not usually exhibited in museums but are available for inspection in the reserve collections. Production of shunga prints was discouraged by the authorities, but only half heartedly, as they were extremely popular with most of the well known artists, making their contribution to the field. For this reason they are well worth saving, although many are crude, some are masterpieces of sheer brilliance. Kitagawa Utamaro (1753–1806), also famous for his prints of Yoshiwira women, designed some of the finest works in this genre.

Actors of the Kabuki theatre played an important part as subject matter for the Ukiyo-e prints. Numerous books and prints were published portraying actors in popular rolls and scenes. It is an interesting fact that some of the female beauties of the Japanese print are in fact male actors in female roles. Portrayal of the actor was all important, little attention being paid to the scenery. Among the masters in this field of the Japanese print were Utagawa Toyokuni (1769–1825), Kiyonobu, Kiyonaga, Shunsho, Sunko and Kunisada.

Toshusai Sharaku also produced actor prints but his work must

be treated separately from these. His prints are quite unique, full of life and energy; his dynamic quality, characterisation and colouring distinguishing his work from all others. Unfortunately we know little about this great artist as his life is shrouded in mystery. His whole artistic production took place in one year, 1794. Apparently without previous training he produced a series of over one hundred actor prints, after which he disappears from the scene. Thus both his work and his life remain an enigma.

Landscape and bird and flower prints provide a superb outlet for the Japanese love of nature. These exquisite pictures are full of feeling and colour. Masters in this field were Katsushika Hokusai (1760–1849) and Ando Hiroshige (1797–1858). Another was Utamaro who in 1788 published a fine set of prints on insects. Hokusai produced a number of landscape works after 1820, including the famous *36 Views of Edo, 36 Views of Fuji, 8 Views of Lake Omi* and so on. He was also an exponent of kacho-e.

Landscape by Hiroshige, from the series 'Edo Kinko hakkei' c. 1840.

Landscapes and heroic prints were always popular in Japan but received an additional stimulus in 1842 when an edict was issued prohibiting the publication of prints of actors and courtesans. With this prohibition much of the energy channelled into actor prints was diverted into the production of prints of artistic and legendery scenes and heroic battles. Some of the greatest compositions in this field were made by the master Kuniyoshi. These prints make a strong contrast to the peaceful scenes and landscapes.

Japanese prints are emblazened with the names of artists, some famous, some less so, some of whom have already been mentioned. Kunisada and Utagawa Kuniyoshi (1797–1861) both students of Toyokuni are less well known and they have occasionally been strongly criticised by some writers. Both, however, have recently become more valuable and acceptable and both are now well worth collecting.

The Japanese print had become degenerate by the middle of the 19th Century. It was being produced on a mass scale and quality was being sacrificed to quantity. Vast numbers were produced for a growing uncritical public. After the death of Hokusai the fate of the Ukiyo-e print was left in the hands of Hiroshige, Kunisada and Kuniyoshi.

The son of a Kyoto dyed goods merchant, Kuniyoshi was born in the capital Edo, he received his diploma in 1818. Noted for their dramatic quality, his Japanese prints are fantastic compositions of heroic exploits and battles. They are milestones in the history of the Ukiyo-e print. Apart from his battle sequence he also attempted prints of actors but they were unsuccessful and unpopular. One of his early successes, published in 1827, was his *Heroes of the Sukoden*. Following the success of this work he produced his masterly melodramatic set of prints entitled *One Hundred and Eight Heroes*.

His ten prints illustrating scenes from the life of the Buddhist Saint Nichiren can also be considered amongst his finest work. The success of his heroic scenes often overshadow his work in the field of landscapes, a subject which he regrettably neglected,

leaving us few examples. His fine treatment of landscapes can often be seen in many heroic scenes. Edo produced many great artists. Kunisada was born there in 1786, his real name was Sumida Shozo. He studied with Toyokuni but left his studio in 1806. In 1844 at the anniversary of Toyokuni's death and with the approval of Toyokuni's relatives he succeeded to his title. Thus Kunisada's prints can be seen signed with the name Toyokuni as well as his own name (early prints). His work can usually be distinguished from that of Toyokuni by the fact that Kunisada usually signed within a red cartouche which Toyokuni never did. His prints cover many subjects but he specialised in theatrical prints.

His landscapes were extremely fine and some show a real talent which is not obvious in the greater part of his prolific output. Prints of this period were often badly printed and his are no exception. However, some of his work is very fine indeed with superb printing and colouring. He sometimes collaborated with other artists such as Hiroshige. He must be considered one of the great masters of the Japanese colour print.

There are many reasons for the decline of the Ukiyo-e print during the 19th Century and some have been mentioned. The cause, however, is unimportant what is important is the fact that Kunisada represents the final period, at least for the collector. Prints made in the middle of the 19th century are generally not as fine as earlier prints, however, it would be wrong to dismiss all the works of this period as of inferior quality.

Kunisada's death in 1864 also marked the demise of the Japanese print. After the country was opened to foreigners in 1868 a mass of foreign innovations flooded into the country. The pupils of the great masters lacking vitality and imaginative ability were unable to deal with this and so the art died, drowned by Western technology. An attempt was made to revive the art in the latter part of the 19th century but it was unsuccessful. Engravers still had their skill, but the designers had lost their touch; the days of the oriental print had passed.

There is great potential in collecting Japanese prints for

although many by the great famous artists are difficult to obtain and therefore command quite a high price, the collector will be able to form a collection of prints by some of the lesser known artists at reasonable expense. The more expensive prints can be added as his experience (and his purse) grows. There are occasions when he will be able to obtain prints by Masters at bargain prices, but these will be very infrequent indeed. He must also beware for many so called 'originals' are in fact reproductions or intentional fakes. There are numerous fakes of Hokusai and Hiroshige, so be extra careful if offered one of these at a price well below their market value. Copies abound, sometimes made contemporarily or shortly after the original print and sometimes very much later. Impressions also are important as late impressions made after the block had begun to wear are worth less than a print made from the blocks when new. Occasionally the blocks were re-cut and comparison with known examples of an early print will expose them.

The collector should try and handle as many genuine prints as possible and acquaint himself with details of the paper quality, texture, size and of course the colour of the inks. Gradually he will build up his knowledge, which will be his best defence against buying a dud. Before buying any print examine it very carefully. Taste too, is important, for many designs of prints were produced during the late 19th century, which have very little or no merit. These should be avoided even if they are at a low price for a print without quality artistically is unlikely to rise in price. The best buy is always quality.

The collector will be able to use a number of things to identify his prints. The majority were signed (although this is only a guide and not a certainty) and he will be able to check this signature with specialist books on the subject. Prints were also impressed with such differences as censors and publishers marks, which can be dated in narrow margins. Finally, always make it a rule that unless absolutely sure of the authenticity of a print never pay more than you would for a modern print. In this way you will always get value for money.

14 Chinese and Japanese Maps

It is well known that the Chinese invented paper, gunpowder, paper money and a multitude of other things, and developed technology well in advance of the West. In fact it is amazing just how many things the Chinese did do before the West. There are, however, some things that were invented or developed either simultaneously or on parallel lines. Map making falls into the latter category. It is also an example of the two technologies and sciences verging, East and West, each affecting the other in a transmutation of ideas.

The printed map, so familiar in everyday life for practical purposes and to collectors for the beautiful and fine examples of antique cartography, is infact both Western and Eastern in origin. For the invention of both printing and paper is Chinese, while the use of a grid on which to base the map outline is common to both European and Chinese culture.

In the West, the pinnacle of early cartographic science was achieved by the Greek mathematician Ptolemy (c. A.D. 90–168). In his 'Cosmographia' or 'Geographia', circa A.D. 150, he set down his ideas for producing maps, constructed using mathematical principles, involving uniform projections, measured distances, and observed latitudes and longitudes. Positions and places were fixed by geographical co-ordinates. In China, the idea of using a rectangular grid on which to draw outlines of maps came into use at about the same time the Greek

geographers were developing the system of co-ordinates expounded by Ptolemy.

Although the use of Ptolemy's system for scientific cartography fell out of use in Europe, leaving it to be rediscovered in the 15th century, the use of the grid system continued in China and was never discarded or forgotten. Later in the 16th century, through the missionary activities of the Jesuits, the two systems came together.

In China, alongside the scientific grid system of map making, there existed a religious cosmography based on the Buddhist conception of the world. This religious cosmography was also present in Japan where its influence was perhaps even stronger.

The Chinese recognised the value of having an exact knowledge of the geography of the Empire early in their history. Maps were essential for the efficient running of the bureaucratic machine needed to run the country, centralised at the hub of a vast land. From the earliest times maps were recognised as essential for organising land ownership, political boundaries, tax gathering, transport, recording natural resources, and for planning defence against both human and natural agencies. Maps were also essential to the furtherance of trade with the 'Barbarian' world outside the Celestial Empire.

Early Chinese records indicate that the Chinese were making maps in the 5th century B.C. and probably a lot earlier. The *Yu Kung* (Tribute of Yu), part of the *Shu Ching*, the Classic of History, records the route taken by the mythical Emperor, The Great Yu, as he constructed Chinese topography. The text which records Yu's journey across the empty landscape, as he created rivers, mountains, and plains, is infact an extremely early economic geography of China, albeit primitive and crude. There are numerous early Chinese geographical texts which give us an interesting insight into the scope of the early maps. The *Shan Hai Ching* (The Book of Mountains and Seas), although published in the 3rd century A.D., contains information much older. It is valuable as it records a wide range of animals, plants and minerals. China's early recognition of the value of her

waterways for transport and irrigation over her vast land is indicated in the *Shui Ching* (the River Classic), of the 1st century B.C., which describes the courses of 137 rivers. It was greatly enlarged in the 6th century.

A remarkable feature of Chinese geographical tradition was the district gazetteer and topography. The tradition, which is present even today, can be traced back to the 4th century A.D. The unique wealth of geographic, economic and historic information is not equalled in any other culture.

The use of a grid for map making is first refered to in a biography of Chang Heng (1st century A.D.) in the History of the Later Han Dynasty. Chang, is also known for his work in astronomy and seismology. His idea of using a grid was elaborated and perfected by P'ei Hsiu (224–271 A.D.) who can perhaps be described as the Chinese Ptolemy.

There are many stories which tell how the Chinese adopted the grid for map making. One of them tells that at the suggestion of a sewing girl, Chang had one of his maps embroidered onto silk, and that when he saw the outline on the silken background, the intersecting lines of warp and weft gave him the idea of using a grid.

During the T'ang and Sung dynasties the art of map making continued to develop and it is to the Sung dynasty that we look for our earliest surviving example of Chinese cartography. Some of these early maps are remarkably accurate. Surprisingly one based on the geographical concepts of the *Yu Kung*, carved on a stone at Sian in A.D. 1137, shows the coastal outline and the course of the major rivers with astonishing accuracy.

The invention of printing early in Chinese history enabled easy duplication. The oldest printed map known dating about 1155, is that of West China included in the *Liu Chin T'u* (Illustrations of Objects mentioned in the Six Classics).

In Japan the earliest surviving maps date to about the 8th Century A.D. Drawn on hemp they relate to subjects such as reclaimed rice land. However, although map making is first documented in Japan in the 7th Century, maps dating earlier than

191

the 16th Century are rare. The first attempt at a general map of Japan appears to have been made shortly before the central government moved to Kyoto in A.D. 794. Evidence for this can be found in later copies of a primitive map of Japan, usually attributed to Gyogi-Bosatsu, a Buddhist priest. The map which was extremely crude and only designed to show the relationship of the provinces to the capital, continued to influence Japanese cartography until the mid 17th Century.

The Mongol Yuan dynasty can perhaps be labelled as the 'Golden Age' of Chinese traditional cartography. During this period China reached out from her shell, extending her influence to the very borders of Europe. During this period also, a number of epic voyages were made by Chinese travellers, a tradition that continued into the early Ming dynasty, when in 1405, the eunuch admiral Chenngho made his remarkable journey to the southern coast of Africa. Contacts with the West and especially with the Arabs gave the Chinese a new insight to the continents outside China. Travellers brought back new information about the world, information that was quickly utilised by Chinese cartographers. The great map of China and its surrounding countries, by Chu Ssu-pen, made between 1311–1320 became the model for future map making, and remained so until the 19th Century.

Chu Ssu-pen, was a geographer of great repute and skill. His work and map of China, although not surviving in its original form can be assessed from contemporary maps reproduced in the famous *Kuang-yu t'u* atlas. The atlas, first published in 1555 can perhaps be described as the apex of Chinese traditional cartography. Nearly thirty years after its publication Chinese and Western cartography were to meet in the person of Father Matteo Ricci.

Ricci, a Jesuit priest entered China at Macao in 1582. Although a priest by calling and a missionary by intent he was nevertheless an accomplished astronomer and geographer. Within only three years of being in China he made three terrestrial globes for Chinese friends 'entirely in their language and script'. Arriving

192

as he did in the late 16th Century he had no knowledge of the 'Golden Age' of Chinese cartography and greatly under-estimated Chinese scientific knowledge. He did not appreciate that Chinese world maps of the 15th Century and the regional maps of the 16th Century were in many ways far in advance of their European counterparts.

Shortly before 1584 Ricci produced his first Chinese map of the world, based on the European map that hung on the wall of his mission room. His maps completely changed the Chinese view of the world. The first known Chinese map to be based on Ricci's map of 1584 is an official map made for administration purposes. Engraved on wood by Lian Chou in 1593 this interesting Sino-centric map shows Canada and America as small islands along the borders. The practice of producing maps with China as the centre continued for some time and Liang Chou's map was used as a model for the next two hundred years. Like most foreign scholars who worked in China, Ricci was given a Chinese name, that of 'Hsi-ju', the scholar from the West.

Map from a Sino-Korean atlas circa 1800, and a fine example of a religious cosmology which flourished alongside the more scientific cartographic tradition. China is shown as a circle surrounded by fabulous seas and mythological countries, with many of the names coming from the Shan Hai Ching.

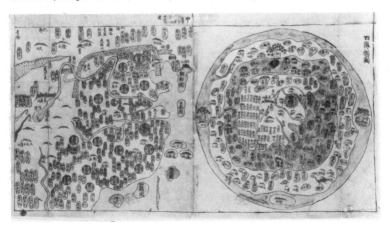

In the preface to the 1603 edition of Ricci's map, (the last and most detailed version) Ch'ang Yin-hsu writes 'As to foreign countries, those dealt with by the Department of Geography are only one hundreth of those on this map. The inclusion of all these countries further helps to enhance the size and extent of our Imperial maps'.

Among the successors to Ricci in China was Father Schall von Bell (in the 1630's) and Nan Huai-Jen, as the Chinese called Father Ferdinand Verbiest. It was Verbiest, who in the 1660's can be said to have brought Western mathmatics and astronomy to China. In 1669 he was given the job of supervising the removal of the old Yuan and Ming instruments from the Peking observatory and refurbishing it with new ones of European type.

The Chinese accepted all this new science and knowledge as 'universal' and not 'Christian' as the Fathers preached, and did not recognise the Fathers' claim that this knowledge was the natural outcome of Christian thought and civilisation. This led to dispute between the various catholic bodies and to the decline of interest in Western science, and eventually to the Fathers loss of Imperial favour.

In Japan, until 1542 knowledge of the world outside came only from China. The Japanese conception of world geography was a religious one based on Buddhism. This religious influence made them aware of the importance of India as the home of Buddhism. Thus the Sino-centric map was replaced in Japan by the Buddhist-centric map. The oldest such map, dating to about the 14th Century, is kept in the Horyu-ji temple at Nara. The map is inspired by the idea of the imaginary continent of Jambudvipa, which Buddhist texts assert is the whole inhabited world.

By the end of the 16th Century, Japan had been influenced in her ideas of the outside world by the visit of the Portuguese to Japan in 1542 and through trade with China when the Japanese first saw the maps and other geographical works of the Jesuits.

At the beginning of the 17th Century, the Japanese Tokugawa Shogunate, seeing the effect that Christian and foreign influence was having in China decided to ban all contact with the outside

world. Trade was restricted to the Chinese and Dutch at the port of Nagasaki and strict censorship imposed.

Ricci's world map of 1600 however escaped censorship and as it was in Chinese was easily understood. In fact from the mid 17th Century Ricci's map was to have a greater influence on Japanese than on Chinese map making. In 1605 his map was in use in the Academy of Princes in Kyoto and in 1645 it became the basis of the first world map to be printed in Japan, the *Bankoku Sozu* (Complete Map of the World). The map, which was accompanied by an illustrative sheet showing the different nationalities of the world, was published in numerous editions throughout the 18th Century. In the mid 18th Century, Yoshimune, the then shogun relaxed the ban on the importation of foreign books as he hoped that it would aid industrial progress in the country. The first cartographic inovation to result from this policy was the world map of 1792 by Shiba Kokan. Engraved on copper (which the Japanese learnt from Western books) it utilised stereographic projection in place of the oval projection used by Ricci.

In China, provincial and regional maps were well advanced by the 16th Century and continued to be made and improved as the centuries passed. In Japan however the story was different. Provincial map making of the early centuries was not at all advanced. This was recognised by the Tokugawa shogunate, who during the first hundred years of their rule sponsored three major cartographic projects. These included regional maps made on their orders by feudal lords of their territories, general maps made from the feudal territorial maps and *Genroku* maps, so called because they were made during the short Genroku period (1688–1703), These maps although greatly detailed are often distorted by decorative devices.

Among the early Japanese map makers may be mentioned Hojo Ujinaga who compiled a map of Japan at the scale of 1:432,000. His work was detailed but lacked popular appeal. Ishikawa Ryusen on the other hand produced colourful and decorative maps which achieved popular appeal but which are

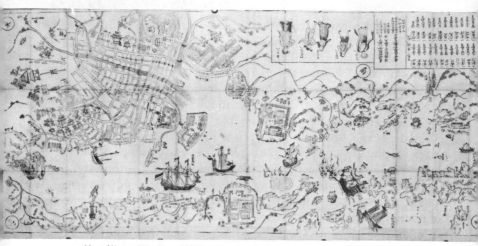

Map of Nagasaki harbour, 1680, woodcut, hand coloured, by an unknown cartographer. Decorated with ships and figures of foreigners and also a table of distances between Japan and various foreign countries. This map was brought back from Japan by a visiting German in the late 17th century, and was one of the first Japanese written materials to reach northern Europe.

often distorted, accuracy being sacrificed to decoration. His maps however retained their popularity for close on one hundred years.

A landmark in Japanese cartographic history was the publication; in 1779 of Sekisui's map of Japan, which discarded the decorative element and introduced for the first time the use of meridians and parallels. His style of map lasted until the 19th Century.

Chinese and Japanese maps can certainly compete with early European maps for their decorative quality and graphic appeal. In Japan, the Speeds and Saxtons were the artists of the *Ukiyo-e* wood block print such as Ishikawa Ryusen and his teacher Moronobu, Hokusai, Hiroshige and many others. Moronobu produced superb illustrations for the *Tokaido Bunken Ezu* the Measured Pictorial Map of the Eastern Highway published in 1690. Hokusai is noted for several panoramic maps. Although colour printing became fairly common by 1765, hand colouring was more common for map production. In colour printed maps

196

there could be as many as twelve wooden blocks. As the choice of colours was the publisher's, quite often the colour of the map would change from edition to edition. By 1772, the technique of graduation printing for shaded colours came into use.

In China, after the decline in favour of the Jesuit Fathers, the influence of Western cartographers slowly ebbed. Conservative scholars criticised Ricci's report of five continents as 'vague and fictitious' and Sino-centric maps continued to be produced. However the twain had met. European science had contributed to the Chinese knowledge of the earth and heavens and Chinese maps and geographical works had formed the basis of the new and vastly improved European maps of China. Thus East and West had met to the benefit of both worlds or should we say one.

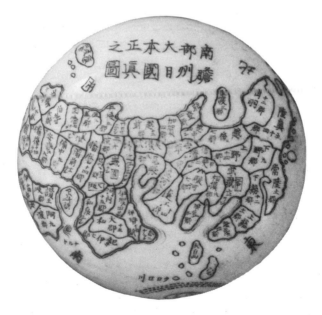

Map of Japan carved on a 19th century ivory netsuke or belt toggle. This netsuke is of the Manju type and is carved on two sections which are fitted together.

15 *Chinese Furniture*

The art of furniture making is essentially a functional craft. At its best it combines superb craftsmanship and design with a deep knowledge and feeling for wood. Furniture not only expresses fine applied art and technology but, as it is made to be used, it also reflects the social climate and surroundings of its immediate environment and time. For these reasons European furniture has long been the most popular with collectors, for, apart from availability, it fitted in well with European tastes in interior furnishings and decoration.

Chinese furniture, although extremely fine and well made, did not fit in—that is, with one exception; Coromandel lacquer. With changes in fashion and a return to simplicity in contemporary trends in architecture, increasing interest has been shown in the furniture of China and the Far East, with the result that it is now extremely sought after, both by collectors and interior decorators. Pieces can and do fetch hundreds of pounds, and sales at Sotheby's Belgravia which feature them are extremely popular and well-attended.

What then is the difference between the furniture of Europe and the Far East? On the face of it this is an easy question, which could provoke a superficial answer such as 'It is different in shape and style, wood and technique of joinery!' Such an answer is really only partial because Chinese furniture can be essentially simple in line or extremely baroque; it can be extremely

oriental, or because of Chippendale's attraction to some of the elements of Chinese furniture and his expression of them in his Chinese pieces, it can have 18th century European overtones and therefore not appear at all unusual to our European eyes. It can be extremely well made with superb wooden joints with no screws or nails, but can equally be made so appallingly, that in the 18th century some patrons of Coromandel furniture preferred to send European furniture to China to be lacquered, risking damage in transit, rather than accept the frequently shoddy workmanship which the Coromandel lacquer hid and which the Chinese chose to export to the European market.

The Chinese have been making furniture for centuries. Few examples of really early furniture survive and practically all our knowledge is derived from illustrated books and paintings and occasionally from archaeological remains. All these sources taken together do not amount to much and leave a great deal to be desired. We do know, however, that the art of furniture making developed very early in China. By the Han dynasty (206 BC–AD 220) several kinds were in use including tables, stools, and a kind of low platform called a k'ang, which was used for sleeping or reclining. The chair also made its appearance during the end of the dynasty.

Most furniture forms were well developed by the T'ang dynasty (AD 618–906) and continued in use with variations in style until the end of the Ch'ing dynasty in 1912. The finest surviving specimens of Chinese furniture were made between the late Ming dynasty in the 15th century and the early Ch'ing dynasty in the 18th century.

The Chinese are a conservative people and this conservatism is shown in their philosophy and arts. It is also reflected in their furniture. Thus, forms popular in the Ming and Ch'ing dynasties had their origins many centuries earlier.

By T'ang times furniture had been divided into the sumptuous and ornate, intended for use in the Imperial household, and the utilitarian, made to be used in the ordinary domestic households. Household furniture tended to be simple and restrained, while

Imperial furniture was by its very nature intended to impress and thus was massive and highly ornamented. This was especially true of late Imperial furniture. But whether Imperial or domestic, ancient or simply antique, the finest pieces of Chinese furniture are those of simple line and form with well matured, polished hardwood surfaces.

Chinese furniture differs radically from European furniture in the technique of joinery. Nails and dowels (with minor exceptions) are completely absent. The Chinese craftsman created his furniture using only mortice and tenons with a limited use of glue and occasional use of dovetailing. Dowels when present are generally an indication that a repair has been carried out at some time. Apart from making it possible to dismantle the furniture easily for transport, this non rigid method of joinery protected the furniture from movement that could arise when it was subjected to the acute changes in temperature and humidity which could occur in China.

Furniture was designed to lock together in such a way that the interlocking arrangement would not be visible, thereby preserving its line and balance. Large curved areas were generally carved out of one piece of wood, although it was perfectly in order to join. Joints when present were not hidden but simply designed to merge with the line and thereby not attract attention.

One of the beauties of Chinese furniture is the use of convex edges which complemented and accentuated the bevelled edges and beading when present. All rounded pieces were shaped by hand and not turned on a lathe.

A great deal of the appeal of Chinese furniture lies in the wood. A number of different woods were used, either on their own or combined together. Hardwood was employed rather than softwood, as it withstood the attention of termites. Most popular was rosewood, Pterocarpus indicus in its different varieties. An unusual wood also favoured was 'chicken wing wood', 'chi-ch'ih mu', identified as Cassia siamea and/or Ormosia. It has a well marked grain and is dark coffee colour but

when fresh is a shade of greyish brown. In addition to these, a number of other woods were used, indigenous as well as timber imported from South East Asia and Indonesia.

While hardwood furniture was popular in north China, south China, which was warmer, also favoured expendable furniture, such as that made from bamboo, which could be used outside the house. Lacquer furniture was also more popular in the south of China than in the north. One of the reasons for this was that lacquer was resistant to insect attack. A coating of lacquer was thought to afford even greater protection than the use of hardwood, which itself had a reputation for being virtually insect-proof. Insects were an ever present threat to fine furniture.

Lacquer furniture tended to follow the same shapes and lines as the hardwood furniture but was sometimes decorated with gilding, painting or inlay work with hardstones or mother of pearl. A superb example of red lacquered furniture is the throne of the Emperor Ch'ien Lung, now in the Victoria and Albert Museum, London.

Another kind of lacquer furniture and probably best known in Europe and America is Coromandel. This first made its appearance during the Ch'ing dynasty. Although named after a town in India it has to the best of our knowledge no connection with India and scholars have puzzled over the name. Furniture of various kinds was decorated with this lacquer, but screens were the most common, large numbers of which were exported to Europe.

The method of manufacture was different from traditional lacquer techniques. The base was made of ply, made from cloth sandwiched between thin layers of pinewood. Finely powdered slate was mixed with vegetable glue and applied to the surface of the cloth covered wood. After drying, the surface was levelled and smoothed with ash until a high sheen was obtained. The surface was then lacquered until the required thickness was achieved, usually about an eighth of an inch. The design was later cut into the lacquer, care being taken not to cut too deeply, lest

the wood be revealed. The design was then coloured with tempera (paint using egg yolks as a medium).

Panels of this product were fixed into lacquered frames to form screens or other furniture. Screens were decorated on only one side by this method; a simple painted design usually covered the other. The oldest specimens of this work date to the K'ang Hsi period (1662–1722). Later works have pieces of mother of pearl, jade and other hardstones, carved and applied to the lacquered surface. Screens imported into Britain were often cut up and used as decorative panels in cabinets or other furniture.

In the 18th century, owing to the increase in trade with India and the Orient, interest in Cathay ran high and chinoiserie was very popular. In furniture this influence was best expressed by Thomas Chippendale. The taste for Oriental designs had in fact begun at the Restoration court. Oriental imports—which included Coromandel lacquer—through the East India Company had helped create an enormous interest in, and demand for, objects with Oriental overtones. Coromandel lacquer was copied in England, but both the materials and the techniques used were different from those of the Chinese originals. The designs were copied from Chinese sources or taken from books of designs and were engraved on the prepared surface and coloured.

Lacquer with a design in relief (this was called 'Japanned') was most popular, especially with a red ground. Oriental designs for furniture were sent to China to be made, but although the lacquer was superior to the English, the joinery in many cases (as it was intended for export) was not, and English copies were eventually preferred to the Chinese originals. In spite of the risk of damage in transit, English cabinets were often sent to China for lacquering.

Many items of European furniture were paralleled in China but their form differs, influenced by Chinese ideas of formal interiors. Almost without exception Chinese furniture was intended to be arranged along the walls of a room. It was never angled out and only occasionally arranged at right angles to a wall, jutting out into the room. Arrangements tended to be

symetrical, horizontally as well as vertically. Chairs were
arranged in pairs, with a table between them. This arrangement
of a group of three could be repeated, forming a group of six and
so on. The table dividing the chairs was used for either holding
refreshments such as bowls of sweetmeats or for displaying a
work of art.

Chinese furniture shapes are generally difficult to describe in
relation to European forms and are best illustrated by
photographs. The range, however, is fairly wide. Chairs were
made with or without arms. Those with arms were generally
reserved for use by men. Decoration could take the form of
combinations of different woods, or occasionally of inlaid stone
slabs laid flush with the wood. This was employed either on the
seat or the back or on both. Occasionally the seat was inset flush
with cane matting. Stools were generally low and were often
used by women.

Rosewood altar table. Ch'ing, 18th century.

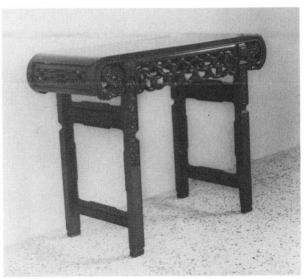

Dining rooms as such did not exist. Tables and chairs were set up in whatever room was favoured for the occasion. Tables were square or round and were never too large, as it was essential for all the diners to be able to serve themselves from the dishes arranged in the centre of the table.

Everything in the Chinese household was stored away from sight. Thus chests were made for storing clothes and cabinets or cupboards were made for writing. In addition to the dining tables and low tables employed in wall arrangements of chairs and tables, tall long narrow tables were used as altar tables in the household shrines. Side tables were also made as was a long low table intended for use on the k'ang. Beds with side panels and curtains were popular. Another item of Chinese furniture was the ch'uang or couch—a kind of double wooden seat resembling a throne. Among the household accessories may be mentioned tall circular tables, popular today as plant stands.

Early furniture, that is of the 18th and 19th centuries, tends to be of simple form, relying on the grain of the mature wood for effect, cabinets and similar pieces occasionally being highlighted with yellow brass fittings.

In the 19th century furniture tended to be highly carved and extremely ornate, almost to the point of vulgarity. The finest are without doubt the earlier pieces, and it is these that best fit in with the taste and fashions of today's interior decoration. From the point of view of investment, Chinese furniture is well worth collecting, for although no longer at the extremely low prices of a few years ago, it is, in comparison to European furniture of similar quality way under priced at present.

16 *Japanese Netsuke and Inro*

Two of the most admired and collected objects of Japanese art, are the netsuke and inro. Both are intimately connected as both are in fact costume accessories. The netsuke or belt toggle needs very little introduction as most collectors are familiar with these attractive little carvings in ivory, horn, wood and sometimes metal, which can be seen in museums and in antique shops. Inro (medicine and seal boxes) on the other hand are less familiar except to those who collect them or specialise in oriental art. The uninitiated collector may pass them by as just an attractive oriental box. In fact both netsuke and inro were a major outlet for the great masters of Japanese art, who regarded them as a useful medium for expressing their artistic genius. Both inro and netsuke then can be regarded as important forms of Japanese art, objects to be admired and collected.

Both inro and netsuke are important accessories to the Japanese dress. The use of belt toggles was common to many oriental countries where lack of pockets in the robe-like costumes necessitated the suspension of purses, knives, chopsticks etc. from the belt. In Japan, however, netsuke became an important item of dress and greatly elaborated. Inro and netsuke did not come into general use until the 16th century, a date which corresponds with the adoption of the kosode, a kind of kimono, as the popular form of costume. The kosode was originally an undergarment, but gradually over the years the many layers of

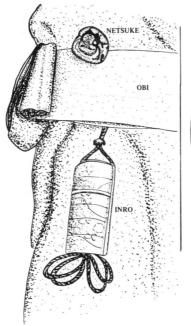

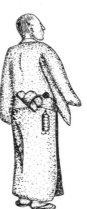

Sketch showing a Japanese
man wearing an obi with an
inro tucked under and secured
by a netsuke.

top clothes were discarded until in the Momoyama Period
(1573–1615) it became the principal mode of attire, regardless of
sex or social position. Unlike the earlier multi layers of dress
which hid the lines of the body, the kosode simply followed the
natural contours. Kosode literally means 'small sleeves' although
to a westerner they are anything but small, but compared to the
early Japanese costume with long flowing sleeves, they justify
the name.

Around the waist of the kosode was wound the obi, a band or
sash of textile up to 12″ in width and approximately 12 ft. in
length. The obi was usually made of beautifully woven textile
and tied as fashion dictated in a special manner. From the obi
various items of personal use were suspended by means of a silk

206

cord which was slipped under the obi so that the netsuke protruded above the sash. Inro, tobacco pouches, money pouches and even writing material were thus carried. The whole assemblage was known as the sagemono. In the absence of pockets in the costume the sagemono was essential to any active man.

The Japanese artist was at his best when he was working in miniature. He excelled in fitting compositions into confined spaces. The netsuke therefore was the perfect outlet for the Japanese genius.

Netsuke were made from all kinds of materials including porcelain, metal, antler and bone but the most common was wood and ivory. All kinds of wood were used both hard and soft, colourful and sweet smelling such as ebony, boxwood, yew, cherry and sandlewood. The variations in material for carving enabled the Japanese artist great freedom of imagination as well as an outlet for his inborn sense of humour.

There are few examples which date from before the 16th century, the majority dating to the 18th and 19th centuries. They come in a number of forms and in an infinite variety of subjects. Bun or manju netsuke are flat, round, sometimes quadrilateral and are usually hollow though they can be solid. They were made in two halves and when hollow were used to carry charms or similar articles. They generally do not date earlier than the 19th century. The ryusa was a variation of the manju but had deeper carving.

Also similar to the manju (lower half) was the kagamibuta or mirror-lid netsuke. These were hollow and were sometimes used to carry amulets or similar items. They had their openings closed by a decorated convex metal disc. Other forms of netsuke were the ichiraku, woven or plaited or the sashi which is characteristic by its long form.

Subjects were drawn from all sources, from nature, mythology and every day life. Religion, too, provided subjects such as the Bodhisattva Kanon, the Seven Gods of Good Fortune and other religious beings. The world of mythology was represented

by carvings of ghosts, oni or evil spirits depicted as grotesque creatures and animals such as the kirin or unicorn, dragons, phoenix, the minogame a supernatural tortoise with tail, and tengu, an aerial monster with the body of a man and a wing, claws and beak of a bird. Each subject provided the artist with a wonderful outlet for his superb sense of humour. It is this element of humour that makes the netsuke so attractive to the collector.

Dating netsuke can at times be a problem but subjects can often be a help. Generally speaking early pieces tend to be simple, elaboration only creeping in as time progressed. Subjects popular in the 18th century included signs of the Zodiac, mythological subjects such as the Seven Gods of Good Fortune, demons and oni and figures of poets and foreigners and representations of historical events and legends. Netsuke of the 19th century on the other hand are characterised by a preference for natural history subjects and every day life such as animals, birds, fruit and vegetables etc. These examples can of course only be a rough guide as there are numerous exceptions. The signature of the artist appear on some of the finer netsuke, but many fine works are unsigned. This is not because of the overwhelming modesty of the artist but because a large part of the output by artists and craftsmen were intended for their patron or lord and was thus generally unsigned, unlike the work which was executed by the artist in his own time or by independent artists—these were generally signed. The netsuke artist also carved okimono, a larger version of the netsuke, though intended for a completely different purpose. They embody the same wonderful sense of composition and were made principally as ornaments and were thus more highly prized in the West than in Japan. Many were made for export. The quality of export carvings was not usually as fine as those intended for the indigenous market. Subjects were similar to those used for netsuke.

As with most oriental antiques the collector of netsuke needs to be on guard for copies and forgeries. A common 'fake' are

small okimono's or fragments of ivory statuary that have had cord holes drilled in them to make them appear as netsuke. These can usually be detected by the fact that the composition is usually unbalanced or too big and that the cord holes show no sign of wear on the edges, which any Netsuke that has been used should have. The appearance of age was imparted by staining and cracks added by heating. Another embellishment was the addition of false inscriptions or signatures, a practice which was also carried out on genuine netsuke.

Modern fakes are produced by one or two methods. For the first, a block of ivory or even ivory coloured perspex is carved by a special machine which traces the exact contour of the original. The piece is then buffed and stained and finished by hand. The other method is to cast an original netsuke with resin and ivory powder. Observation is the collector's friend, for only if he uses his eyes and his hands, will he gain sufficient experience to be able to tell fake from genuine, good from bad.

The inro was next to netsuke in popularity. It was regarded by the upper classes as an essential accessory of dress and therefore something of a status symbol. Lavish attention was paid to the decoration of both netsuke and inro. During the end of the 17th century it became fashionable for merchants to wear kinchaku, elaborately decorated purses and tobacco pouches, in much the same way as the aristocrats wore inro.

The word inro literally means *in*—a seal, *ro*- a container or vessel. They developed from the need to carry a personal seal or chop and the red seal ink. The fashion for affixing a seal to a document or article came from China where it had long been in use as a substitute for a signature or as a means of signifying authority and authenticity of a document. Thus originally inro were made simply to hold the ingyo and inniku, the seal and ink.

Inro can be made in a variety of shapes, but the most common is that of an eliptical cylinder made in several sections which lock neatly into each other, one on top of the other. Down the sides of the cylinder a cord would pass through apertures in each segment securing it together. The cord was fastened at the bottom of the

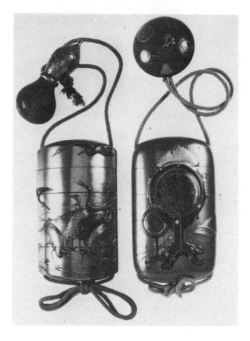

Right. Four-case inro, signed Jokosi with Kakihan, decorated in gold, black, red and silver Hiro-maki-e. 19th century.

inro, sometimes beneath the base, in an elaborate knot or in two knots at the base of the apertures of the lower section. At the top of the inro would be a length of cord to which was attached a netsuke. In between the top and the netsuke was a small bead called the ojime, which drew the two cords together increasing the tension and thereby securely holding the segments together. The netsuke and ojime were ornamented in a manner which would complement the beauty of the inro. Attaching the inro to the obi by means of a netsuke had the advantage that it could easily be removed for use and of course to show to admirers (remember it was an important vehicle for Japanese art). Although both men and women wore the kosade and obi, the use of inro was confined to men.

210

Inro were made in various shapes, eliptical cylinders, oval 'pebbles', oblong boxes and round discs. They could be long or short, thick or thin. The variety of form was only limited by the practicability of suspension on the costume and by the imagination of the Japanese artist.

Although at first used for carrying seals, the inro later became a container for powdered medicine, aromatic herbs, and other items. It was thus enlarged from the earlier three sections, which had been adequate for carrying seal and ink, to five or six sections. The number of sections must not, however, be used as a criteria of age as inro of varying numbers of sections were made over a number of years.

They were most commonly made in lacquer though other materials such as ivory, wood and even metal were occasionally used. Most popular and indeed most beautiful are those made of lacquer. All the great lacquer artists used inro as a means of displaying their talent.

A variety of different kinds of lacquer decoration was employed in their manufacture. Lacquer is to Japan what porcelain is to China and over the years ingeneous artists had developed different techniques used on inro, i.e. maki-e, a process whereby gold and silver dust was sprinkled over the object after the design had been drawn in lacquer on the surface. Togidashi-maki-e was a further development of this technique where the surface was afterwards covered with a thin layer of lacquer and polished until the gold showed through.

Sometimes pieces were enhanced with raden, the application of thin flakes of mother-of-pearl. Another technique, hira-maki-e, involved the application of gold lacquer on a uniform flat background. Designs in relief were also employed. In taka-maki-e, a design was produced in relief by superimposing multiple layers of lacquer and in kamakura-bori the design was incised onto the object. The Chinese red carved lacquer was also copied in Japan and used with great success in the manufacture of inro. The indigenous Japanese techniques of lacquer work, however, are more beautiful.

Sometimes a variety of techniques were used on the same piece. Whatever the technique of the exterior of the inro the interior was most commonly finished in nashij-i, a rich ground of powdered gold of varying tints and colourings.

The designs used to decorate inro were drawn from many sources, not least from the rich literature of Japanese mythology. Perhaps most frequent are representations of nature, such as pine trees, bamboos, chrysanthemums, camellias, iris, seaweed, coral, shells, cranes, deer, cockerels and a host of mythical animals. Landscapes and seascapes were also fashionable subjects, especially popular beauty spots such as Fujiama and the pine forests on the edge of Lake Biwa. Copies of famous paintings were also popular.

The ingenuity of the inro artist was comparable with that of the netsuke artist, and indeed in many cases he was one and the same. Illusion was one of his favourite themes and many a time an inro appears to be that which it is not, either in substance or subject. The design of inro are varied and wonderful, for the creative imagination of the Japanese artist knew no bounds. The composition of all are striking and powerful.

The great Japanese artist Koetsu (a genius of the Tokugawa and Momoyama periods) is thought to have made lacquer inro. Schooled in the Tosa style of painting he worked in a number of mediums. Another great all round artist known to have made inro was Ogata Korin perhaps the greatest lacquer artist of the 18th century. He was a follower of Koetsu both in painting and lacquer work.

The Japanese people are rather formal and severe, and yet their art shows a great sense of humour, especially evident in the miniature works of art such as inro and netsuke. This is almost the exact opposite to the Chinese who are outwardly gay and happy, but whose art is simple and severe.

To the Japanese, the Chinese preference of sticking to a tried and successful formula, whether it be for painting, sculpture, metal or lacquer work, would be considered a failure. The Japanese artist has always preferred to experiment and to allow

his creative genius licence. This of course did not always result in success, there were many dismal failures, but they failed with honour. It is this imaginative experimentation which makes Japanese art so different and objects like inro and netsuke so much sought after.

Many inro are signed, and if the collector refers to a book on reading Japanese characters (there are several available and your local library may be able to help) he may with luck, be able to identify the artist. Most of the early pieces are, however, unsigned.

The Koma and Kajikawa families are probably the most famous makers of inro. The Komas were court lacquerers for more than two hundred years, the first of the name died in 1663 and the last in 1858.

In reading Japanese names the family name comes first and the personal name second for example Koma Kwansai means Koma family, personal name Kwansai or in English Kwansai Koma. When dealing with Japanese culture, however, we adhere to Japanese usage.

Among the great makers of inro may be mentioned Koami, Shiomo Masanari, (both 17th century artists), Koma Kyuhaku, Ritsuo, Shunso, Kajikawa Kyujiro, Nomura Chohei, Koma Kwansai, Koma Koriyu, Koma Yasumasa, Tatsuki Takamasu and Baigiokusai all 18th century artists, and Hirose Nagamitsu, Nichimura Eiki, Koma Toshi of the 19th century. The names of Iwamoto Ryokwan and Mitsumori both well known metal workers are also known for inro.

Sometimes two or more artists collaborated on the same piece, especially if they were proficient in different disciplines. For example a metal openwork case containing lacquer sectional trays.

Although the presence of a signature on the inro can be a help in identifying the artist it cannot be taken as a guarantee as both signatures and styles were copied.

At the end of the 19th century, after Japan had relaxed her policy of isolation, Western ideas, good and bad, began to

influence Japanese life. Many of the old ways, began to be abandoned as Japan took her place in the modern world. This change in ways had a detrimental effect on a number of traditional Japanese art and crafts. Among the early casualties were the inro and netsuke. The introduction of the Western fashions of dress into Japan resulted in less people wearing the traditional kosode and consequently less demand for inro and netsuke. The great period of the art of the inro had come to an end.

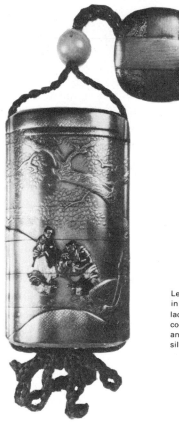

Left hand. Six-case inro signed Kama Kyuhaku, decorated in gold hiro-maki-e, okibirame roller techniques of gold lacquer. Two figures inlaid in various metals watching cock fight in landscape. Attached coral ozime and a gold and red lacquer morju netsuke decorated as a skein of silk, signed Zeshin.

17 *Chinese Jade*

Jade is to the Chinese as gold is to the West. Its mystery, power and beauty were recognised as early as Neolithic times and have continued to be highly regarded ever since. As with many things that were first invented and appreciated in the East its beauty and value is now recognised in the West and it is widely sought after by collectors.

Jade has an air, quality and texture all of its own, and ranges in colour from white to purple. Indeed in its most sought after form it may not be recognised as such by most people who think of it as green stone. Its unique character had made it important in the esoteric rituals of early times and symbolic in Taoism. Other races have used the mineral including the Maoris of New Zealand and the Mayas of Yucatan, but it was the Chinese who raised its importance above all other materials.

The stone was carved in China mainly for small figures and miniature work as far back as Neolithic times. It has always been greatly treasured and has often figured as tribute to the emperor from outlying barbarian lands.

The term 'jade' can be misleading as it is used to describe a number of minerals that have similar appearance. Genuine jade, however, is the classical nephrite or calcium magnesium silicate. It has a hardness of 6½ degrees on the Mohs scale. In China nephritic jade is called Chen Yu, though other minerals such as Chinese serpentine can also be so called. Jadeite or sodium

aluminium silicate began to be imported into China from Burma in the 18th century and became very popular. There are some accounts, however, that suggest that it was in use in China from much earlier times. When in colours such as emerald–green and vivid red it is easily distinguishable from nephrite.

Generally, nephritic jade is not found in China, and was principally imported from Turkestan, where it was gathered as pebbles from the river beds as well as extracted from rock. It may be because of its rarity that it found such wide acclaim in China, for it is otherwise strange that a substance not native to the country, achieved such great popularity and importance. Its rarity was further influenced by factors such as the political situation, both within and without China, which could interrupt the importation from bordering countries. The intermittent supply of jade may have had an effect on the styles in which jade was carved, a problem of yesterday which directly affects the collector today. This interruption of supply sometimes lasted for whole generations.

Jade was thought to have great beneficial powers—both to the Chinese and the early Europeans. The Portuguese called it *pedra-de-mijada* (from which we derive the name jade) because it was believed that it could prevent urinary and kidney diseases.

Jade comes in a multitude of colours and tints resulting from the presence of various oxides and silicates. It can range from a pearly white when almost pure to purple, pink, blue, lavender and nearly black/green. When white, it is generally dull with a noticeably greasy appearance, the Chinese refer to it as 'mutton fat' jade. 'Cabbage' green jade is however the most common.

Over the centuries jade has been carved into most forms and used for a variety of purposes. Subjects have varied from figures both human and animal, relief panels with inscriptions and landscapes, seals, snuff-bottles, belt buckles, religious and ritual objects, sceptres, etc. to small personal items such as jewellery, amulets, pendants and bangles.

One of the earliest documented description of jade objects is in the Book of Rites, which was written at the end of the Chou

dynasty (1122–294 B.C.). In it six ritual objects are mentioned. They are the Pi, the Ts'ung, the Kuei, the Chang, the Hu, the Huang. The Pi is particularly interesting as it continued to be made over a long period of time and is still made today. It is discoid in shape, sometimes decorated and other times plain. Some of the earliest Pi were found in Shang tombs at Anyang. These were decorated with symbols similar to those found on the ritual bronzes of Shang (c. 1523–1027 BC) and Chou (1027–221 BC) periods. Other jade objects were carved with mystical *t'ao t'ieh* masks and *kuei* (dragons). The Pi which symbolises heaven is thought to be a representation of the sun. They were buried with the dead.

The Ts'ung is also interesting in shape. Popular during the T'ang (AD 618–906) and Sung (AD 960–1279) periods, they take the form of a cyclindrical tube within a rectangular brick form by four vertical triangular prisms. Their exact significance is not known but they are thought to have some connection with an earth or fertility cult. The degree of technology of jade working of various periods greatly influenced the shape and decorative motifs employed. The hard jade could only respond to an abrasive working with harder materials.

Jade was first worked in Neolithic times when it was shaped by rubbing the surface with an abrasive probably consisting of a mixture of crushed garnets and grease. The abrasive was rubbed on the jade with a bone or bamboo stylus. Holes were made by rubbing the abrasive with bow drills with bone tips. In the Bronze Age improvements were made in the technique with bronze or copper tips replacing the bone. This again was improved with the invention of iron but the actual rubbing technique in all cases remained the same. Some scholars believe that the diamond tip was introduced into China during the first millennium BC, but it seems more likely that it was not the diamond but the corundum tip. Diamonds do not appear to have been used after the first centuries AD when the technique of embedding a diamond or corundum tip in metal became too costly and fell out of use. It was used on occasions but did not

reappear in general use. In the 18th century it was used especially for engraving texts on objects.

Before detailed 'carving' could take place, the jade blocks had to be cut to size. This was done with a rotating iron disc and abrasives. In the 13th century a new abrasive supplemented the crushed garnets. This was 'black sand' or crushed corundum. During the Ch'ing dynasty a number of deposits of corundum were discovered in China and the technique of manufacture and use of abrasive was refined and perfected. A new method of making corundum paste, using fine clay instead of grease was perfected. This allowed many new processes and techniques to be evolved.

Figurative sculpture in jade is not common before the Sung dynasty. One of the earliest examples is in the British Museum in London, a stylised figure of a man. Other than this figure which dates to the late Chou or early Han period (4th–6th century BC) human figures are noticeable by their absence, a factor probably caused by the popularity of figurative sculpture in other mediums, especially pottery. On the other hand animals were carved and were extremely popular. They were usually mythological and highly stylised, the fine naturalistic sculpture of the head and chest of a horse, belonging to the 2nd century AD in the Victoria and Albert Museum, London, being an exception to the rule. This superb dynamic figure bears all the stylistic features of sculpture and modelling seen in other mediums of the period. Generally speaking, however, animal sculpture tends to be stylised right up to Sung times.

The Yuan period (AD 1280–1368) is responsible for a number of massive jade sculptures. One of the finest examples of these is in the British Museum in London. It is a large tortoise carved from a boulder of grey-green nephrite, measuring 2′ (68 cm) long, it is delightfully naturalistic and quite unlike the jade sculpture of earlier periods.

Human figures became popular during the Ming period (AD 1368–1643) and continued in popularity until the present day. Figurative subjects were chosen from the world of myth and

218

religion as well as reality and included deities of the Buddhist and Taoist Pantheons such as the Goddess Kuan Yin, Manjusri, Sakyamuni and the Taoist Lao-Tzu and the Eight Immortals. In addition to figures, vessels were also made but were less popular during the Ming dynasty than during the earlier periods. During the Sung dynasty there had been a revival of archaic shapes and styles and it can often be very difficult to distinguish genuine archaic jades from those carved during this period. In fact there have been some instances where a vessel has been dated to the 4th–3rd century BC by one expert and the 17th century AD by another!

The Ch'ing dynasty (AD 1644–1912) is generally regarded as being the Golden Age of Jade. Numerous fine jades in private collections and museums all over the world testify to this. A number of fine works were executed for the Imperial household. The Emperor Ch'ien Lung (1736–1795) was extremely fond of jade and had a number of fine works of art made for him. Perhaps the most interesting of these are the large jade boulders carved in the form of mountain scenes. These are sometimes embellished with poems by the Emperor. During this period jade from Siberia was imported to China.

Perhaps the most famous examples of jade are the fabulous jade funerary suits of Prince Liu Sheng and his wife Tou Wan of the Han dynasty. These were discovered in 1968 when their tombs in the Lingshan mountains in the western suburb of Mancheng, Hopei were excavated by soldiers of the Peoples Army. Their tombs were gigantic in size and sealed from the world of the living by a wall of iron. Although both tombs contained a treasury of objects, the jade funerary suits are without doubt the most spectacular. They are both unique and beautiful. The suits were constructed of thousands of small jade plates sewn together with gold thread. Prince Sheng's contained 2,690 pieces of jade and 1,110 grams of gold thread while his wife Tou Wan's was made up of 2,156 pieces of jade and 703 grams of gold thread. The workmanship was brilliant, every plate had been cut with a fine saw of a thickness no greater than a 0.3mm.

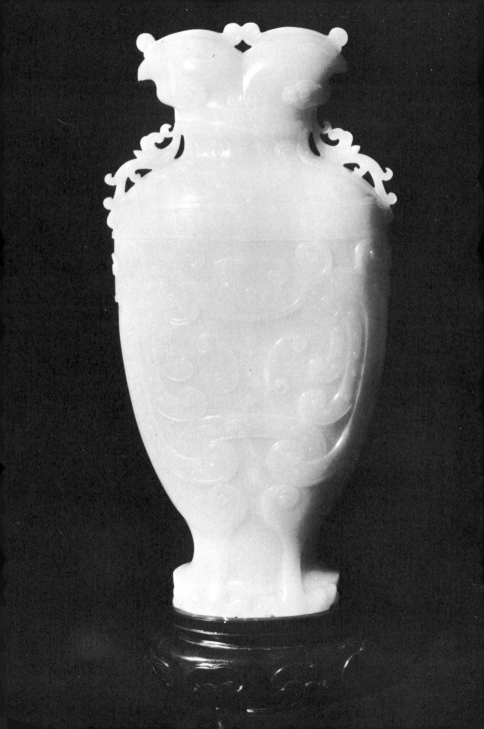

Each plate had holes 1mm in diameter drilled at the corners with a sand drill. The workmanship was so fine that they fitted together perfectly forming an armour like suit. Each suit would probably have taken an expert jade worker more than 10 years to make.

The suits were originally intended to protect the body but the discoverers found the bodies had decomposed and the suits had collapsed. Chinese experts restored the suits and inserted dummies making them majestic, though somewhat macabre, jade figures.

During the last few years many spectacular discoveries have been made in China and much information has been made available, helping us to understand more fully China's artistic heritage. Some of this information has helped in our problems of dating jade, especially of the earlier periods. However, precise dating on later jades, especially those attributed to the 17th–18th centuries, is far from perfect and cannot be relied upon with any certainty.

Buying jade is a particularly hazardous occupation for there are many imitations. The collector must take precautions to ensure that the object he desires is in fact made of jade and not of marble, soapstone or alabaster. The hardness test will often reveal its true nature. See if it will scratch with a metal point (on some hidden part of course). Jade is hard and will not scratch.

Chinese craftsmen were great copiers and looked on the masterpieces of earlier periods for inspiration. They were also expert artisans and thus it is often difficult to distinguish between the fake and the genuine article. In order to protect himself the collector should become thoroughly familar with the materials and techniques that were employed at various periods. He is also advised to study, observe and handle as many genuine pieces of jade as possible for only in this way will he learn to separate the wheat from the chaff.

Chinese jade vase. 18th century.

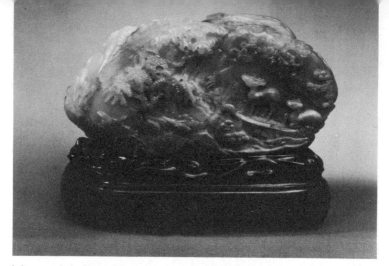

Jade mountain landscape. The pieces, usually made from large block were often embellished with poems by the Emperor Ch'ien Lung. Ch'ing dynasty. 18th century.

So far we have only mentioned the copies but there are also intentional fakes. The surface of jade was often treated to simulate the surface discolourisation due to oxygenation and carbonisation that occurred when jade was buried. The natural process takes a considerable time to take place, usually more than 1,000 years depending upon conditions before visible stains occur. When they do occur they can penetrate quite deeply into the body of the jade. Stains very often enhance the aesthetic quality of the object and many collectors regard them as an indication of age. Fakes, however, have been produced with an imitation stained surface generally by heating the jade in high temperature ovens.

The great fake factories are still in operation in Hong Kong and Taiwan and many of these pieces are imported into Europe and the U.S.A. The golden rule is experience and experience can only be gained by handling as many genuine pieces as possible. Having gained such experience, the collector will find no difficulty in distinguishing between the modern and the old. The usual rule that if unsure never pay more than for a modern piece, of course still applies.

18 Chinese Snuff Bottles

Perhaps the greatest deterrent to the would-be collector in these days of moving populations, small houses and flats, is the fear of being surrounded by a mass of bulky and fragile antiques. For this reason many never indulge in man's natural instinct for hoarding and collecting. This, however, need not be the case, for there are collectable items such as coins, Japanese netsuke, and Chinese snuff-bottles that are attractive, aesthetically pleasing, a good investment, and are small enough to be kept in small boxes or cabinets.

The snuff-bottle is the Chinese answer to the netsuke, for into its genesis go all the artistry, skill, craftsmanship and wit of the kind that the Japanese lavished on the toggle. Both netsuke and snuff-bottles are personal items and both are small, but of course there the similarity ends, for they were made for completely different purposes.

It is this highly personal aspect of both that perhaps make them the subject of artistic expression for the artist-craftsman. The variation of materials used in their production offered the artist a challenge of fitting his design to the size, shape and flexibility of the material before him—an aesthetic relationship between man and material.

Chinese snuff-bottles usually take the form of miniature vases averaging a height of about 2½ to 3 inches (6.3 to 7.6 cm). They can be made of a wide variety of materials such as jade, agates and

other hardstones, porcelain, lacquer, glass, gold, silver, bronze, horn, bamboo, ivory, amber, cloisonne and Canton enamel, and decorated in an equally wide variety of techniques.

Although tobacco was introduced into China from Manila in the Philippines in 1530, early bottles made to hold snuff are very rare. Most snuff-bottles are of the 18th century design or even later. In the case of agate bottles and other hardstones it is most unlikely that some of the beautifully carved examples cheerfully attributed to the reign of the emperor Ch'ien Lung in the 18th century ever saw the period, as the use of carborundum as an abrasive for 'carving' these bottles was not discovered until the last century. Agate is in fact harder than jade, having a hardness of 7 on the Mohs scale, while jadeite has only a hardness 6.75 and nephrite 6.5. Jade therefore can be scratched by agate.

Porcelain bottles that can be attributed with certainty to the reign of K'ang Hsi (1662–1722) are very rare indeed, a rarity that also applies to genuine bottles bearing the marks of Yung Cheng (1723–35) and Ch'ien Lung (1736–95). Most genuine marks belong to Chia Ch'ing (1796–1820) and Tao Kuang (1821–50). This does not mean that bottles bearing the early reign-marks are rare—on the contrary, it only means that bottles bearing the genuine reign-mark are rare. Like other examples of other Chinese porcelain, snuff-bottles were often adorned with earlier reign marks out of reverence for the period and admiration for its fine porcelain.

Snuff-bottles were made and decorated in most of the popular techniques and specimens can be found decorated in the proverbial underglaze blue, underglaze red and a combination of the two. Overglaze enamels in the *famille rose* and *famille verte* palettes were also popular, as well as enamels applied directly onto the biscuit of the bottle. As with the larger vases from which many bottles took their inspiration, monochromes were extensively used, including the famous mirror black and other glazes such as *sang de boeuf*. Bottles of white or a creamy-white ware of Ting type were also treasured.

Another kind of decoration more peculiar to snuff-bottles is

that of fine white drawings on a black background, either matt or glossy. These are mostly of later date and some bear the mark of Tao Kuang. Porcelain bottles of more elaborate type include those decorated with finely carved reliefs and with pierced ornament, the former imitating agate and glass bottles.

Subjects of porcelain bottles are as varied as their shapes and techniques of decoration, but popular subjects were historical and mythological scenes, paintings of Taoist immortals, women, landscapes, birds, animals (real and mythological), flowers and fishes.

In recent years Yi-Hsing stoneware bottles have become much sought after. These bottles, mainly made during the first half of the 19th century, are difficult to obtain and consequently are fetching high prices. Specimens were included in the sale of the Ko family collection at Christie's in London and fetched prices ranging from £140 to £420 each.

Perhaps most popular, both with the Chinese for whom they were originally made and for present day collectors, are the snuff-bottles made from agates and other hard stones. Here the Chinese artist has really risen to the challenge of using natural materials to their best advantage. Agate and hardstone snuff-bottles are, generally speaking, more sought-after and are therefore comparatively more expensive.

A wide range of stones are included under the term agate, for it is generally taken to include a section of semi-transparent stones such as quartz, amethyst and citrine. There is a very close relationship in the variations, as the difference between the more opaque agates and the semi-transparent stones is usually in the size of the crystals. It is possible, therefore, by a change in crystal size in the same stone to have a combination of say crystal and agate. This relationship has often been used by the Chinese craftsmen to produce bottles with an outer 'carving' in relief of crystal on agate, or in other combinations of stones that occur naturally. To the geologist the agate is simply a crypto-crystalline quartz as against a crystalline quartz. It is this admixture of different cystalline sizes that give rise to various

225

kinds of agates such as the moss and fern agates.

There is, in fact, an extremely wide range of agates, and often stones called separately under such names as cornelian or carnelian are just forms of agate coloured by minerals, in this case by traces of iron. There is, however, disagreement among authorities as to whether some stones should be classified as agates or not. For our purpose we shall include a wide range of stones as all were utilised by Chinese craftsman.

Agates occur in a wide and beautiful range of colours, banded and figured with impurities, such as those in moss agate. The colours of plain agates, the chalcedonies, are varied and subtle, ranging from black through pastel colours to white. The rarest is pure light blue. An especially rare form of chalcedony is jasper. Where blemishes occur, the clever artist has utilised them as part of his overall design. Banded agates take many forms, two special forms being onyx, where the bands are black and white, and sardonyx where they are red and white.

Because of the hardness of agate, we cannot speak of it as being 'carved'. The shapes and relief decorations are the result of being worn or ground into shape by means of an abrasive powder and water. The crude shape is first achieved by the use of a high speed rotating metal wheel (iron or copper) to which a liberal supply of abrasive and water is applied. Agates are normally worked with carborundum powder, today made artificially. Any abrasive harder than the stone may be used, but the only abrasive harder than carborundum is diamond and that is far too expensive.

The interior of the bottle, as well as the finer details and design were ground by a bow drill, which, although time-consuming, allowed a very high quality of workmanship to be achieved.

High-speed electric equipment today allows this process to be achieved in less time, but it is uneconomical to carry out, and therefore on the whole the collector can be reasonably sure that most agate snuff-bottles he will encounter are at least 40 years old. It must also be pointed out that a few small attractive bottles, mainly of carnelian, have been made in China recently,

but generally they are uneconomical to produce. One authority in the United States estimated that it would cost 10,000 dollars to produce a plain bottle by modern methods—and that was thirteen years ago.

Like those of porcelain, agate bottles come in a wide variety of forms, colours and decoration. The plain bottles generally rely on the beauty of material for effect, while those with relief decoration may rely wholly on the quality of the design and workmanship or combine the two. Some of the clear agates have, when the hollowing-out has been fine enough, been painted with a picture inside the bottle. Inside painting, often with calligraphy, was also carried out on glass bottles. These bottles are often sought after by connoisseurs of Chinese painting as well as by collectors of snuff-bottles.

An indication of the quality of the bottle may usually be had by the size of the opening and the degree to which the bottle has been hollowed out. If the hole is large and the hollowing poorly executed, it is generally not a high-quality bottle. This must be qualified, however, as in the case of bottles made from very rare stones the risk of fine hollowing was thought too great. When a bottle is hollowed out it should float. To achieve this, a sufficient quantity of the interior of the bottle had to be removed to make it less dense than the water. Agate has a density two and a half times that of water; the operation involved the removal of a considerable amount of the interior and was therefore extremely delicate and risky. Needless to say, floating bottles are rare and much sought after. Some of the finest carving is found on a group of bottles known as 'Soochow' bottles.

When buying agate bottles attention must be given to the quality of the material and carving and the ingenuity of the artist, for each of these variables may affect the price. Another point to bear in mind is to avoid giving undue prominence to the age of the bottle; the bottle must stand up for itself as a work of art and must be judged aesthetically and not by age (which in many cases anyway may be difficult to pinpoint).

Apart from porcelain and agate, the third most popular

material for snuff-bottles was glass. Glass examples to a great extent seek to imitate those made of agate and other hardstones and were often 'carved' in the same way, as glass too is a hard substance.

Glass was introduced into China at an early date. The Northern Histories accredit it to the reign of T'ai Wu (AD 424–452) while the Southern Histories attribute it to the reign of Wen Ti (AD 424–454). Glass, however, never competed successfully with porcelain and was mainly used in the manufacture of small items such as snuff-bottles. Much of the glass known as Peking was originally made in Po-shan-hsien in the province of Shantung. Dealers from Peking bought it either in the form of rods or as finished articles. It thus acquired the name of Peking glass.

A glass factory was established in the palace at Peking under the patronage of the Emperor K'ang Hsi in 1680, the products of the factory being intended primarily for Imperial use. A director of the factory by the name of Hu, whose studio name was Ku Yüeh Hsuan, 'Chamber of the Ancient Moon', became famous for his work, which included a number of snuff-bottles.

Glass snuff-bottles are generally not blown but made of solid glass, sometimes of several colours overlaid. This glass mass was fashioned in the same way as agates. The technique of overlays used by the Chinese is much like that used on the famous Portland Vase. The use of an artificial substance such as glass, however, gave the artist a wider range of colours than could be obtained from natural stones. The Chinese achieved an extremely high degree of skill in fusing together glasses of different colours without the colours inter-mixing.

As mentioned earlier, a wide variety of materials was used in the production of snuff-bottles and in each case the qualities of the material were used for the best possible effect. The stoppers, however, could also be, and often were, made from a variety of materials and did not have to match the material of the bottle itself. The marriage of bottle with stopper added the final touch to the aesthetic appeal of the bottle.

With the increasing interest in netsuke in past years and the corresponding scarcity of good pieces, these toggles have priced themselves out of the reach of most collectors. Chinese snuffbottles, on the other hand, still offer the collector the opportunity of acquiring fine specimens at reasonable prices, though of course prices are rising rapidly and the more sought-after specimens may be highly priced indeed, but not necessarily expensive.

Examples can be acquired from most general antique shops and antique markets, but here a word of advice may be useful. The collector should not be afraid of visiting specialist dealers, for at such establishments he will not only be guided on his acquisitions but also be able to choose from a wide range of stock at realistic prices.

Sales of snuff-bottles are also held occasionally at the major International auction rooms.

The priced catalogues of sales such as these make good guides for the collector, as they not only illustrate numerous examples but give indications of current market prices.

19 *Chinese Soapstone*

Collectors are always looking for something different and interesting to collect that will not only be reasonably priced but also a good investment. With the current interest in things oriental on the part of both Western and Eastern collectors and dealers, it would seem that few aspects of oriental antiques are still relatively unexploited. But such is the case with soapstone.

Soapstone or steatite has traditionally been regarded as the poor relation of jade and hardstones and for this reason has been neglected by collectors. Although sometimes passed off as jade and unfortunately many times mistaken for it, soapstone is comparatively easy to recognise. In the first place it is not as hard as jade and is therefore easy to scratch—in fact this can quite often be done with the fingernail. It has a hardness of one degree on the Mohns scale while jade is very much harder having a hardness of 6½ degrees. In the second, it is not as cold as jade and quickly warms in the hand. Thirdly, it has a soapy feel, a characteristic which has given it its name.

Because of its softness, soapstone is literally carved, like wood or ivory with metal tools, unlike jade which has to be worn into shape by abrasives. The soapstone carver has often turned this to his advantage producing objects of great beauty in a comparatively short time, while if the same object had been carved from jade the work would have taken ages. As a material, soapstone has been worked both by jade carvers and by artisans

230

used to carving materials like ivory and rhinoceros horn.

Soapstone is an aggregate form of talc, a common mineral, hydrous magnesium silicate. It occurs both as veins and foliated masses and is also present in certain rocks in metamorphic terrains. It has been used throughout history both for utilitarian and decorative purposes. The ancient Egyptians carved scarabs from it and the Assyrians and Babylonians used it for cylinder seals. Soapstone is a very versatile material and has almost as wide a range of colours as jade, the most common being white, yellow, grey and green. In China the earliest objects carved in soapstone were miniature talismans and similar personal objects. They date from the Neolithic period, c 3000 BC.

Soapstone group, 19th century.

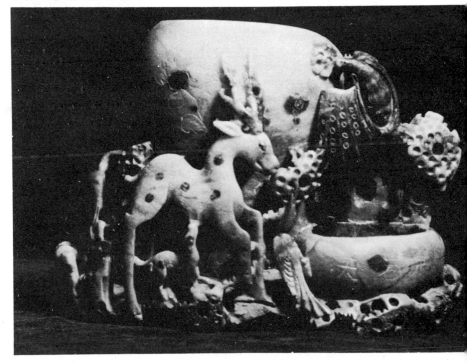

Soapstone that has been buried often has surface discolouration. If it has accidentally been in a fire, its surface may have turned white and have lost its soapy feeling. These changes of surface colour are mainly found on ancient soapstone. Occasionally, however, soapstone has been coloured artificially. This practice was especially prevalent in the 19th century and can be clearly seen on the carvings that have been chipped, the dye penetrating only slightly below the surface.

Perhaps the most popular use of soapstone in China has been for carving seals. Seals were an essential part of official and private life; every official, scholar, artist, family or individual had to have one. Soapstone seals are usually square in section with the characters carved in archaic script. The seal itself is commonly square-sided and surmounted by a mythical creature, the most popular being the kylin or mythical lion. The seals range in size from about half an inch to over a foot high.

Few pieces can be dated to the Ming dynasty (1368–1644). During the Ch'ing dynasty in the 18th century soapstone followed the fashion of jade. The Emperor Ch'ien Lung (1736–95) was especially fond of large jade boulders carved with mountain scenes and often embelished with poems; these boulders were occasionally imitated in soapstone.

Soapstone has always been popular for large figures and vessels because it was much cheaper than jade. The true genius of the artist can be seen in the character of the figures, especially those of the 18th century. Figures of the eight immortals and other mythological figures were extremely popular in both the 18th and 19th centuries. The eight immortals are carved either as separate figures or as a group on a base. They can be easily recognised from the following descriptions:-

1. *Chung-li Ch'uan*, generally shown as a fat man with a bare belly holding a fan.
2. *Chang-ko-Lao*, usually shown with a mule and holding a bamboo tube drum.
3. *Lu Tung Pin* (born AD c 755 died 805) shown in the guise of a scholar with a fly whisk.

4. *T'sao Kuo-ch'iu*, wears court headdress and holds castanets.
5. *Li T'ieh-kuai* represented as a beggar leaning on an iron crutch. He is shown thus because on one occasion his spirit left his body and so had to enter the body of a lame beggar.
6. *Han Hsiang-tzu*, whose emblem is the flute and who is credited with the power to make flowers grow and blossom instantly.
7. *Lan Ts'ai-Lo*, who carries a flower basket.
8. *Ho Hsien-Ku*, a woman who became a fairy, having eaten a supernatural peach. Her emblem is the lotus in her hand.

Kuan Yin, the Buddhist Goddess of Mercy was also a popular subject.

Soapstone figures and vessels can be found in most antique and junk shops, but although they are plentiful, quality pieces are not that common. The value of soapstone lies almost entirely in the quality of the carving and it is for this that the collector should search.

How then does one judge quality? This to a great extent must be a matter for personal judgment but the points one should watch for are:-
1. The general finish of the stone—it should be smooth and without ridges or toolmarks.
2. The colour—which should be natural and pleasing.
3. The composition should be well balanced.
4. The carving of details, for example, of face and hands in the case of a figure, should be well done.
5. The ingenuity and originality of the carving—only experience will guide the collector here.

Prices vary, but generally soapstone is still greatly undervalued and therefore underpriced. It is a field of collecting that in the future will prove most rewarding.

Before dashing out and buying up every piece you see remember that like most oriental objects, soapstone carvings are still made today. Modern carvings tend to be obvious but the collector should take care and bear in mind the simple rule—if unsure, never pay more than if the piece were modern.

20 *Fakes*

Collectors of oriental antiques should beware, for all that glitters is not Ming. The businessmen of Hong Kong and Taiwan are ready and willing to provide that 'treasure' which the uninitiated will pay well to add to his collection. The antiques of ancient China are the export of modern China, both in and out of the People's Republic. China herself, has taken advantage of the current interest in Chinese antiques, and she exports a number of first rate copies, which are sold legitimately, until by some round about route they arrive in an antique shop and there the danger lies. Hong Kong and Taiwan on the other hand, have been exporting reproductions of Chinese antiques for years. Their manufacture is a big business but the way in which they are made is traditional. What in many cases is a cottage industry, carried out by a few craftsmen in cottages or in the back streets is exploited by modern methods of business, from plush premises, with exports to all parts of the world. While the majority of these exports are harmless, others are works of art and fakes of the first order. These are what the collector should look out for. If that were all the danger that faced the uninitiated collector it would be bad enough, but the Chinese have been copying their ancient relics for years, what looks like a genuine Ming vase may be Ming, an 18th or 19th century copy or a fake made a matter of weeks ago!

In China there are fakes and fakes. Perhaps, befor examining

the whole question, we should define what constitutes a fake. The straight forward answer would be *a work of art or object which is primarily intended to deceive and defraud*. While this may hold true for European works of art, where the motive behind most forgeries is monetary gain, it cannot be the whole answer for oriental fakes, where this motive is only a comparatively recent introduction. The philosophy behind the forger of oriental works is often very different and indeed it is sometimes questionable whether he can be labelled a 'forger' in the European sense of the word. True, there are forgeries made specifically for gain, but in many cases the forgery lies not with the maker but with the seller or even the buyer.

'Forgeries' can even come about by the lack of knowledge of the beholder, be he collector or curator. 'Forgeries' of this type, are in the main, confined to mistaken period or provenance. There are even genuine works which have been and are still being labelled as 'forgeries', but which have the misfortune to bear such labels due to ignorance, and also to a trait in our modern society which maintains that everything and indeed everyone should fit neatly into little compartments. As we all know, man has always produced the great, the unexpected and the unusual. It is this ability to produce items of originality which has created all great works.

With the advance of modern science, we can add many new weapons to our armoury for the detection of fakes. The use of stylistic arguments to decide whether a work of art is genuine, may well be accurate enough when dealing with Western paintings or decorative art, but when employed on its own to oriental art can be misleading. With new methods of detection such as thermoluminescence dating for pottery, it is possible to show that sometimes an item which has been accepted on stylistic grounds as genuine, has not passed the test, while another totally unacceptable on stylistic grounds, has been shown to be genuine.

The field of oriental forgeries, copies and reproductions, is too vast to deal with in a single chapter. I shall, however, examine

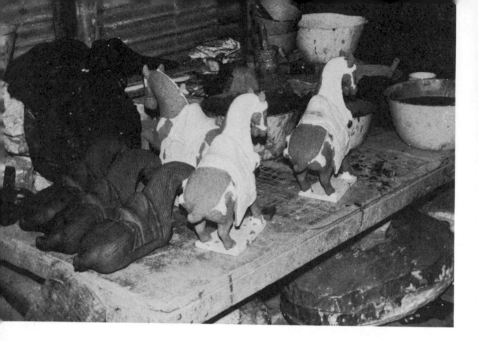

Part of a fake factory in Hong Kong. Fake 'T'ang' horses are being assembled and coated with glaze, prior to firing.

some of the fields in which deceptive pieces are found, and the motives of their creators.

Probably the most common forgery known to the orientalist is the 'T'ang' horse and other tomb figures. These are forgeries in the true sense of the word. Most of the examples of this type of object were made and are in fact still made in 'fake factories'. Although fakes are mainly confined to the more attractive and expensive figures, especially of the T'ang dynasty, the forger has also ventured into some of the other periods such as the Han and Wei dynasties. Until comparatively recently, fakes cf these items were unknown. It was not until a demand had been created that the forger attempted to supply that demand.

During the first part of this century a large number of figures were recovered from tombs when the Lung Hai railway cut right

through a cemetery. Many of the figures in museums and private collections throughout the world were found at this time. During the early 1920's allowing for the difference in the value of money, tomb figures were fetching extremely high prices, even more than today, but prices soon hit an all time low, due to a glut on the market. Figures were sold in London auction rooms in lots of ten or more. A T'ang camel could be bought for £1.50. However, with prices so low it was soon common knowledge that after the supply of the genuine figures ceased, figures continued to reach the market, but this time were products of a fake factory. The presence of these affected the prices for some time. Prices today, however, are high for the better pieces, but the collector should remember that these fakes are still around.

It is unfortunate that tomb figures are comparatively easy to fake. They can be produced either from moulds of genuine pieces or modelled afresh. The latter are much easier to detect. Figures can be glazed and unglazed; most successful fakes, however, are unglazed and painted with cold pigments. It is much more difficult to fake aged glaze, both in colour and condition. The body of T'ang figures is usually buff or red/brown, while that of Wei figures is usually grey, however the clever forger copied both these characteristics. Painted figures were aged by first applying the paint then brushing some of it off and then applying a coat of liquid mud.

Today, first rate fakes are produced in fake factories in the back streets of Hong Kong and Taiwan. After much persuasion a local dealer permitted me to visit one of them and I saw a number of 'treasures of ancient China' being made. Their speciality was glazed pottery of the 'T'ang dynasty'. The conditions were primitive in the extreme but the results would worry anyone except the expert. After firing, the glazed figures were aged. Some were broken others were simply distressed. The forgeries were then buried in a soil rich in mineral salts. The 'burial' was watered regularly until, at the end of several months, the figures were exhumed and mended. The layer of salt which covered the

figures resembled genuine iridescence. Orvar Karlbeck describes a visit to a similar fake factory near Lo yang in his *Treasure Seeker in China* (London 1957).

A lesser known forgery allied to the tomb figures, is the fake of the early T'ang glazed vessels. These are often made in the same factories as the figures, employing similar glazes. Not quite in this class are the reproductions, not made with the intention of deceiving, but which have been embellished by some unscrupulous dealer and sold as genuine. These will be discussed later.

Science today is coming to our aid. A method of dating pottery by thermoluminescence, originally developed as an aid to archaeologists, is now being used to date tomb figures. Tests in Britain are carried out by the Research Laboratory for Archaeology and the History of Art, Oxford, and by the Research Laboratory of the British Museum.

Thermoluminescence dating of pottery is based on the principle that minute particles of uranium and thorium, contained in the clay of the pot, emit alpha particles, which are absorbed by the other minerals in the clay surrounding the radioactive impurities, causing ionization and releasing electrons which are stored in the pot. These electrons remain trapped at ordinary temperatures, but when heated either during the original firing or subsequently, are released with the emission of light. Thus the build up of electrons increased with time, and in theory a vessel of greater age will have greater thermoluminescence. The process of carrying out the test is very complicated but the results obtained are generally accurate to within 10 to 15%. The process, however, is not infallible.

A number of fake factories are in operation today, and I have seen bronzes, sculpture and paintings of various periods produced. The best are exported, while the bulk find their way into antique shops, where they await the eager eye of the tourist. Many a visitor to the East has succumbed to these attractive but worthless pieces, often going to great lengths to send them back to Britain, only to find on his return to this country that they are

fakes. Many of these can be found in British and American antique shops and there is still a danger of the unsuspecting collector making the same mistake. A few of these fake factories are very large indeed employing numerous artists and craftsmen. I have seen some of the better products from these ateliers on sale in London;

'Ancient fakes' may have been made for a variety of reasons. Good examples are the forgeries of Chinese archaic ritual bronze vessels. Chinese bronzes of the Shang and Chou dynasties were greatly venerated by Chinese connoisseurs, even as early as the Sung dynasty. Scholarly works were written about them, one of which refers to fakes and the way to detect them.

Often the vessel itself was not faked, but the inscription, as inscriptions were greatly valued by Chinese connoisseurs. However bronzes *were* faked. The 13th century scholar Chao Hsi-ku described bronzes that had been buried in the earth for centuries as having a coating or patina as blue as a kingfisher. He described fakes with surfaces that had been abrased and coloured, and indicated methods by which forgeries might be detected.

Two types of ancient forgeries may be mentioned. The first, a cast of an original and the second, an outright copy. The latter are usually exposed by the regularity and symmetry of their designs in strong contrast to the artistic originality and freedom of genuine pieces; while casts often lack the brilliance of the original, chips, wear and abrasions being cast on. Patinas were faked but experience will often expose the fraud.

Most forgeries of Chinese ritual bronzes, however, are modern and are made explicitly for monetary gain and aimed at the European connoisseur. There are of course forgeries of many other types of objects which fit into the category of 'ancient fakes' but which space does not allow discussion.

Forgery by addition of dates, inscriptions etc. on genuine objects is more commonly found in the Far East, especially China, where the written word of ancestors was held in great esteem and reverence. Bronzes, both archaic and Buddhist, were

embellished with dates and inscriptions. While the intention was most times simply to add interest and importance to an object, sometimes it was aimed at giving the object greater antiquity and thereby increasing its value. In the latter case there are some amusing failures, where the forger has failed to appreciate the age of an object and has given it a date later than its true age. An example of this type is a small bronze figure of the Buddha now in the Cincinnati Museum, U.S.A., which is dated to AD 528 but which from its style must have been made about AD 480.

Other obvious examples of this type of forgery are paintings and prints which have had signatures and/or dates added to them. There is yet another type of forgery, where a false collector's mark or attribution is added to a painting. The original work may well have been an innocent copy or a painting in the style of an artist of repute. The motive here may be for gain and simply to boost some collector's ego.

Forgery by deletion is more common, however, like fakes by addition, they were not originally made to deceive. Most have had some inscription, date or mark which would have distinguished them from that which they imitate. The forger in this case is the seller or person who has deliberately erased these marks in order to deceive.

Porcelain is perhaps one of the principal fields where this type of forgery is found. During the 18th century large numbers of copies of Sung celadons were made in reverence, not intended to deceive. Many of these bore 18th century reign marks, which have since been removed by grinding or by hydrofluoric acid. These will however rarely deceive the experienced observer.

Porcelain of a number of types and periods was forged during the Ch'ing dynasty. Ironically, later when legitimate porcelains of early Ch'ing periods were being sought after, they too were copied by later forgers. Forgeries of Chinese porcelain were also produced in Europe. Among the more convincing specimens are the copies of Chinese armorial porcelain made by Samson of Paris. Originally made as legitimate copies and marked with the Samson marks, the marks have often been fraudulently removed.

240

An extreme example of forgery by deletion is 'skinning'. This term is used to describe an item of porcelain which has had its glaze and decoration ground off and replaced by decoration of a more profitable type. This was often done to blue and white ware, where a vase was required to produce *famille noir* ware, which was fetching such high prices in Europe early this century.

Copies, reproductions etc. including electrotypes, although intended as perfectly legitimate copies mainly for decorative use, can often be as dangerous as 'bona fide' forgeries. The danger comes when they are sold by unscrupulous dealers as the genuine article. Many reproductions and copies are extremely good, especially some museum casts and electrotypes, which unfortunately are not always marked. However, as the majority of items reproduced are from famous collections and well known, they should be familiar to most collectors.

Some items not intended to deceive have been endowed with dates and provenance not in keeping, which may have been added as a statement of quality or reverence. Probably the best examples of this type of deceptive object are the numerous vessels of blue and white porcelain with reign marks of the Ming period. Especially prevalent is the mark of Ch'eng Hua. Many of these pieces are made in shapes and decorated with designs incompatible with the period of the mark they bear. It is only the inexperienced collector who will be deceived.

Signatures on Chinese paintings are more dangerous. There are numerous paintings in the style of earlier artists which are also signed with their names. Copies in the early Sung style have been made for centuries. These are not necessarily intended to deceive but were executed as an act of appreciation for the work of the artist copied. The danger however remains, and only expert familiarity will guard against mistakes.

'Forgeries' wrongly labelled through ignorance are more common than one would suppose. It will be seen by the foregoing that the best guard against fakes is complete familiarity with styles, fabrics, methods of production and history etc. Ignorance is the forgers best ally, but ignorance works both ways. While it

is perfectly possible for a fake to be accepted as a genuine piece, it is equally possible, on the same basis, for a genuine piece to be labelled as a fake. Ignorance being the common denominator.

In today's modern society, where nearly everything is required to conform to strict rules, anything that is different is looked at with extreme suspicion. This attitude has unfortunately crept into art appreciation and criticism, especially of oriental work. I have seen articles, which although unusual were in every respect in keeping with the age and artistic ideals in which they were made, described as 'fakey', simply because the critic had 'not seen anything quite like it before'. Unfortunately some museum curators have adopted this defensive attitude in order not to be accused of passing spurious objects as genuine, with perhaps even more regrettable results.

Some 'experts' at the reception counters in our principal auction rooms, are also apt at times to adopt this attitude. A more responsible attitude would be to obtain other opinions and carry out a little research, when confronted with an unusual object, rather than to make snap judgments.

I recently saw two pottery horses of the Hui-hsien group of ceramics, that had been labelled as 'fakes' by one critic, simply because he had not seen anything like them before. Reference to other collections or even such a popular work as *Chinese Art* by Lubor Hajek would have provided a photograph of similar horses (plate 87) in the National Museum, Prague. The matter could have been settled by a thermoluminescence test. The critic's judgment may well have been coloured by the fact that a number of fakes of the Hui-hsien group of ceramics have recently been identified, but that does not mean that all are fakes.

These are just a few of the many pitfalls which face the collector. Constant handling, observation, familiarity with genuine objects is his only guard. In spite of this a few spurious objects are bound to creep into even the best collections. It is perhaps a sobering thought to realise that the successful fakes are those which have yet to be exposed and which might occupy some place of honour in our museums.

21 *Marks*

Probably one of the first things a collector does when he is presented with a new piece of porcelain, silver or a painting, is to look for a mark or signature. With European antiques he can be reasonably sure that if he finds a mark or signature, he will with luck be able to decipher and read it and refer to a work of reference for further information. With oriental antiques the story is different. It is one of extremes. Oriental antiques can either be anonymous—plain silent testimonials to the artistic genius of one of the faceless masses of the East, or carry so many marks that it is difficult, without experience, to know which if any are relevant or contemporary. The latter is certainly true of Chinese and Japanese paintings. The problem is further aggravated firstly by the fact that marks are usually written in Chinese or Japanese, a language and script naturally alien to the collector, and secondly by the not unimportant point that they may not be contemporary with the object or painting that bears them. This, however, need not deter the collector, for the very fact that the object is marked will enable him to weigh up the information provided by the mark with that provided by the piece itself. It is, however, essential to have experience of the type of antique that one is dealing with, only in this way can one prevent oneself from being deceived by the very mark that one is hoping will aid.

The barrier to understanding oriental marks is first and

foremost language and script. This need not be insuperable, for there are a few basic and simple points that can help in this respect. In this chapter I shall show some of the marks that are found on Chinese and Japanese pottery and porcelain, date marks and how to read them and also the important marks to look for on Chinese and Japanese paintings and prints. For further information the collector will have to refer to a number of books as no comprehensive reference work on oriental marks exists.

Probably the most common oriental antique familiar with European collectors is porcelain. We shall therefore start here.

Chinese porcelain normally carries marks under the base of the object, either impressed or painted in underglaze colours, commonly in blue, although marks in red, black and gold are also known. Sometimes pieces carry an inscription on the side or neck of the vessel.

Marks on porcelain (and sometimes on objects such as lacquer, cloisonné etc.) are usually of one (or more) of five kinds, date marks, hall marks, signatures, marks of commendation and description, and symbols. Inscriptions are written in either ordinary characters or ancient seal characters.

Dates are indicated by two systems. One using a cycle of sixty years and the other the arbitrary names given by the Emperors to the periods of their reign, the *nien-hao*.

The cyclical dates are not common and where they occur are inconclusive, as it is sometimes difficult to place the cycle in context. Each of the years in the cycle is known by the name formed by using one of the 'Ten Stems' with one of the 'Twelve Branches' which are also the names of the signs of the Zodiac. The cycles begin in the year 2637 BC, but for our table we begin with the 76th cycle, i.e. AD 4 and take it up to AD 1923. Inscriptions are written top to bottom, right to left. Two examples using the system are shown below.

Wu(1)-*ch'en*(2) *nien*(3) *Liang*(4)-*chi*(5) *shu*(6). Meaning—painting(6) of Liang(4)-chi(5) in the Wu(1)-ch'en(2) year(3). The first two characters will be found to represent the fifth year in the table, but no indication is given of the cycle to which it belongs.

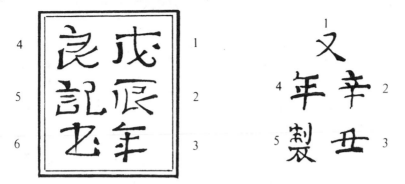

In the other example, B, the date can be guessed. It reads *Yu(1) hsin(2)-ch'ou(3) nien(4) chih(5)*. Which means made(1) in the hsin-ch'ou year recurring 5. The hsin-ch'ou year, the 38th of the cycle, recurred in the reign of K'ang Hsi who completed a full cycle in his reign in AD 1721.

Dates signified by the *nien-hao* are far more common, which is fortunate for the collector, as they are on the whole simpler and more accurate. The *nien-hao* is the name adopted by the emperor for his reign, on the New Year succeeding the death of his predecessor. Dates are usually composed of six characters written in two columns. The first characters signify the name of the dynasty, followed by the reign name of the emperor, ending with the words 'period made'. An example is as follows.

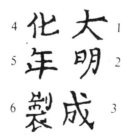

The translation reads *Ta(1) Ming(2) Ch'eng(3) hua(4) nien(5) chih(6)* made(6) in the Ch'eng(3) hua(4) period(5) (of the) great(1) Ming(2) (dynasty). *Nien-hao* marks are sometimes shortened to four characters omitting the name of the dynasty.

245

Some of the principal date marks used on Chinese porcelain and other works of art; both in archaic seal characters and script are given below.

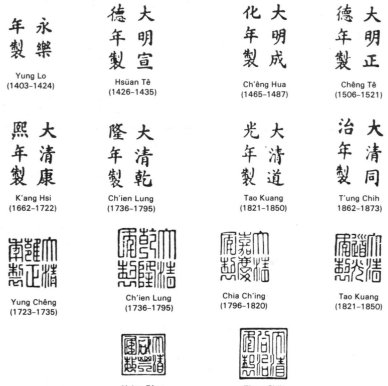

Yung Lo
(1403–1424)

Hsüan Tê
(1426–1435)

Ch'êng Hua
(1465–1487)

Chêng Tê
(1506–1521)

K'ang Hsi
(1662–1722)

Ch'ien Lung
(1736–1795)

Tao Kuang
(1821–1850)

T'ung Chih
1862–1873)

Yung Chêng
(1723–1735)

Ch'ien Lung
(1736–1795)

Chia Ch'ing
(1796–1820)

Tao Kuang
(1821–1850)

Hsien Fêng
(1851–1861)

T'ung Chih
(1862–1873)

Don't be too excited if one of your pieces of porcelain bears some of the early marks, remember the Chinese venerated their past and often put on earlier marks on porcelain of a much later date, out of admiration for the works of the earlier period. (See the chapter on fakes.)

Often porcelain will not bear a date mark only a hall mark.

The hall mark is probably best equated with the modern potter's mark, although in other ways it is perhaps more accurate to equate it with a studio mark or even a factory mark. In China, hall marks were used to refer to a potter's or painter's studio, a dealer's emporium, a hall of nobility or a pavilion of an emperor. It could indicate that it was either made at the place indicated or made for the place indicated. Common terms used in hall marks are *t'ang* a hall, *chai* a studio, *hsuan* a terrace, *t'ing* a summer house and even *fang* a retreat. Some hall marks are shown below.

 Yu t'ang chia ch'i
'Beautiful vessel
for the jade hall'
Late Ming/early
Ch'ing dynasties

 Ts'ai jun t'ang chih
'Made at the hall
of brilliant colours'
Early-19th century

 Tan ning chai chih
'Made in the
pavilion of peace
and tranquillity'
1736–95

A common trait of oriental antiques and particularly paintings is that they are often found inscribed with lines of commendation, either placed on the piece by the maker or later by a connoisseur or collector. They often include laudatory terms such as *Pao sheng* 'of unique value' or remarks such as 'a gem among precious vessels of rare jade'.

On the whole signatures are rare on oriental (Chinese in particular) works of art other than paintings or prints. A name or signature on a vessel may therefore best be equated with a studio name or hall mark, as often the vessel may have passed through numerous hands before it was completed.

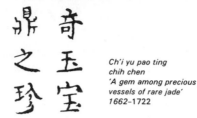

*Ch'i yu pao ting
chih chen
'A gem among precious
vessels of rare jade'
1662–1722*

Far more common are devices and symbols of a semi-religious nature. These include the Eight Buddhist Symbols, the Hundred Antiques, attributes of the Taoist Immortals, or Emblems of Happiness and Longevity, such as the bat or fungus.

Vase—One of the
eight Buddhist
emblems

Fungus—Emblem of
longevity

A bat and two
peaches—Symbol
of happiness and
longevity

Quite often Chinese porcelain is found with a double ring mark, either alone or with a symbol or device. This practice seems to date from AD 1667 when the Emperor K'ang Hsi forbade the use of the Imperial title or any sacred phrase on porcelain, in case it should be broken or desecrated. Although this edict only remained in force for a short while, the practice was continued almost as an indication of antiquity.

Marks on Japanese pottery and porcelain are either incised, stamped or painted. The stamp and seals being by far the most common. Unlike the Chinese, the Japanese potter often marked his pots with his signature. These signatures are numerous, as it was the Japanese practice to have a number of pseudonyms. This makes the number of signatures found on Japanese pottery and porcelain immense. Only a specialist work on Japanese potters or a book on reading Japanese characters will help in this respect, and then the information so given will generally be of little value. It is far better to rely on style, fabric etc. for an indication

of the ware and period. A few of the more common marks can be found in general dictionaries of porcelain marks.

Japanese porcelain also bear marks with the words *tei* house, or *yen* garden, which roughly correspond to the Chinese hall marks. To complicate matters still further Japanese marks are usually written in Chinese script or archaic seal characters, although vessels inscribed in Japanese cursive script are also found. They normally end with the words, *sei*, *tsukuru* or *saku* meaning made, or *hitsu* pencil, meaning drawn, or *ga* or *yegaku*, meaning painted. The word *tsukuru* followed by *kore* (this) simply means 'made this'. This is commonly combined with a signature.

tsukuru – made

saku – made

koreo tsukuru – made this

hitsu – drawn

sei – made

ga or *yegaku* – painted

Japanese date marks are similar to the Chinese. The cyclical system is the same with the reign marks related to Japanese chronology. Some Japanese marks are shown below.

SATSUMA

in ordinary and
contracted forms

SATSUMA

Satsu sei
on Tachino-
ware c. 1830

YAMASHIRO
RENGETSU

a woman potter
1830–1860

249

Chinese and Japanese paintings like their European counterparts are often signed. But perhaps one big advantage with them (depending upon the way one looks at it) is the fact that we must appraise the painting before deciphering the inscription or signature, to find who painted it and when. If we could only look at European paintings in the same way, how much better it would be! How often does one see people in an art gallery looking at the label beneath a picture before the picture itself, their reactions to the picture being coloured by the small print on the label. If the name is famous, the painting must be good, therefore I should like it! How much more pleasurable to make up one's own mind, uninfluenced by what the art historians think—even if it is a Picasso or Rembrandt. By the time we come to decipher the name on Chinese or Japanese paintings or prints, we have already made up our mind as to whether we like it or not, irrespective or whether it turns out to be a Ma Yuan or an Utamaro.

As a whole, signatures on oriental paintings are dangerous. Like porcelain, there are numerous paintings in the style of earlier artists, which are also signed with their names. Another common practice was to add the names of famous artists to otherwise unsigned works. In addition paintings often bear inscriptions of commendation and attribution by connoisseurs, together with their seals. Here the collector can really do very little except to refer to a work such as *Seals of Chinese Painters and Collectors of the Ming and Ch'ing Periods* by Victoria Contag & C. C. Wang. (Hong Kong University Press.)

To the uninitiated, Japanese prints seem to bear innumerable marks and inscriptions. The collector can, with perseverance, use these to some effect in dating and attributing prints to particular artists. However, the inscriptions which appear so numerous may often tell the collector everything except what he wants to know.

Most Japanese prints are signed and the signatures they bear are, by virtue of the fact that they are printed, fairly standard. Therefore, if one refers to a dictionary of Japanese print artists

one should be able to identify the artist with some ease. This of course will not indicate whether it is an original print, a copy, or a later impression. The signatures of the most famous artists are illustrated below. Sometimes the signatures are contained within a cartouche.

Utagawa Toyokuni
(1769-1825)

– Also used by
Toyokuni II
(Toyoshige)
Toyokuni III
(Kunisada)

Kitagawa Utamaro
(1753-1806)

Ando Hiroshige
(1797-1858)

Kutsushika Hokusai
(1760-1849)

Utagawa Kunisada
(1700 1004)

Utagawa Kuniyoshi
(1797-1861)

An indication of the date of the print may be had by the form of the signature or the presence of censor's or publisher's marks. It was quite a common practice for artists to change their name, and if one knows the dates of these name changes and the introduction of the artist's new signatures, an indication of the date of the publication of the print may be had. Censor's marks also changed at different times, and these combined with information provided by the signatures and publishers's mark where present will narrow the date down to a few years.

Date marks using cyclical dates and Japanese period marks (*nengo*), similar to those on Japanese porcelain, are also found on

Japanese prints. In addition to the marks mentioned above, it is also possible to identify actors, courtesans and brothels in the Yoshiwara district portrayed in the prints, which can also act as guides to the date of the print. When all the information obtained from the marks is related to the subject matter, it will be possible to decide whether the print belongs to a certain group. It is of course essential to have a working knowledge of Japanese prints. The presence of marks can only act as aids to experience, they do not replace experience. One ignores this advice at ones peril.

Round *aratame* (examined) seal, used between December 1853 and December 1857 inclusive.

Kiwame seal, used 1804 onwards.

Three seals reading *kiwame* (investigated), used either on their own or with others between 1790 and 1845.

Index

Acknowledgments *The publishers gratefully acknowledge the following for permission to reproduce illustrations: The British Museum; The British Library; Mallett & Sons, London; Russell-Cotes Museum, Bournemouth; Messrs. Christie's, London; Victoria and Albert Museum, London; Sotheby's, London; Imperial Collections, Japan.*